How can I explain to dainty, delicate women what it is like to climb down into a rodeo chute onto the back of a wild horse? ... If, with my present arthritis, I must pay the price of every bronco ride that I ever made, then I pay for it gladly. Pain is not too great a price to pay for the freedom of the saddle and a horse between the legs.

—Fanny Sperry Steele
1912 Woman Bucking Horse Champion

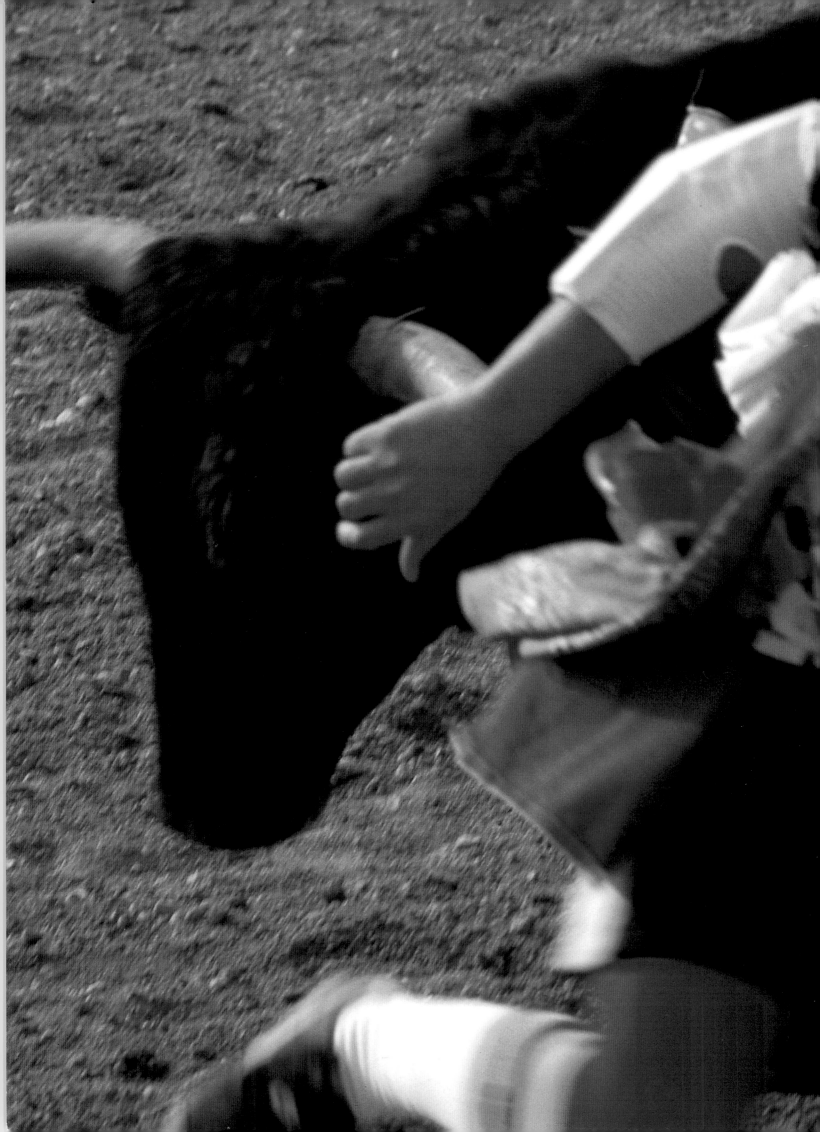

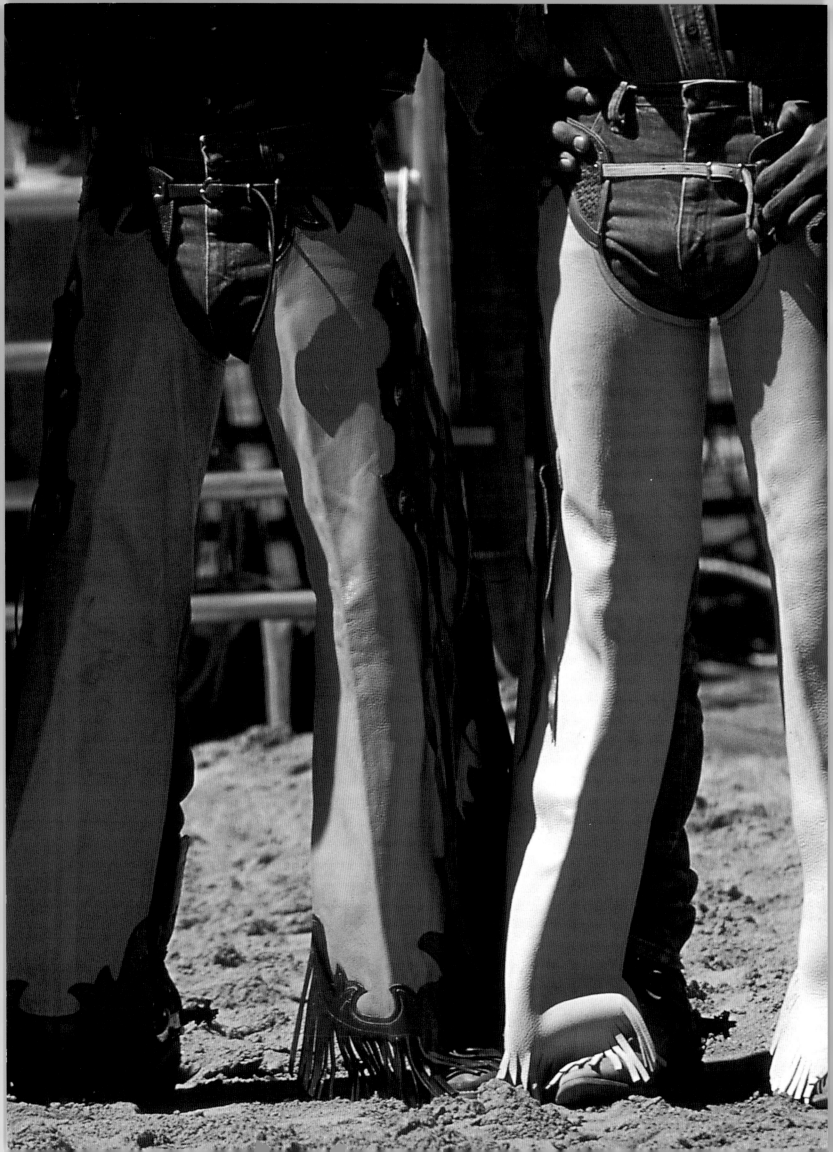

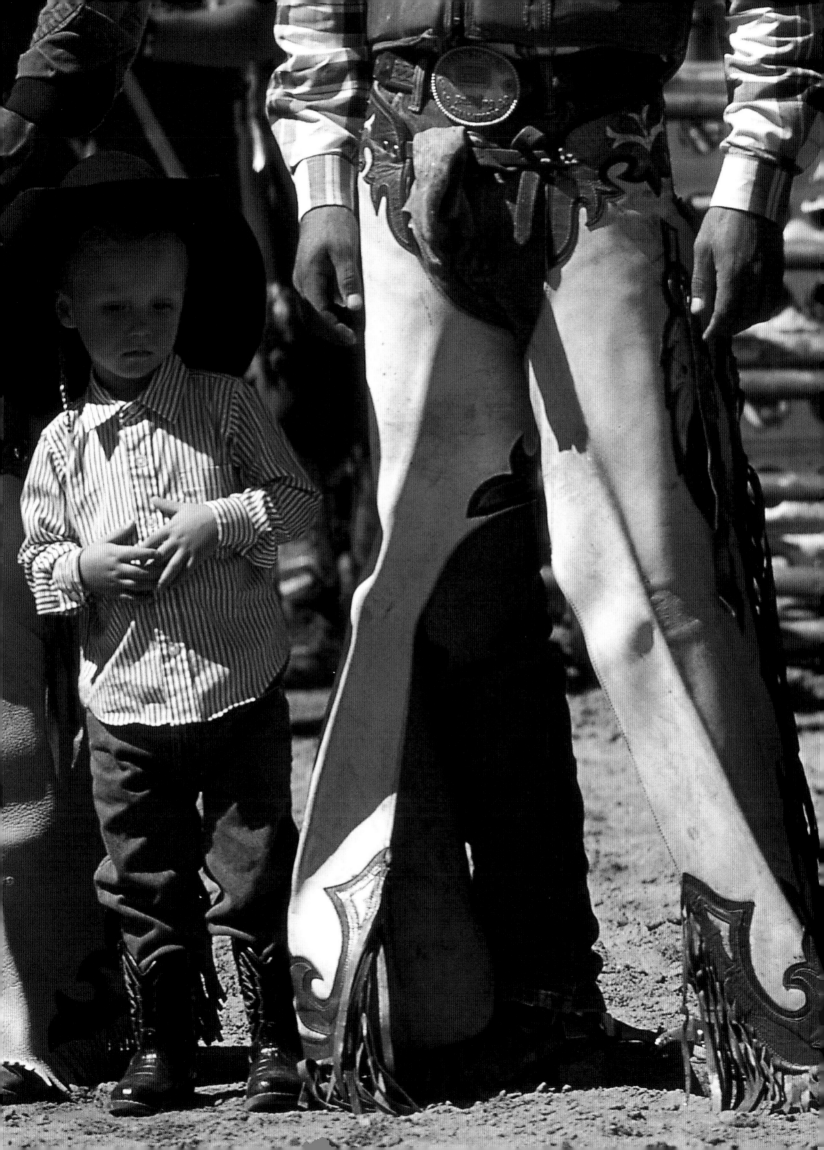

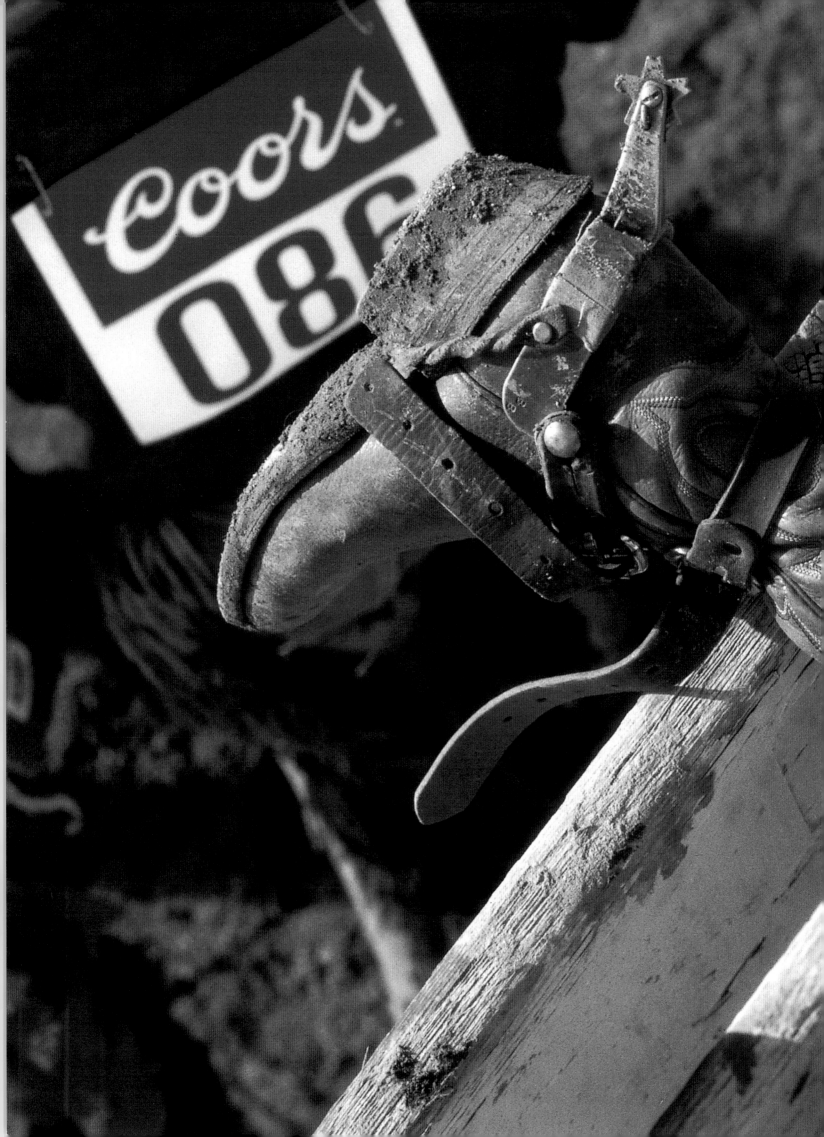

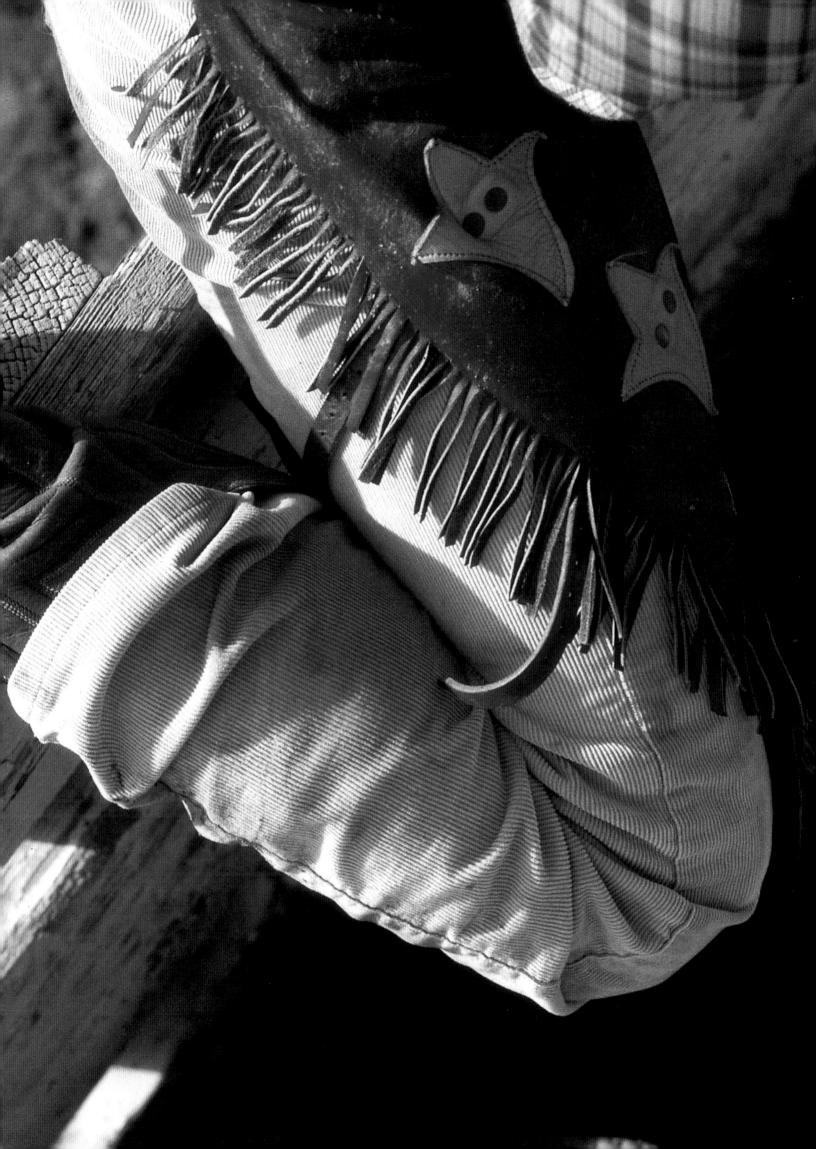

ALSO BY JOHN ANNERINO

Photo Essay

Apache: The Sacred Path To Womanhood

People of Legend: Native Americans of the Southwest

The Wild Country of Mexico/La tierra salvaje de México

Canyons of the Southwest

High Risk Photography: The Adventure Behind the Image

Non-Fiction

Running Wild: An Extraordinary Adventure of the Human Spirit

Dead in Their Tracks: Crossing America's Desert Borderlands

ROUGHSTOCK

The Toughest Events in Rodeo

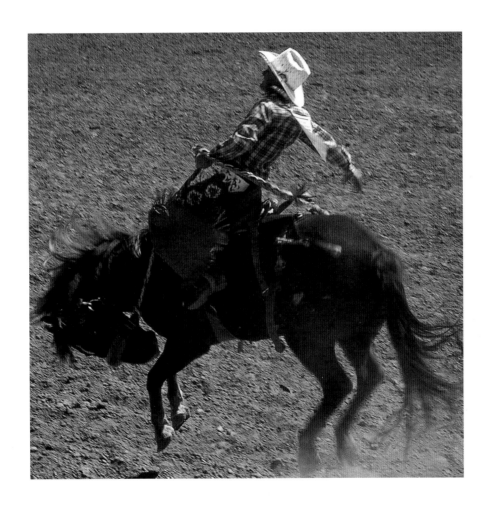

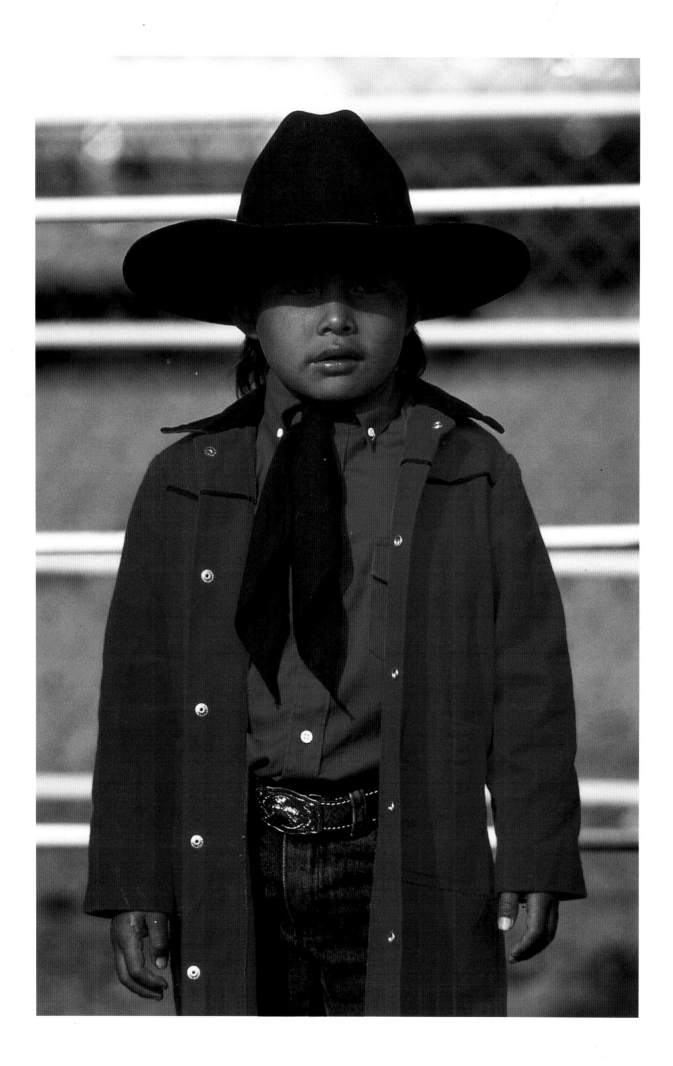

ROUGHSTOCK

The Toughest Events in Rodeo

essay and photography by

John Annerino

Four Walls Eight Windows
New York/London

PAGES 2–3: A clown dances with a Mexican fighting bull.

PAGES 4–5: A young cowboy is dwarfed by bull riders.

PAGES 6–7: 086 boot and spur.

PAGE 9: A cowboy "marks out" a saddle bronc ride.

PAGE 10: A young Apache cowboy.

RIGHT: Missouri-born Scottie McTeer follows in the footsteps of women like Lucille Mulhall, who became "America's first cowgirl," at the 1897 St. Louis Fair.

Photographs and text © 2000 John Annerino

Published in the United States by:
Four Walls Eight Windows
39 West 14th Street, Room 503
New York, N.Y., 10011

U.K. offices:
Four Walls Eight Windows/Turnaround
Unit 3, Olympia Trading Estate
Coburg Road, Wood Green
London N22 6TZ, England

Visit our website at http://www.4W8W.com

First printing October 2000.

Library of Congress Cataloging-in-Publication Data:
Roughstock/ photographs and text
by John Annerino.
p. cm. ISBN 1-56858-177-7
1. Rodeos – Pictorial works. 2. Cowboys – Pictorial works. 3. Cowgirls – Pictorial works. I. Title.
GV1834.A65 2000
791.8'4 – dc21 00-035460
CIP
10 9 8 7 6 5 4 3 2 1

Text design by Ink, Inc.
Photography, layout and design by John Annerino

Printed in China

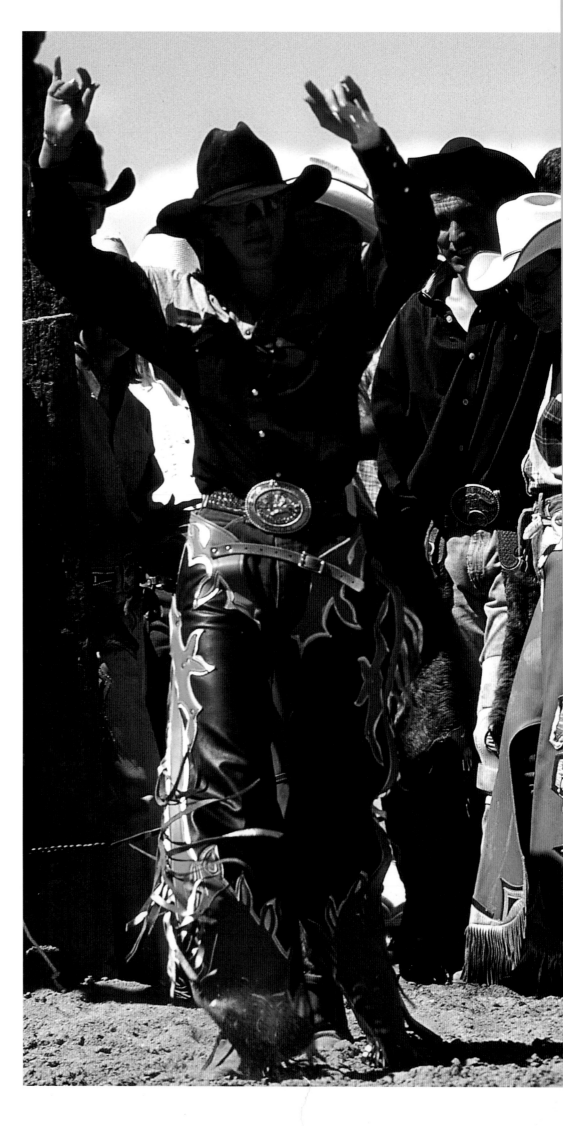

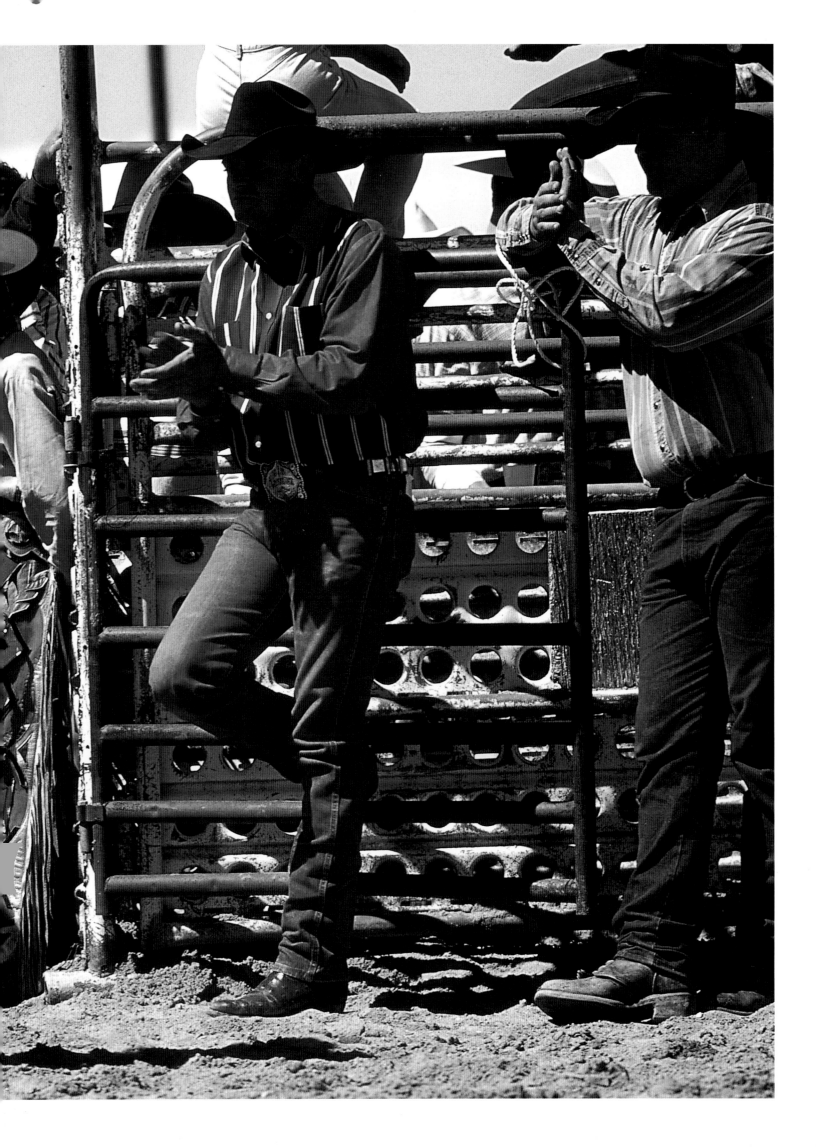

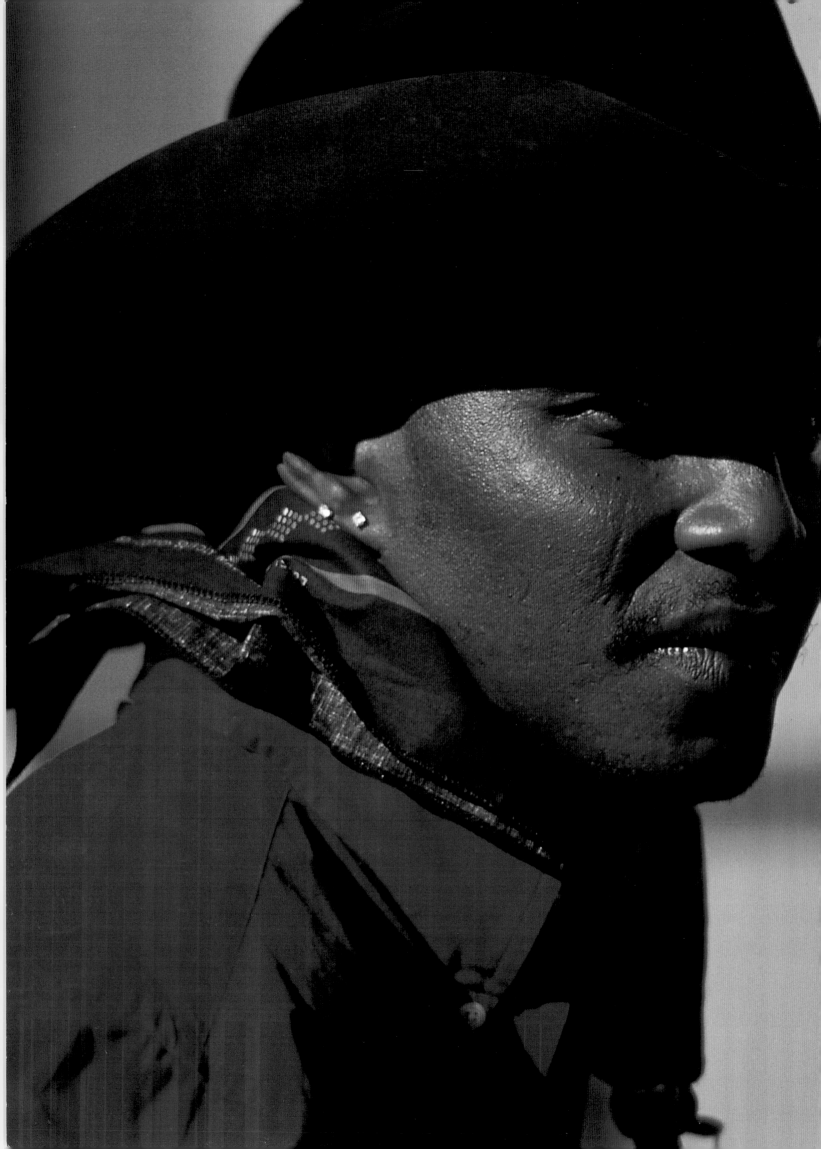

CONTENTS

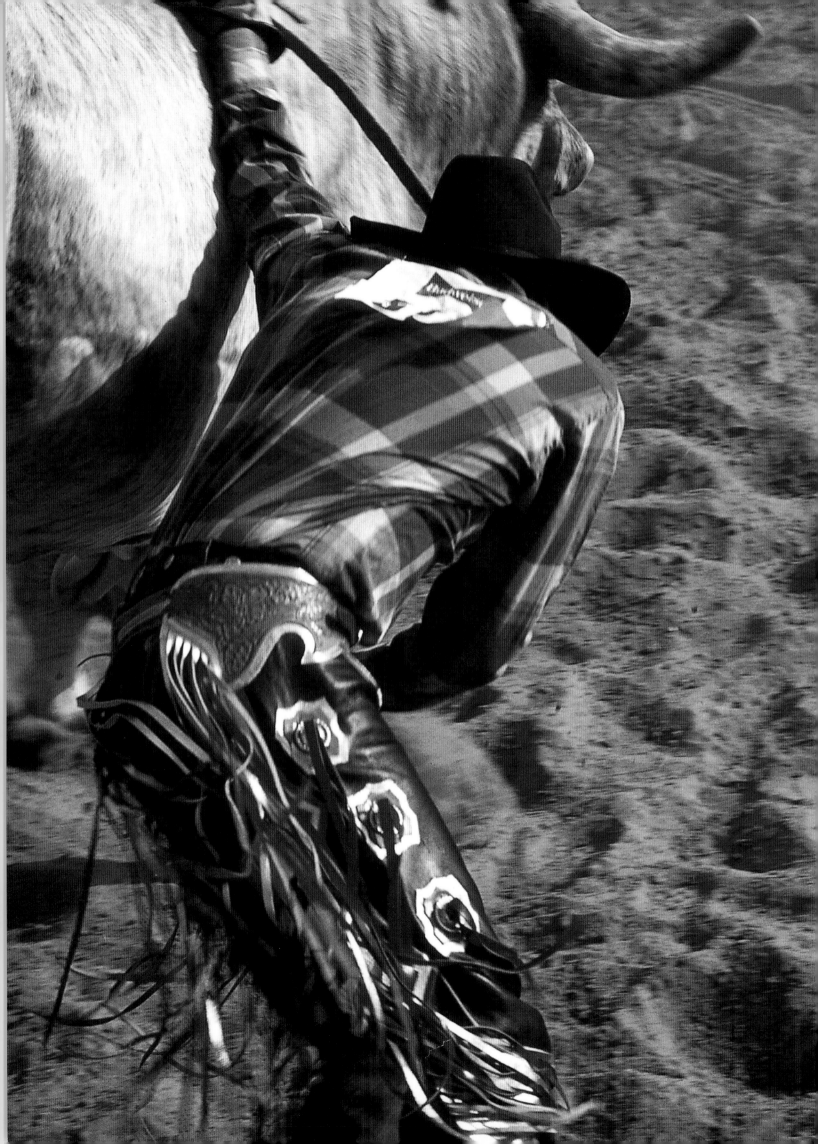

*This one's for mom
—and the rodeo cowboy.*

MANY SEASONS HAVE COME AND GONE since Colorado stock contractor Harry Vold and his flankers took me behind the chutes to photograph the seldom-seen view of roughstock at the "World's Oldest Rodeo" in Prescott, Arizona. I am grateful to Mr. Vold, Pro Rodeo Hall of Fame honoree, and his outfit, the Harry Vold Rodeo Company, for opening my eyes to this enduring American tradition, and to the Casper Baca Rodeo Company of New Mexico, the Honeycutt Rodeo Company of Colorado, and other stock contractors who gave me vital chute access to photograph most of the images which appear in this book. Among the long list of others who helped out behind the scenes, I'd like to thank the good people at the Andy Devine Days Rodeo, the African American Cultural Council, the Bill Pickett Invitational Black Rodeo, the Desert Thunder Pro Rodeo, the Fiesta de Los Vaqueros Rodeo, the Justin World Bull Riding Championship, the Navajo Nation Fair & Rodeo, the O'odham Tash Days Rodeo, the Prescott Frontier Days Rodeo, the Whiteriver Apache Rodeo, the Wickenburg Old Timers Rodeo, the Winslow Jaycees, and elsewhere, and especially the cowboys and cowgirls, bullfighters, clowns, flankers, pickup men and others who grace the pages of this book. During the conceptual stages of this book, Melvin L. Scott generously provided me with film, processing, and a keen eye while a picture editor at *Life*, while most of the recent film I shot was entrusted to the care of Esther Meyer and Nancy Jones. My wife Alejandrina, Tim Miller, Jim Curtis, Anthony Ebarb and Cynthia Garrett were indispensable in the pre-production of this book, as was Thomas Whitridge at Ink, Inc. I thank my publisher John G. H. Oakes for his wit, wisdom, and generosity.

LEFT: Hung up in his rigging, a bull rider gets dragged through the dirt.
PRECEDING PANEL: Diamond studs highlight the outfit of this rodeo cowboy.

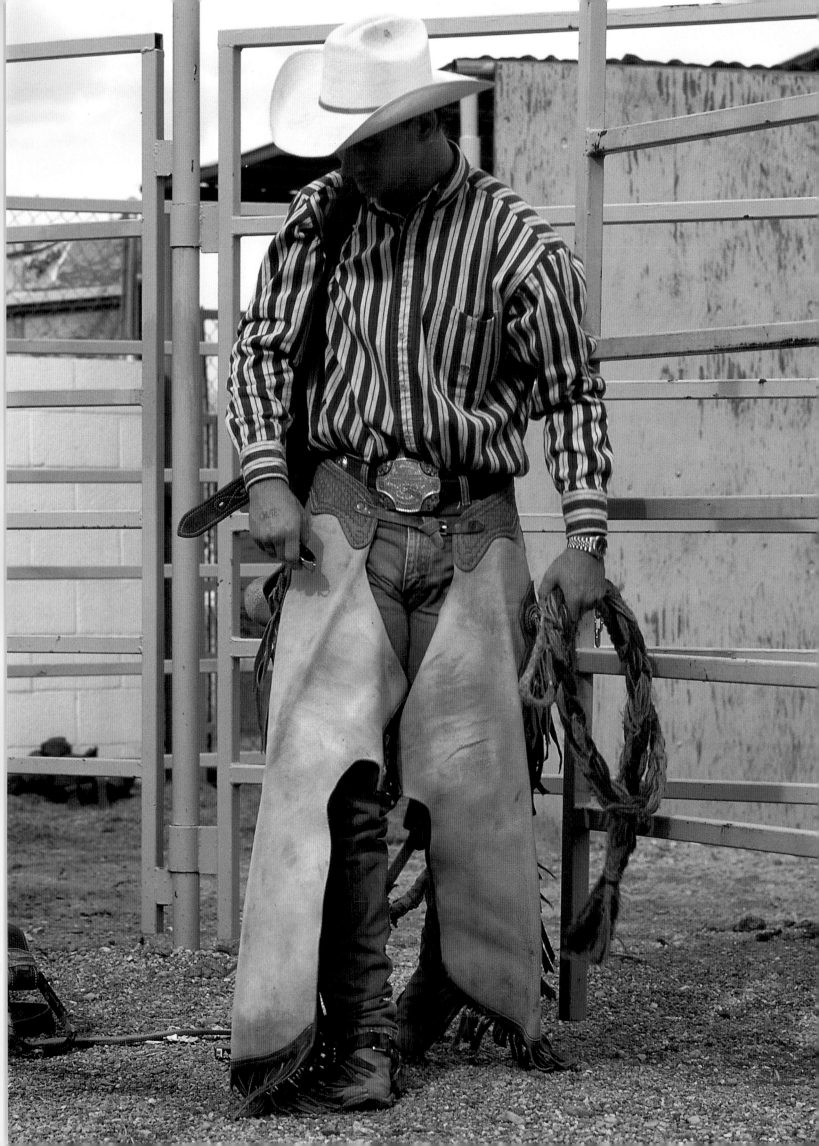

I REMEMBER IT TO THIS DAY – the first time I was hooked by the horns of a bull. The winter sun had finally burned the frost off the desert hills of Arizona's gold rush country. My nose was filled with the pungent smell of rodeo, knifed by the crisp mountain air, saddle leather, chewing tobacco, horses, pay dirt, spilled beer, and Sunday go-to-meetin' perfume. I was still wiping—and there's no way to dress this up for pretty ears—the shit mist off my face and camera lens from the last bull, when the flanker rolled the next bull into the wooden bucking chute; it was a speckled black brahma.

Still green to the hazards of working around brahma bulls, I bent over the top plank of the chute and pressed in close as the rider eased down onto the back of the bull; he cinched his rigging around its thick quivering hide and wrapped the braided rope around his leather glove. Slapping his face with the palm of his free hand, he nodded to the flanker to open the gate. But without warning, the bull climbed up the chute, twisted his head like a mean snake, and slammed me across the chest with a two-and-a-half foot rack of ugly yellow horns. Pitchforked through the air, I saw the blur of the bull and rider busting out the front of the chute as I landed with a hard thud behind it. It must have been a good ride, because as I lay groveling in the dirt making promises to the Lord I couldn't keep, I heard the bull's bells clanging in the arena and the crowd cheering in the stands. They were not cheering for me. But, luckily enough, the brahma's horns had been "tipped" (the sharp points sawed off), or some old hayseed would have written my epitaph right there: "Here lies the body of that photographer feller. He died with a hole in his brisket big enough to throw a cat through. 'And of such is the kingdom of heaven.'"

I wiped the blood off my mouth and camera, grabbed a wooden fencepost and struggled to my feet, coughing. Like an unrepentant sinner, once I realized I hadn't broken any bones I knew I'd breach my hasty promise not to get that close for a good picture again. Schooled by tales of Robert Capa, I wanted to put readers on the backs of the rankest bulls and the wildest broncs, and the only way to do that was to work behind the chutes with the flankers and riders, as close to the action as I could get. But from that day forward I took my cues from the stock contractors who knew the cussedness of every bull and bronc, the flankers who cinched on their bucking straps and sometimes "juiced" them with a hot shot from a cattle prod, the

LEFT: A cowboy enters rodeo's hallowed ground behind the chutes.

cowboys who forked over hard-earned money to try to ride the roughstock, and even the nervous twitches of the animals themselves.

Raised in the heart of the West, my fascination with cowboys, Indians, and desperadoes came easily. It was shaped by colorful tales—some true, some tall—of territorial peace keepers like Wyatt Earp and Doc Holiday, outlaws like Jesse James and Billy the Kid, revolutionaries like Pancho Villa and Emiliano Zapata, and Apache warriors like Geronimo and Cochise. My youthful passions were further stoked by the cinematic western heroes of my father, whose favorite lawman was John Wayne, who led a hard-riding posse of good guys that included Robert Mitchum, Burt Lancaster, and Kirk Douglas. To be sure, none of those stars ever portrayed rodeo cowboys, but for my dad's money they cast the longest shadows across the West's cinematic landscape.

Focusing my own lens on the Western myth also came easily. As a rock climber living in the Bradshaw Mountains outside Arizona's territorial capitol of Prescott—made famous by the 1863 gold strike on Hassayampa Creek up the trail from my cabin, and made infamous by the frontier saloons, dance halls, soiled doves, card sharks, drifters and two-legged varmints on Whiskey Row down the road from it—I felt a certain kinship with cowboys though I did not share their lifestyle. Like climbers, cowboys were also risk-takers who built their reputations and measured their courage by staring death in the face; in their case, that usually meant under the horns of a bull or the hooves of a bronc. Rodeo cowboys embodied the spirit of America's Western traditions, and I was drawn to capture that on film.

The true saga of the working cowboy, and that of his heir apparent, the rodeo cowboy, however, does not fit the fast-shooting, chain-smoking Euro-American legends served up by dime novelists, early film makers and highway billboards. An intriguing, multi-cultural chronicle, the history of the North American cowboy dates back to April 19, 1519. That's when Captain General Hernán Cortés landed in the Mexican port city of Veracruz. Riding point for the Spanish conquistador were sixteen horseback *soldados*, and together they had sailed from Cuba to lay siege to the Aztec empire. When the screams of 150,000 slain Indians fell silent and the smoke finally settled in Tenochtitlán two years later, Cortés had, with the help of his Aztec lover Malinche, crushed a civilization and, unwittingly, reintroduced the horse to North America—extinct since prehistoric times. From Cortés' strike force of Andalusian horses and the armadas that followed, conquistadors, soldiers, padres, charros, and vaqueros began building herds of livestock and driving them throughout *Nueva Viscaya* (New Spain), to establish founding mission pueblos, haciendas, and ranchos.

Francisco Vásquez de Coronado was among the first to bring horses and cattle into what became the United States. In 1540, starting his expedition to discover the fabled Seven Cities of Gold, Coronado began with an army of six hundred Spaniards, eight hundred Indians, a thousand pack animals and hundreds of livestock. On May 4, 1598, two hundred sixty-eight years before cattleman Charles Goodnight drove two thousand head of beef from Texas to New Mexico, Captain Juan de Oñate crossed the Rio Grande at El Paso del Norte, leading eighty-three wagons and seven thousand head of livestock on an epic 1,700 mile cattle drive up the *Camino Real* from Mexico City to Santa Fé, New Mexico. The journey across the desert of southern New Mexico was so dangerous it became known as the *Jornada del Muerto*.

Between 1694 and 1701, the Jesuit priest Eusebio Francisco Kino and his escort Captain Juan Mateo Manje made nine journeys across the most desolate country imaginable in northern Sonora and southern Arizona, founding twenty-seven missions they stocked with Spanish horses and cattle. Known to ride up to forty-five miles a day between baptisms, masses, and conversions, Kino also pioneered a treacherous immigrant route across southwestern Arizona; ironically, it later become known as the *Camino del Diablo*, because hundreds of California-bound gold seekers and settlers died there from heat exhaustion. Juan Bautista de Anza also traced Kino's route across the merciless desert trail, leaving San Miguel de Horcasitas, Sonora on September 29, 1775 with a caravan of two hundred forty-two people, six hundred ninety-five horses and mules, and three hundred twenty-five head of cattle destined for Mission San Gabriel Arcángel, California.

There was seemingly no obstacle the Spanish explorers could not overcome in traversing the great *despoblado* on horseback. And wherever they ventured throughout the harsh, largely uncharted northern frontier of New Spain to establish missions and forts, they trailed horses and cattle. According to scholar Nora E. Ramírez, by 1834, 31,000 mission vaqueros oversaw 396,000 head of cattle in California alone.

Predecessors to the American cowboy, Mexican vaqueros were responsible for the grueling day-to-day tasks of herding cattle, tending cows, branding and castrating calves, slaughtering beef, and skinning and tanning hides. Many mission vaqueros were Native Americans, and that violated an unforgivable decree of the Spanish crown: "Indians, even if descended from kings, are not allowed to ride horses, under the penalty of death." The lucre for the California mission system, however, came from selling hides, tallow and soap to foreign ships that plied West Coast waters, and Franciscan padres needed a cheap, hardworking labor force.

Enter the myth-shattering Indian cowboy. In his 1846 book *Life in California*, Alfred Robinson described the skill of Native American vaqueros at Mission La Purisima Concepción's annual rodeo and *matanza* (cattle killing) held at Rancho Guadalupe: "The vaqueros [Chumash Indians], mounted on splendid horses…performed by far the most important part of the labor. When the majordomo pointed out the animal to be seized, instantly a lasso whirled through the air, and fell with dextrous precision upon the horns of the ill-fated beast. The horse, accustomed to the motion, turned as the lasso descended and dragged him to slaughter…Sometimes it happened that one would escape…and some of the more expert would seize him by the tail, and putting spurs to his horse, urge him suddenly forward, overthrowing the bull in this manner."

Native American or Mexican, it was from the vaquero that "American" cowboys later adopted their own peculiar glossary for outfits, horse tack, and methods they used in day to day chores, spring and fall roundups, rodeos, and cattle drives: Bronc was anglicized from *bronco*, buckaroo from *vaquero*, cavvy from *caballada* (herd of horses), chaps from *chaparreras*, corral from *corral*, dally from *dale vuelta* ("give it a turn," as in "dally the rope around the saddle horn"), lariat from *la reata*, lasso from *lazo*, mission from *misión*, mustang from *mesteño*, ranch from *rancho*, remuda from *remuda de caballos*, (change of horses), and rodeo from *rodear* (to surround).

A full half-century before Buffalo Bill spurred his stallion Prince across a New York stage, real Wild West shows had also found their precursors among California's missions and ranchos when vaqueros–Luiseño and Ipai Indians among them– lassoed grizzly bears during roundup and pitted them against longhorn bulls. One of the most spirited accounts of such a bloody contest was written by Major Horace Bell, a onetime soldier of fortune for Benito Juárez and tracker who hunted the legendary horsethief Joaquín Murrieta. In *On the Old West Coast*, Bell writes of a bear which, facing its fifth bull of the day, is finally overwhelmed by a longhorn's charge.

By 1775, Spanish mustangs were roaming throughout the far reaches of Native America's western ancestral lands, along the length and breadth of the Sierra Nevada and Rocky Mountains, through the Great Basin, Mojave, Sonoran and Chihuahuan Deserts, and across the Great Plains from Canada to the Gulf Coast of Texas. Three centuries lapsed between the arrival of Cortés and the first Euro-American cowboys who donned batwing chaps and sugarloaf sombreros to drive herds of Texas longhorns from San Antonio, Texas north along the Chisholm Trail to the railhead at Dodge City. Kansas. And during that time, Native Americans like the

Lakota, Apache, and Comanche, to name a few, had readapted their lifeways and culture around the horse. Horseback, they became formidable warriors who tried to stem their peoples' unconscionable slaughter: the five to ten million Native Americans were "reduced" to 237,196 people by century's turn.

Few horseback warriors were as feared as Geronimo. Born to the Bedonkohe band of Chiricahua Apache sometime during the 1820s, Geronimo led thirty-eight mounted Apaches on an epic campaign of guerilla warfare against 5,000 American troops. Geronimo's bold hit-and-run tactics became legendary, and before surrendering to General Nelson Miles at Skeleton Canyon on September 4, 1886, he conducted some of the most audacious cattle drives ever, rustling up to 350 head of *ganado* at a time from Mexican soldiers patrolling the Sierra Madre – before pushing them 250 miles north to the Chiricahua held captive at San Carlos, Arizona.

The Lakota, among many Northern Plains people, were no less the horsemen. When "Custer Got Siouxed," as the bumper sticker reads, Hunkpapa Chief Sitting Bull's warriors executed his visionary battle against Lt. Col. George Armstrong Custer and the Seventh Cavalry from the backs of horses they revered. Oglala Lakota medicine man and warrior Black Elk witnessed the last stand at Little Bighorn in Montana Territory on June 25, 1876, and later said: "The lightning has wings and rides on a horse."

Lightning also rode with the Comanche of the Southern Plains. As early as 1758, two thousand mounted Comanche warriors were counted at San Saba River Mission, Texas. Led by Comanche chief Quanah Parker who learned to ride at age five, the Comanche carried out horseback raids deep into the heart of Mexico, as far south as Zacatecas, during what settlers came to fear as September's "Comanche Moon." When Quanah Parker finally "retired" to the reservation in 1875, he and the Kwahadi band of Comanche brought their own string of one thousand five hundred horses with them and began leasing grasslands to Texas cattle barons for up to $200,000 a year.

In comparison to Mexican vaqueros and Native American horsemen, who'd already been in the saddle – or riding bareback – for hundreds of years, the era of the "American" cowboy was brief, but it was the most celebrated, and it was from this generation that rodeo took hold. Spanning three short decades from the end of the Civil War in 1865 until the West was strung up by sodbuster Joseph F. Gidden's patented barbed wire in the 1890s, an estimated 40,000 cowboys did the same tough, thankless work of their vaquero predecessors. In fact, according to the history books, one out of seven cowboys was a Mexican vaquero and one out of seven was an escaped slave or Buffalo Soldier.

Riding into America's imagination, the working cowboy's day-to-day life was not what Hollywood made of it; if he packed iron, he seldom used it. But the cowboy life demanded youth, stamina and grit. From the camp song lament, "The Kansas Line," they sang:

> The cowboy's life is a dreadful life,
> He's driven through heat and cold;
> I'm almost froze with the water on my clothes,
> A-ridin' through heat and cold.

For meager wages of "a dollar a day and found" (food), cowboys worked seven days a week, and they often spent eighteen hours a day in the saddle—changing tired mounts for fresh horses in the *remuda* two or three times—before rolling out their bedroll under starry or stormy skies. Lashed by cold wind and prairie dust, pelted by stinging hail and mountain snow, or burned by the desert sun and furnace heat, the tasks of a cow puncher varied from "brush popping," or beating the brush for strays, bringing in "mavericks" (unbranded feral cattle), doctoring fly-infested wounds, crooning to the herd to keep it from stampeding, keeping an eye out for rustlers and horsethieves, and—until they were fenced in by barbed wire they cursed as the "devil's hatband"—living out their dreams in the wide open spaces on black coffee, sourdough biscuits and sonuvabitch stew.

> My ceiling's the sky, my floor is the grass,
> My music's the lowing of herds as they pass;
> My books are the brooks, my sermons the stones,
> My parson a wolf on his pulpit of bones...

Between 1867 and 1887, cowboys drove an estimated ten million longhorns north from Texas along the Goodnight Loving Trail, the Chisholm Trail, the Western Trail, and the Cherokee Trail to railheads in Dodge City, Wichita, and Kansas City, Kansas, and to outposts as far north as Cheyenne in Wyoming Territory, Miles City in Montana Territory, and Fort Buford in Dakota Territory. It was indeed "a hard way to make a $100," and there was little more to keep a cowboy company on the long, lonely trail other than his horse, distant memories of a cowtown sweetheart, and the promise of a pay day blowout when the drive was over. When the drover squared up at trail's end, the cowboys reeked of saddle leather, trail dust, and campfire smoke. They slaked their thirst with redeye whiskey in rowdy saloons and paid for the pleasures of red light ladies in the bawdy rooms. Too drunk or pious

for a roll in the hay, some blew off steam by shooting up the town or lost their pay to gamblers working the faro tables.

Born on the Kentucky frontier "about 1806," Charles Goodnight was said to be one of the hardest riding and hardest driving cowboys, trail bosses and cattlemen the West has known. Author J. Evetts Haley wrote that Goodnight "rode bareback from Illinois to Texas when he was nine years old, hunted with the Caddo Indians when he was thirteen, got into the cattle business when he was twenty, guided Texas Rangers when he was twenty-four, and blazed two-thousand-mile-long cattle trails when he was thirty." During the summer of 1866, Goodnight hired eighteen cowboys to drive two thousand head of cattle from Fort Belknap, Texas to Denver, Colorado along a route that later earned its name as the Goodnight Loving Trail. Riding back to Texas from Denver trailing a mule laden with $12,000 in gold, Goodnight made and lost a fortune in the cattle business, before staking a spread around Palo Duro Canyon in the Texas Panhandle. Bankrolled by easterners John and Cornelia Adair, Goodnight built a herd of 100,000 head of beef that earned his blue-blooded investors $512,000 in 1882 dollars.

In his colorful biography of Goodnight, Haley also wrote: "Great *caballadas*, or cavvieyards, of wild ponies, some duns, blacks and *grullas*, but mainly bays with dark manes and tails, swept over the trails. Wherever they passed, with long manes tossing and tails streaming almost to the ground, they stirred the imagination of men as surely as their hooves stirred the dust of the trail." Cattlemen like Goodnight couldn't move their herds without a remuda of dependable horses, and they paid professional bronco busters five dollars a head to break wild ponies into working saddle mounts. But there were some horses that just wouldn't take to the saddle. Such "outlaws," as broncs have since been called, lured cowhands to neighboring ranch rodeos to try their own luck, much to the whoops and hollers of other hands. Even cattle kings of the Lone Star state like Goodnight, who was said to eat more horsemeat than most cowboys, credited his riding ability to a bucking horse: "That pony made me a rider," he mused. "I guess it threw me a hundred times, and I always thought it bucked me off just for amusement."

It wasn't until 1886, when onetime scalp hunter, buffalo runner, and Pony Express rider Colonel William Frederick "Buffalo Bill" Cody took his Wild West Show to Madison Square Garden that bronc riding made its grand entry into the American conscience. Eager for colorful tales of a Wild West that had already passed, the public roundly accepted Cody's re-enactments of gunfights, mock cavalry and Indian battles, and bronco busting. And as Buffalo Bill Cody's Wild

West Show drew fame in Europe touring with Chief Sitting Bull himself, rodeo began taking hold in frontier towns back home. First held in Arizona on July 4, 1888, the Prescott Frontier Days Rodeo still claims to be the "World's Oldest Rodeo," and Wyoming still boasts the Cheyenne Frontier Days Rodeo, first held on September 23, 1897, as "the Daddy of Them All." Rodeo took off. Early rodeos like Prescott, Cheyenne, and other cowboy jamborees still flourish among more than one thousand other rodeos today, such as the Pendleton Round-Up in Oregon, the Calgary Stampede in Alberta, the Cow Palace Rodeo in San Francisco, and the Fort Worth Exposition and Livestock Show in Texas.

Most closely associated with the working cowboy was saddle bronc riding, and it was the first of three roughstock events that drew—and draws—ticket buyers to watch cowboys try to ride high-kicking broncs. In the early days of rodeo, that was no mean feat. Before the advent of front-loading wooden chutes, called "shotgun chutes," a skittish bronc first had to be "snubbed," or held down and blindfolded in the middle of the arena while a cowboy did his best to saddle it. Once the horse was saddled and mounted, the blindfold was removed and the cowboy either rode until he was bucked off or until the bronc quit. Most famous among the storied cowboys inducted into the Cowboy Hall of Fame and the Pro Rodeo Hall of Fame, perhaps, was Casey Tibbs. Born in Ft. Pierre, South Dakota in 1929, Tibbs was the first rodeo cowboy to win six World Champion Saddle Bronc titles. A larger-than-life bronze statue of Tibbs bucking out on a bronc called Necktie now stands in front of the Pro Rodeo Hall of Fame in Colorado Springs.

Even Tibbs, who once rode a saddle bronc blindfolded, had his predecessors; among them was an early Montana cowboy who, one story goes, busted broncs while "quietly shaving, holding a small mirror in one hand and the razor in the other, with the mug, hot water, and bay rum in a little basket on his arm." One of the greats, though rarely mentioned in the histories of rodeo, was Native American Tom Three Persons. A Kainai (Blackfoot) Indian, he was the first cowboy in over a hundred to ride the bronc Cyclone to a standstill. The September 9 edition of *The Albertan* described Three Persons' $1000 ride at the 1912 Calgary Stampede:

> Three Persons' ride was a wonderful performance. 'Cyclone' tried every art known to his craft. He stood and pitched, started to stampede several times, then stopped and tried the trick that has sent 129 men to earth. He reared straight up and feinted as if to throw himself backward, then took prodigious leaps and twisted and corkscrewed his body in a fury of contortions that

threatened to tear him in two. The Indian sat in his saddle as if glued to it, with hands up and a challenge to 'Cyclone' to do his worst.

Again and again the horse stopped, but only for a few seconds, when he renewed the struggle. Again he tried to throw his rider backward and then, acknowledging he had met his master in the aborigine, he surrendered.

Split skirts, as cowgirls were called in Annie Oakley's heyday, also made their mark on the rodeo circuit, and it wasn't from riding side-saddle. In 1900, Missouri cowgirl Lucille Mulhall earned the enviable reputation as "America's first cowgirl" demonstrating her flair for trick riding and roping in New York City. But the first woman to compete against men in saddle bronc riding was Colorado rancher Bertha Kapernick Blancett; she rode a "long lanky roan, full of deviltry" to a standstill at the 1904 Cheyenne Frontier Days. The local paper reported: "It was one of the most remarkable exhibitions of rough riding ever seen here, and would have been exciting had the rider been a man. As it was the multitudes cheered . . . this extraordinary young lady who has conquered the West." Blancett's ride also won over rodeo officials who finally sanctioned women's saddle bronc riding in 1906. The tragic death of Idaho cowgirl Bonnie McCarroll after getting bucked off and trampled at the Pendleton Roundup in 1929, however, changed the course of women's saddle bronc riding; resistance grew until it was eliminated from professional rodeo. Fifty-seven-year-old Jan Youren, a mother of eight and grandmother of 38, has bucked such sentiments by riding broncs bareback for over four decades. Deemed the "grandmother of rodeo," who claims to have "broken every bone in [her] body," the Idaho ranch woman is a Cowgirl Hall of Fame honoree and a living inspiration for women roughstock riders. But few have summed up the feeling of a woman bronc rider better than Montana cowgirl and 1912 Woman Bucking Horse Champion Fanny Sperry Steele: "How can I explain to dainty, delicate women what it is like to climb down into a rodeo chute onto the back of a wild horse? . . . If, with my present arthritis, I must pay the price of every bronco ride that I ever made, then I pay for it gladly. Pain is not too great a price to pay for the freedom of the saddle and a horse between the legs."

The first bareback riders in North America were undoubtedly Native Americans, but which tribe first rode a Spanish mustang with nothing more than its mane to hang onto and their moccasins to "spur" it is not known. Oregon's Palouse of the Nez Percé tribe were such fine bareback riders the Appaloosa horse derived its name from them. Officially, bareback riding was first held as a roughstock event in

1913 at the Prescott Frontier Days Rodeo; three years later Black cowboy Jesse Stahl was photographed at the Pendleton Roundup riding a bronc named Backward Sally *backwards*. Next to Casey Tibbs, though, one of the most enduring names in rodeo—and bareback riding—is Jim Shoulders. Born in Tulsa, Oklahoma in 1928, Shoulders won sixteen world championships in the roughstock events between 1948 and 1961, including four Bareback Riding Championships. The reason for his astonishing career was his ability to ride competitively whether healthy or injured. Shoulders, author Bob Jordan wrote, "probably had more broken bones than anyone in sports. He competed many times with a cast. If his riding hand was broken or injured, he would simply ride with the other hand and win." Of bull riding in particular, and rodeo life in general, Shoulders said: "If you're gonna ride bulls, it isn't if you get hurt, it's when.... When rodeoing you learn to sleep fast."

Hard-riding African-Americans also gained fame sleeping fast between championship rides on the rodeo circuit. As sharpshooting Buffalo Soldiers who rode with the Ninth and Tenth Cavalry Regiments after 1866, Black cowboys also demonstrated their equestrian prowess punching cows on the great Western cattle trails and later riding "anything with hair" in the rodeo arena. Nat Love earned his moniker "Deadwood Dick" by showing off his roping and riding skills at a cowboy tournament in Deadwood, South Dakota in 1876, while Bronco Jim Davis rode the bronc that "knew no taming" in front of eight thousand people in Denver in 1887. Most famous of all Black cowboys, however, was Bill Pickett. Long credited with inventing bull-dogging, or steer wrestling as it is popularly known today, Pickett actually became famous for modifying a technique first used by another Black cowboy in Texas during the 1870s who'd lost his lariat and needed to wrestle a steer to the branding fire. Galloping full speed alongside a charging steer, Pickett would dive off his horse, grab the bull by both horns, and then sink his eye teeth into its whiskered lower lip; his hands aloft, Pickett hung on like an English bulldog until the steer tumbled to the ground.

Pickett's greatest, most dangerous rodeo performance was with the 101 Ranch Wild West Show held in Mexico City's Plaza de Toros on December 23, 1908. On a bet wagered between American promoter Joe Miller and a group of Mexican matadors drinking together one night at the Café Colón, Pickett accepted the challenge to bull-dog the Mexican fighting bull Frijoli Chiquita (Small Beans). Two days later, the matadors promenaded into the plaza carrying Pickett's empty black coffin in front of five thousand rabid fans. They wanted blood, and they got some of it. As Pickett rode in close enough to the bull to jump, Frijoli Chiquita gored Pickett's horse.

Pelted with beer bottles thrown by angry fans, Pickett hung on to the bloody horns of the fierce Tepeyahualco bull when, as author Bailey C. Hanes wrote, Frijoli Chiquita "launched an effort to dislodge the intruder, tossing the luckless and unwelcome cowboy from side to side like a sheet in the wind. Unable to dislodge Pickett, he tried to gore him and even attempted to ram the man into the wall of the bull ring, all to no avail. Pickett stuck like a bur." The crowd went crazy and President José de la Cruz Porfirio Díaz ordered two hundred armed *rurales* to escort the bloodied Pickett, the 101 Ranch cowboys, and their winnings from the plaza before they were killed by the mob. The American cowboy's bravura was summed up in the December 24, 1908 edition of the Mexico City newspaper *El Imparcial*: "Pickett subdued the beast and put his snout on the ground, doubling his neck under the weight of his [Pickett's] herculean strength. But the crowd wanted blood, as that is the reason they go to the circus: blood of bulls, blood of horses, blood of men; blood which stains and darkens the grayish and monotonous sand of the bull ring. But this occasion did not give them that pleasure. Now it will be another time." The matadors later declined Pickett's challenge for them to bull-dog one of their own fighting bulls.

What started out as an 1884, July 4th celebration became the largest "rodeo" in Dodge City, Kansas when saloon keeper A. B. Webster ponied up $10,000 in gold and hired five Mexican bullfighters to face down twelve Texas longhorns. Billed as the Grand Spanish Bullfight, the deadly performance drew four thousand spectators from the afternoon's festivities of horse races, shooting matches, and cockfights. It was only a matter of time before some cowpoke started wondering what it'd be like to ride a bull instead facing it down in a deadly *corrida*—perhaps the first time anyone had gone one-on-one, unarmed, against a bull since Crete, circa 2,000 BC. The idea took, and riding "Texas Wild Steers" became part of Buffalo Bill Cody's Wild West Show before bull riding became popular at the 1925 Prescott Frontier Days Rodeo.

In the annals of rodeo, few bull rides have left a more indelible impression on fans than Warren "Freckles Brown" Granger's ride at the 1967 National Finals Rodeo in Oklahoma City. Freckles drew a bull that took its name from the storms that have wreaked havoc across the Great Plains since day one—Tornado. The rankest of the rank, Tornado had already busted up and tossed 220 other cowboys. Worse, Freckles was a 47-year-old bull rider, and he had broken his neck five years earlier getting thrown from an ornery beast called Black Smoke. The deck was clearly

stacked against the aging Wyoming cowboy. But Freckles had what rodeo folks call "a lot of try," and the 1962 World Champion Bull Rider climbed down into the bucking chute equivalent of the pit of hell. He cinched the rigging around the girth of the monstrous bull and wrapped the rope around his gloved hand. Before the gate swung open to chute number two, "Freckles nodded for the 1,850 pound Braford." Bob Jordan wrote: "About halfway through the ride the crowd of tense and excited fans got to clapping and cheering so loud that Freckles never did hear the whistle. Never before or since has a cowboy got such a standing ovation."

Many cowboys have gone down the road in search of a great bull ride like Freckles Brown's; some, like Larry Mahan, Charlie Sampson, Lane Frost, and Ty Murray, have become legends and Pro Rodeo Hall of Fame honorees. Others, like cowgirl Deedee Crawford, have broken taboos by following the lead of Texan Jackie Worthington who entertained rodeo fans by riding bulls during the 1940s. In *The Horn and the Sword*, Jack Conrad wrote: "Bulls are the essence of male force." And many cowboys will echo that sentiment by telling you in no uncertain terms the back of a bull is no place for a woman. One muggy summer afternoon in Winslow, Arizona, I watched Deedee Crawford, a young Texas cowgirl, climb onto the back of a bull most men would run from—and get pummeled before she was carried out on a stretcher. Several weeks later, I asked another bull rider his thoughts on the subject while he was taping up behind the chutes. He looked me squarely in the eye and said: "The only place I wanna see a woman is cookin' in the kitchen or having my babies." Women roughstock riders from Fanny Sperry Steele to Jan Youren have paid no heed to such talk.

Slim Pickens was a onetime bull rider-turned-Hollywood actor whose most famous ride was on a nuclear bomb in the movie "Dr. Strangelove." When Pickens was asked why he went from rodeo cowboying to movie cowpokin', the character actor famously said, "Ain't never had one dang camera run over me." And the Cowboy Hall of Fame honoree's words sum up perfectly the risks rodeo cowboys and cowgirls face every time they ease down into the chute and cinch their saddle or rigging around a thousand-to-two-thousand pound animal that's likely to kick, stomp, or gore them.

They call bareback, saddle bronc, and bull riding the roughstock events; they are the toughest events in rodeo—and the focus of this book. In her anthropological study of the wild and the tame, Elizabeth Atwood Lawrence wrote that rodeo is "identified as 'Western' by Americans, and indeed as 'American' by the rest of the world." Today, the Professional Rodeo Cowboys Association sanctions more than

eight hundred rodeos throughout the United States each year. Dating back to the original 1936 Cowboy Turtle Association, the P.R.C.A. is the most venerable rodeo association, but it is only one among many. Official rodeo organizations include the First Frontier (New York, New Jersey), Little Britches (children), All Indian, Women's Professional, Bill Pickett, Military, Korean American, Okinawa Bull Riders, and so on. Yet, in spite of rodeo's long tradition, popularity and renown, it's still difficult to find regular mention of it in the sports pages. Reportedly, when shown a rodeo poster, one sports editor is said to have scratched his head and asked: "Where's the ball?" In fact, unlike most professional athletes whose five-, six- and seven-figure salaries would laden a pack string of Charles Goodnight's mules, rodeo cowboys don't even make the frontier cowboy's pittance of "a dollar a day and found" – unless they win. And except for the lucky few who saddle up with sponsors or earn enough prize money to pay entry fees, travel expenses, insurance and medical bills, most rodeo cowboys hold day jobs to follow the circuit from one dusty arena to the next. To be sure, most no longer earn their pay punching cattle, but they come from distant hamlets, cowtowns and cities across the nation to find common ground and risk their lives for an eight second ride in the most dangerous events in sports. Men and women, both, they are today's roughriders. And they still embody the spirit and traditions of the American West.

John Annerino
Tucson, Arizona
August, 2000

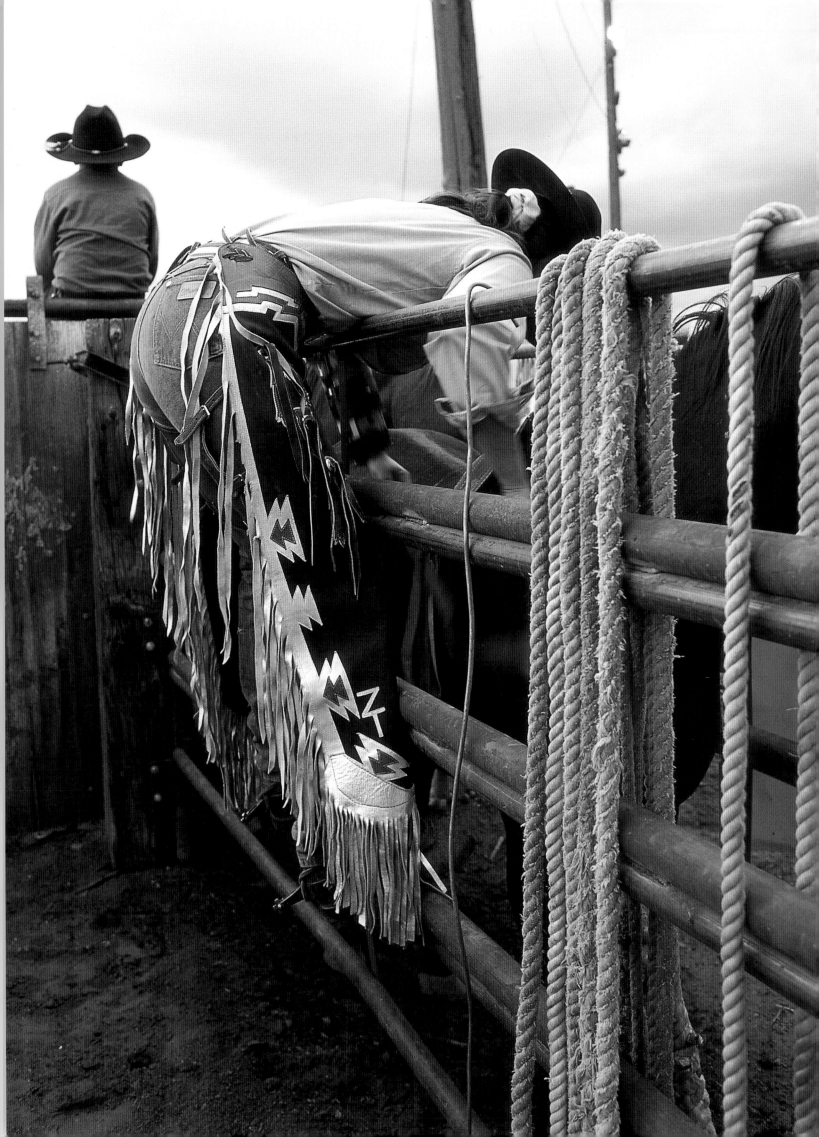

1. Behind the chutes

LEFT: Australian cowgirl Tammy Graham readies her steed.

OVERLEAF: Georgia cowboy Noel Perry tempts fate before his ride.

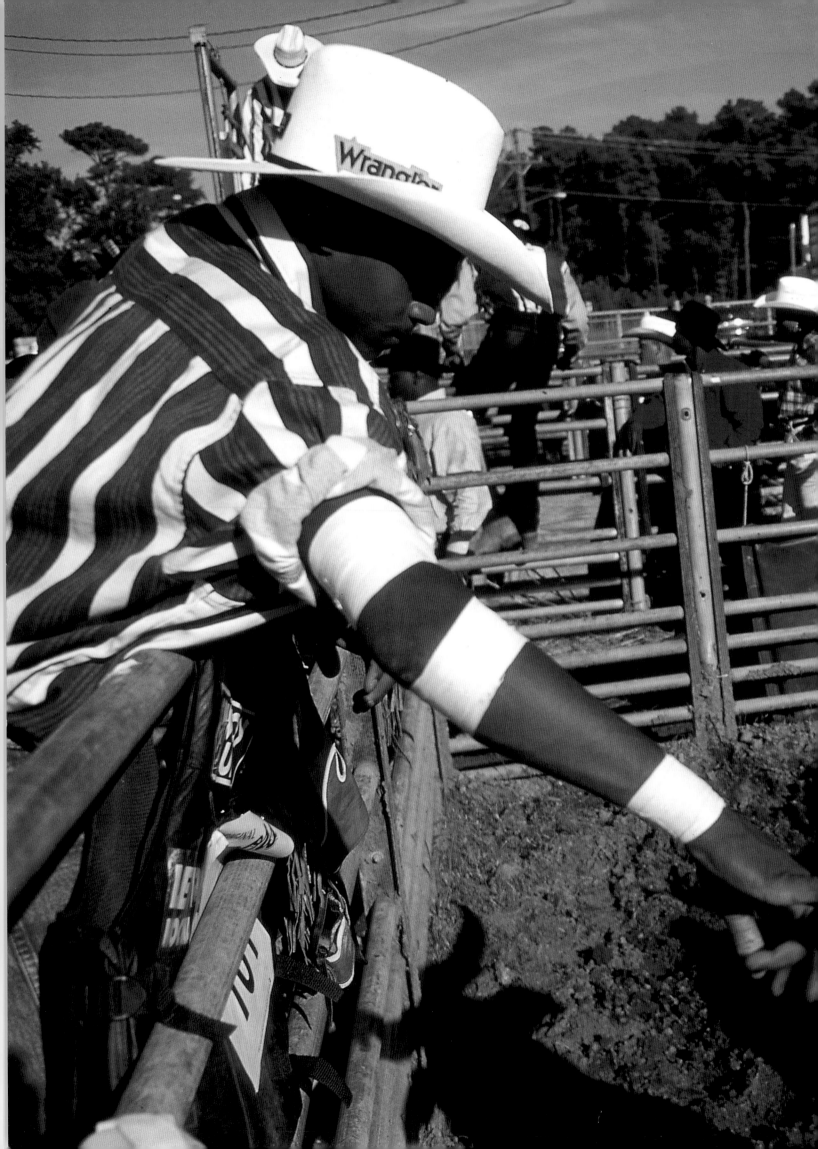

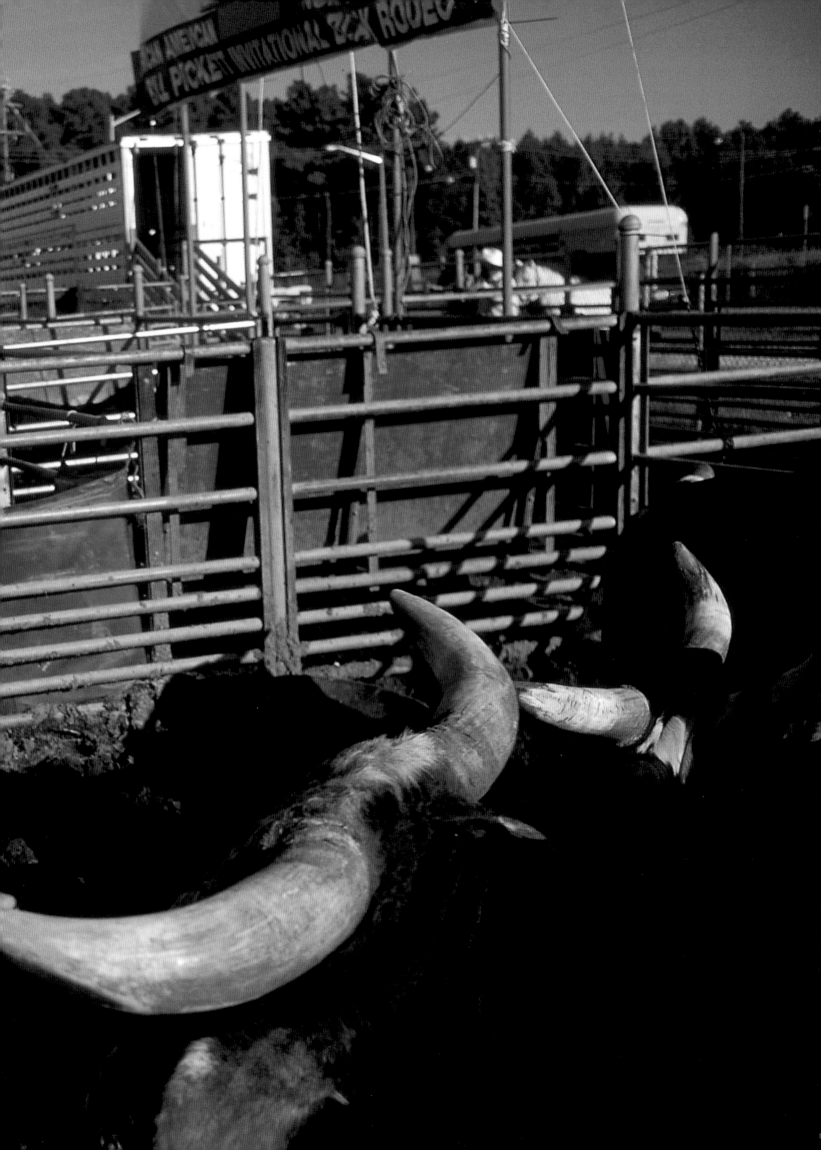

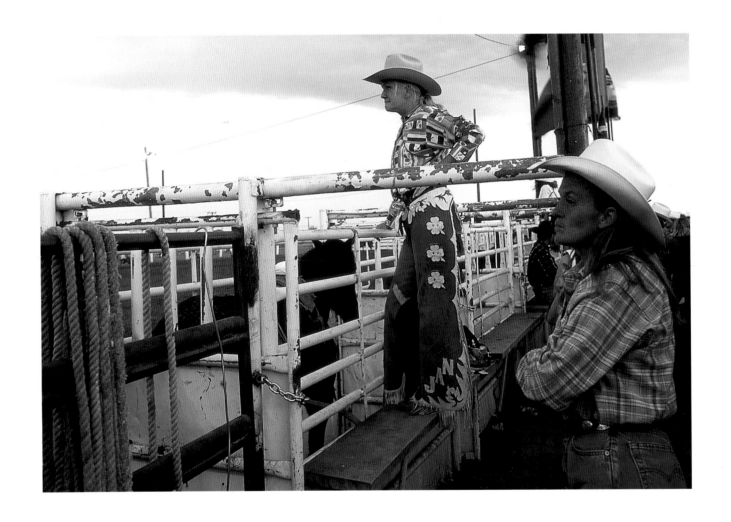

ABOVE: Cowgirl Hall of Famer Jan Youren (left) and a Casper Baca wrangler watch the action.

RIGHT: Behind the chutes: where cowboys and cowgirls prepare for the most dangerous events in sports.

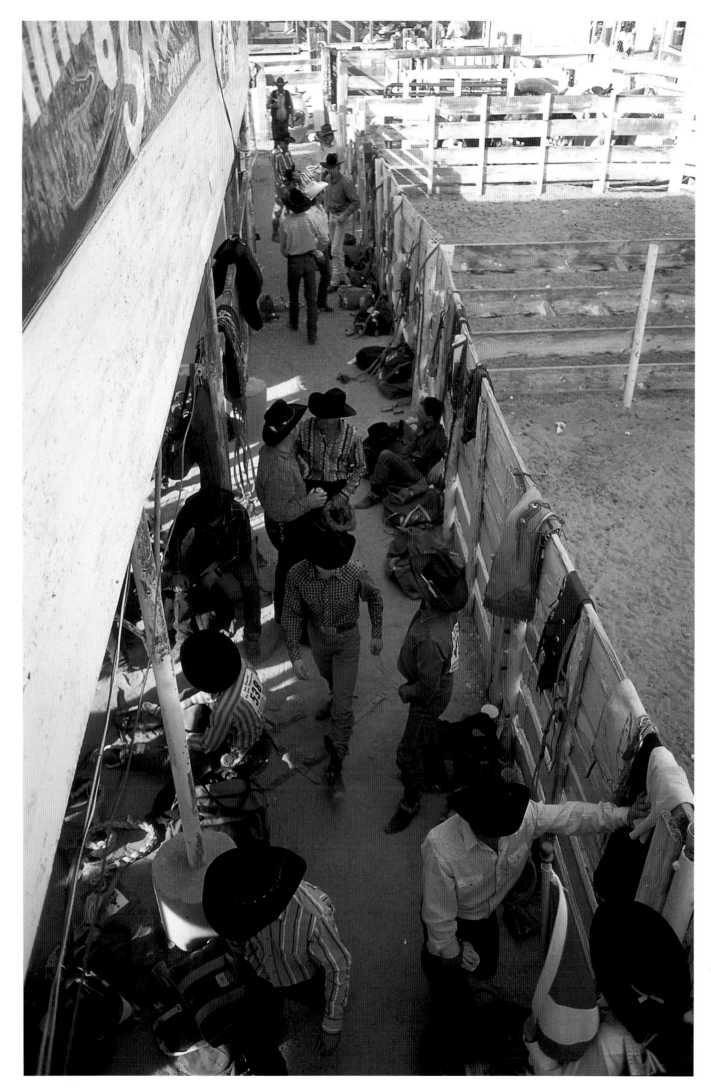

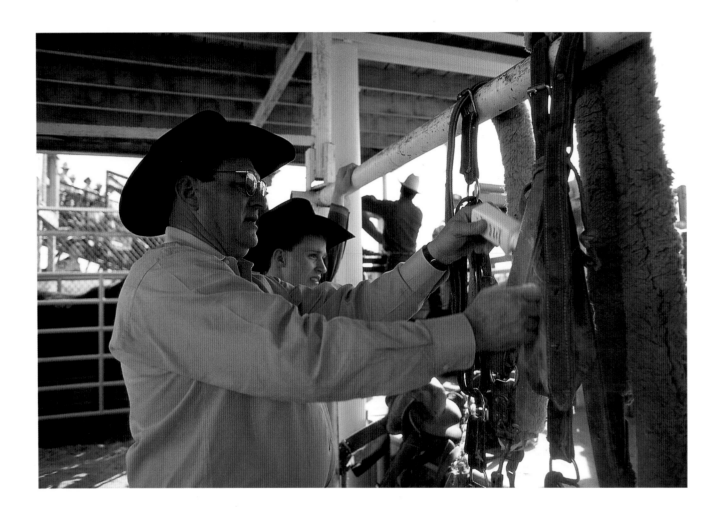

ABOVE: A flanker powders down the bucking straps used for roughstock events while Texas cowboy Ty Murray waits his turn to ride.

RIGHT: Pro Rodeo Hall of Fame cowboy J.C. Trujillo (right) buckles on his chaps while talking to a less-fortunate cowboy.

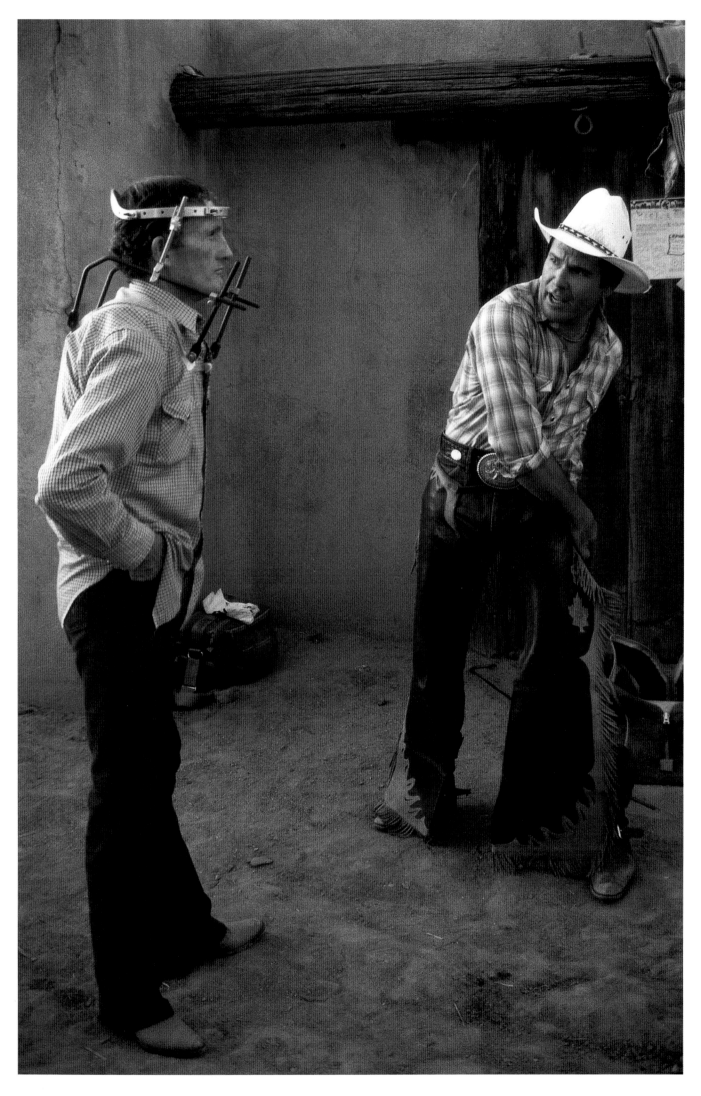

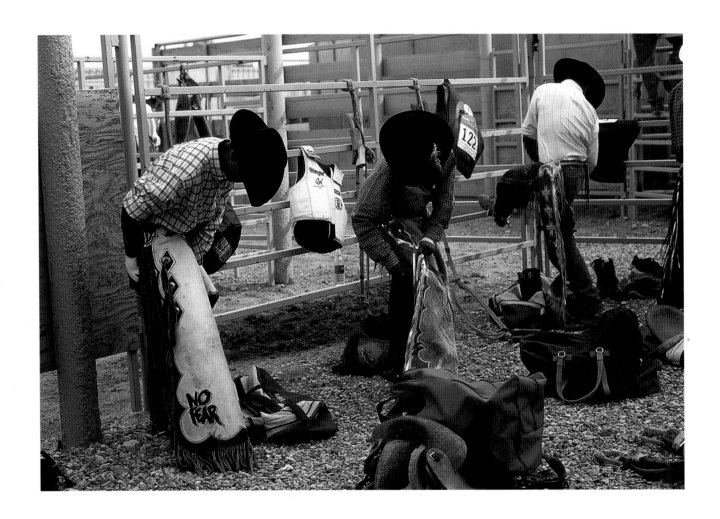

ABOVE: Native American cowboys get ready to ride.

RIGHT: A cowboy buckles on his chaps.

OVERLEAF: Next to a cowboy's hat, boots are synonymous with all roughstock events; the late master bootmaker Cosimo Lucchese said: "We used to make them to fit a stirrup. Now we make them to fit the gas pedal of a Cadillac." That may hold true for city slickers, but roughstock cowboys lash on their boots with rawhide to keep them from flying off while "marking out" an animal with their spurs.

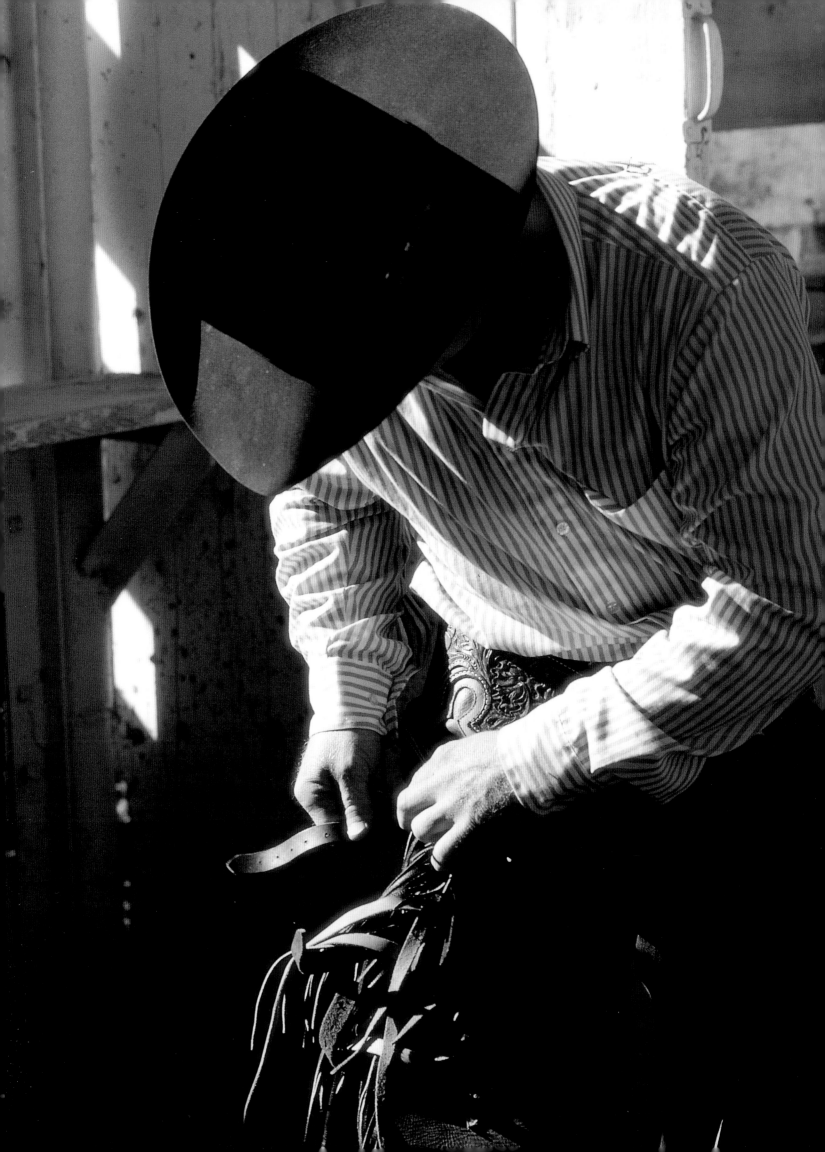

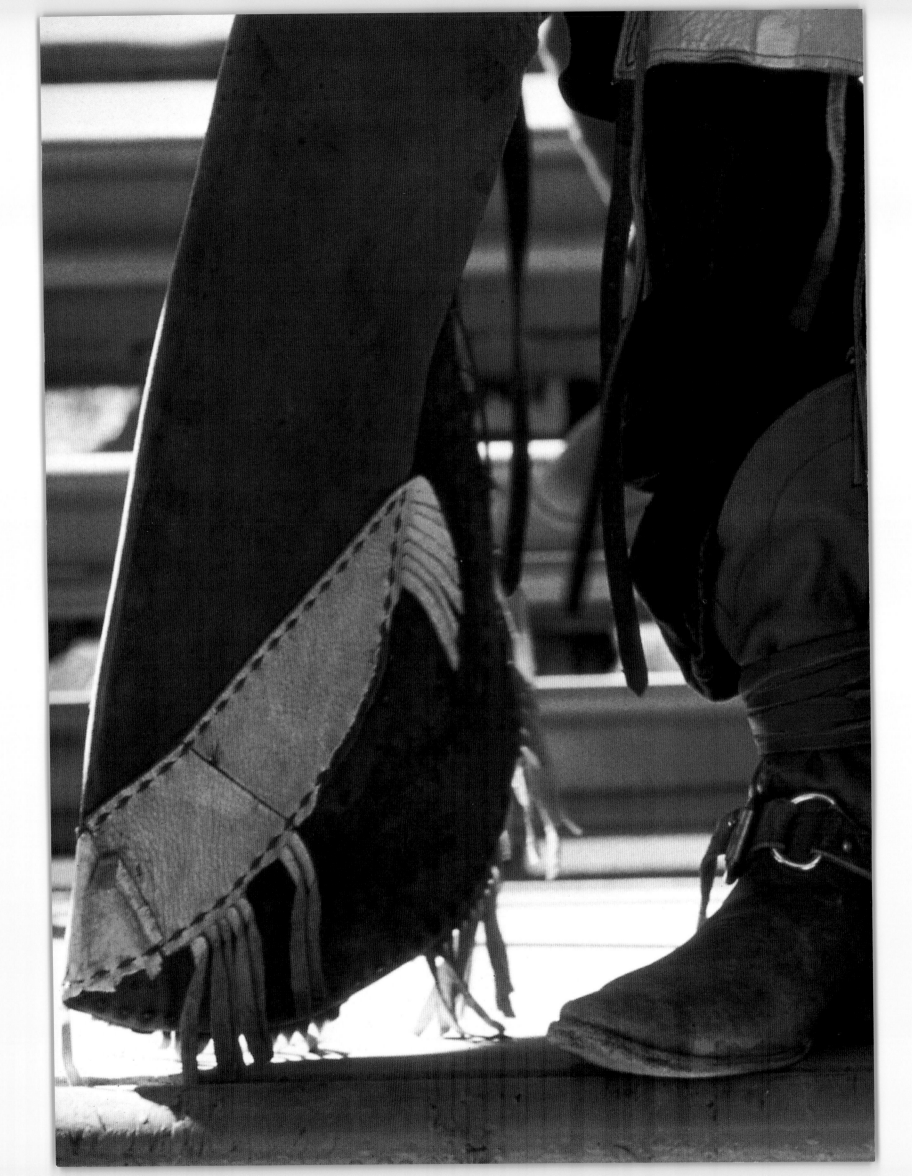

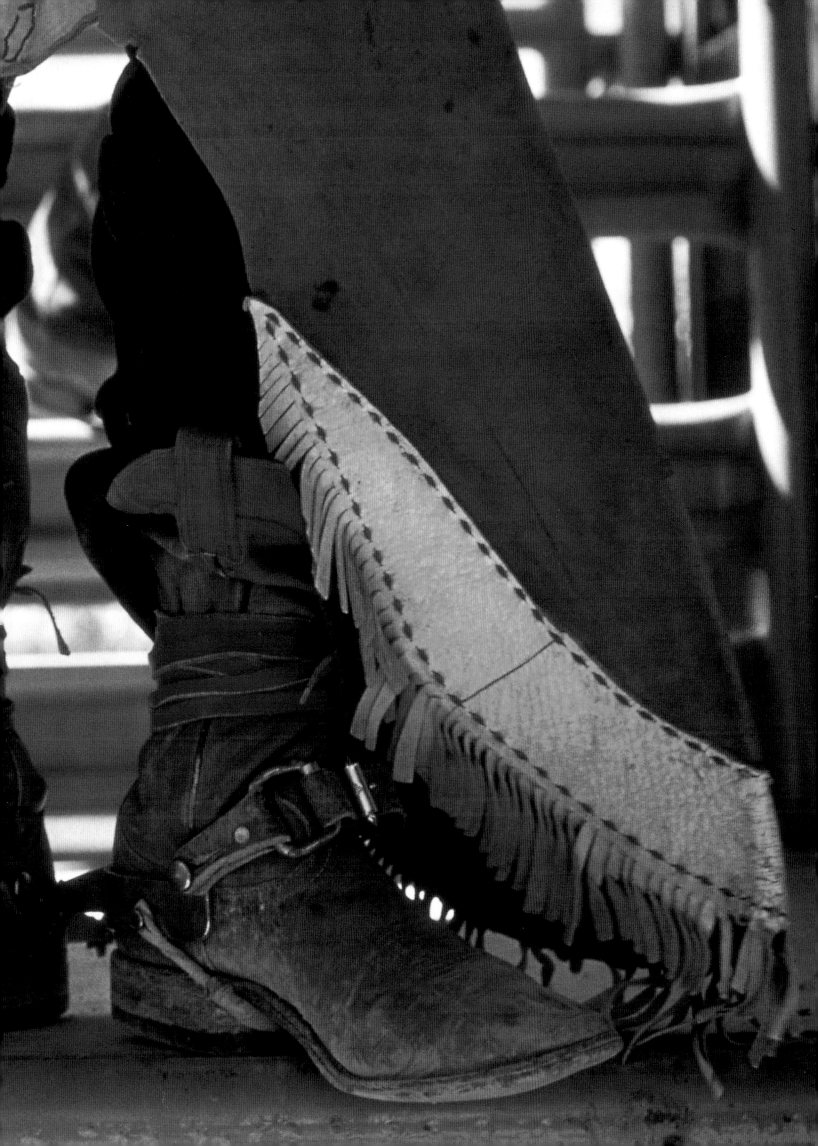

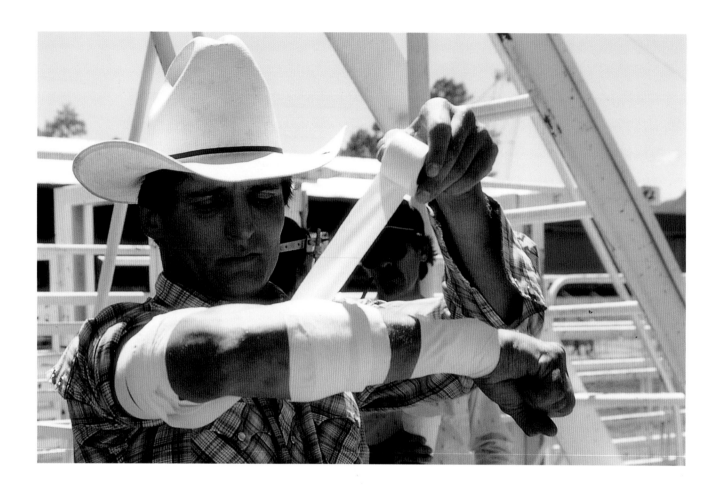

ABOVE, RIGHT AND OVERLEAF: Taping up. Rodeo cowboys, one sports medicine authority wrote, sometimes make "that spine-rattling ride in spite of an injury—broken jaw, dislocated shoulder, torn ligaments — which sideline most professional athletes."

SECOND OVERLEAF: The hands of nine-time world champion rodeo cowboy Ty Murray.

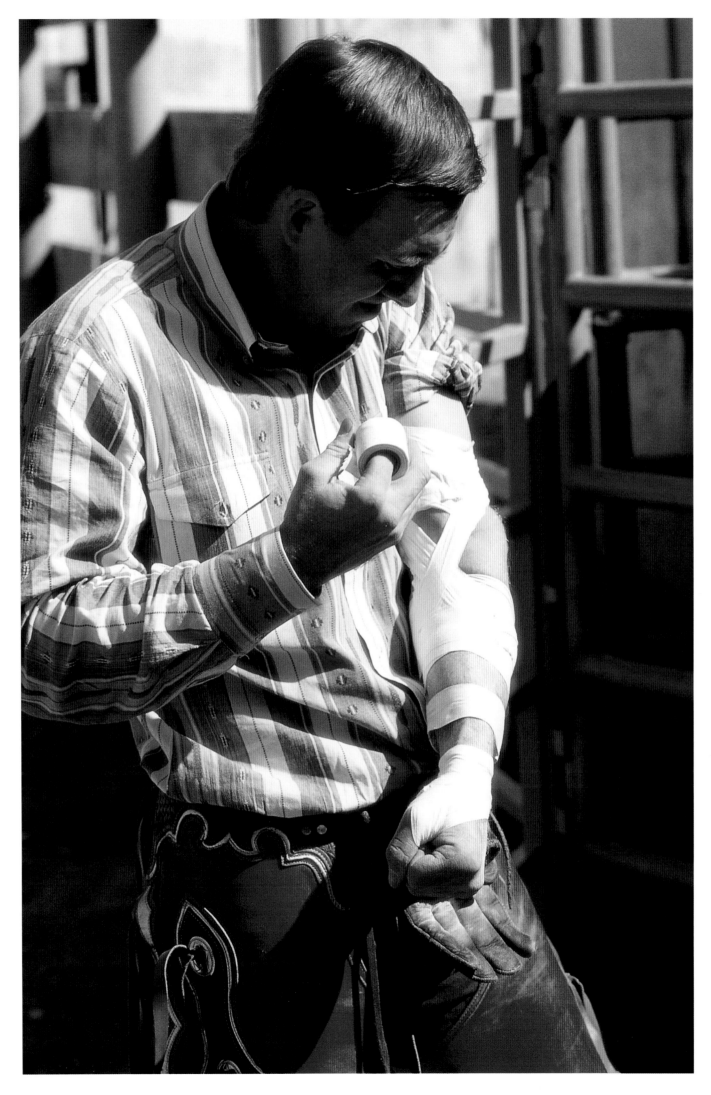

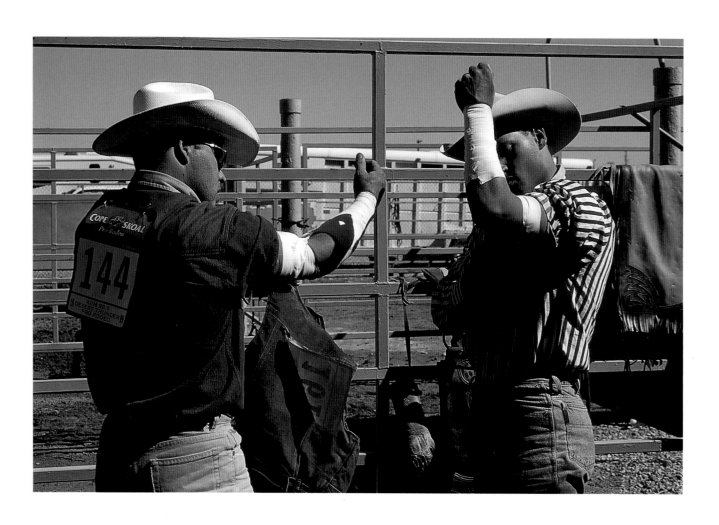

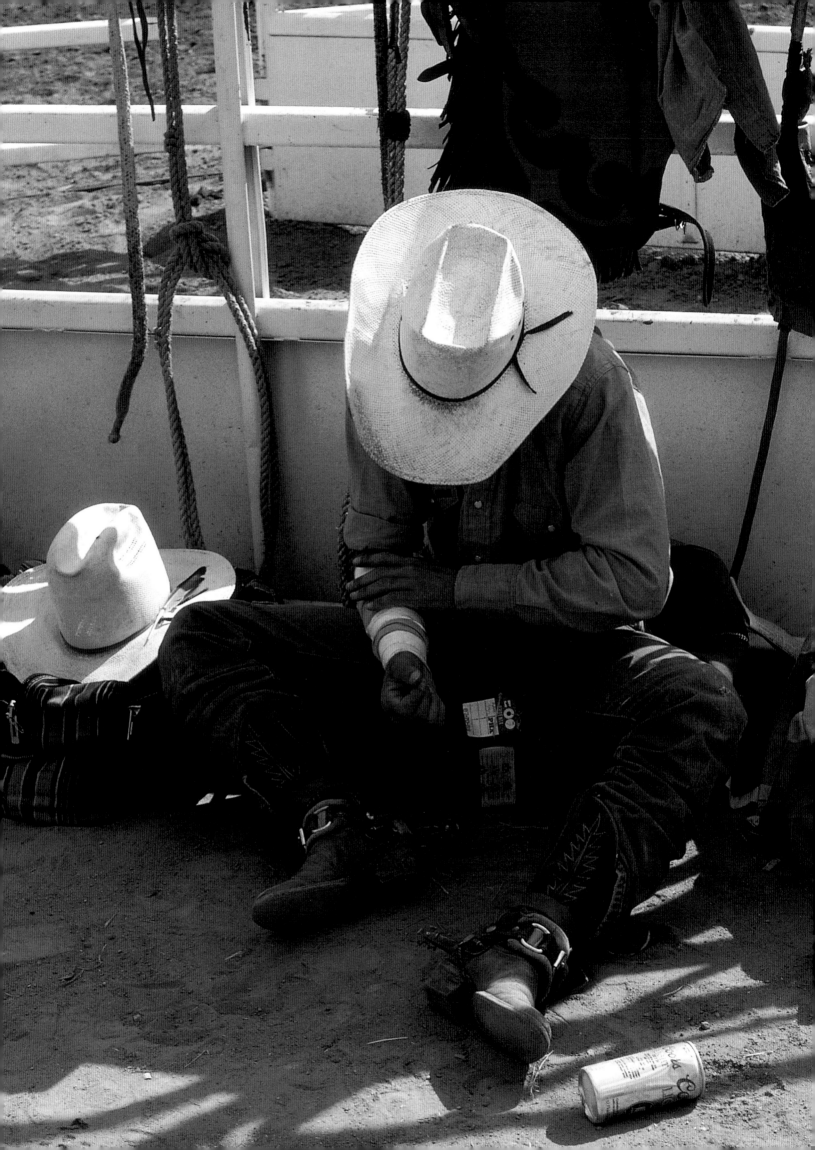

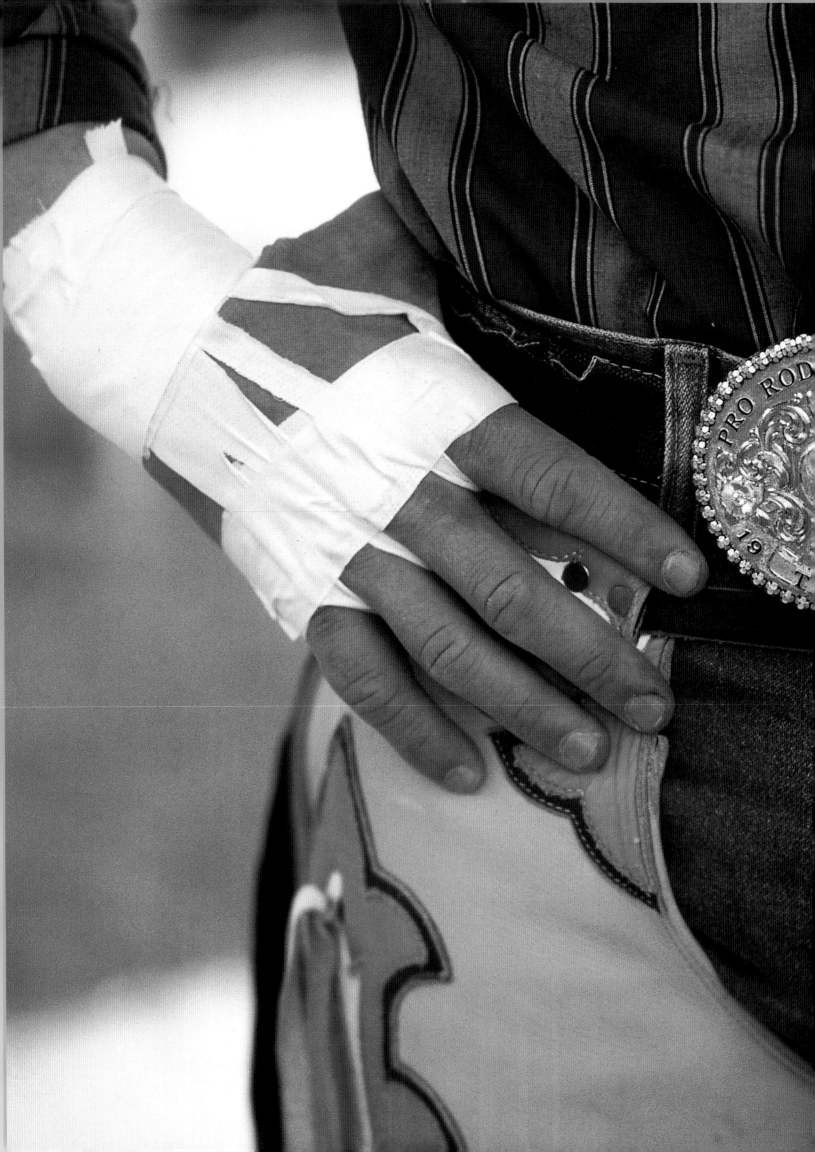

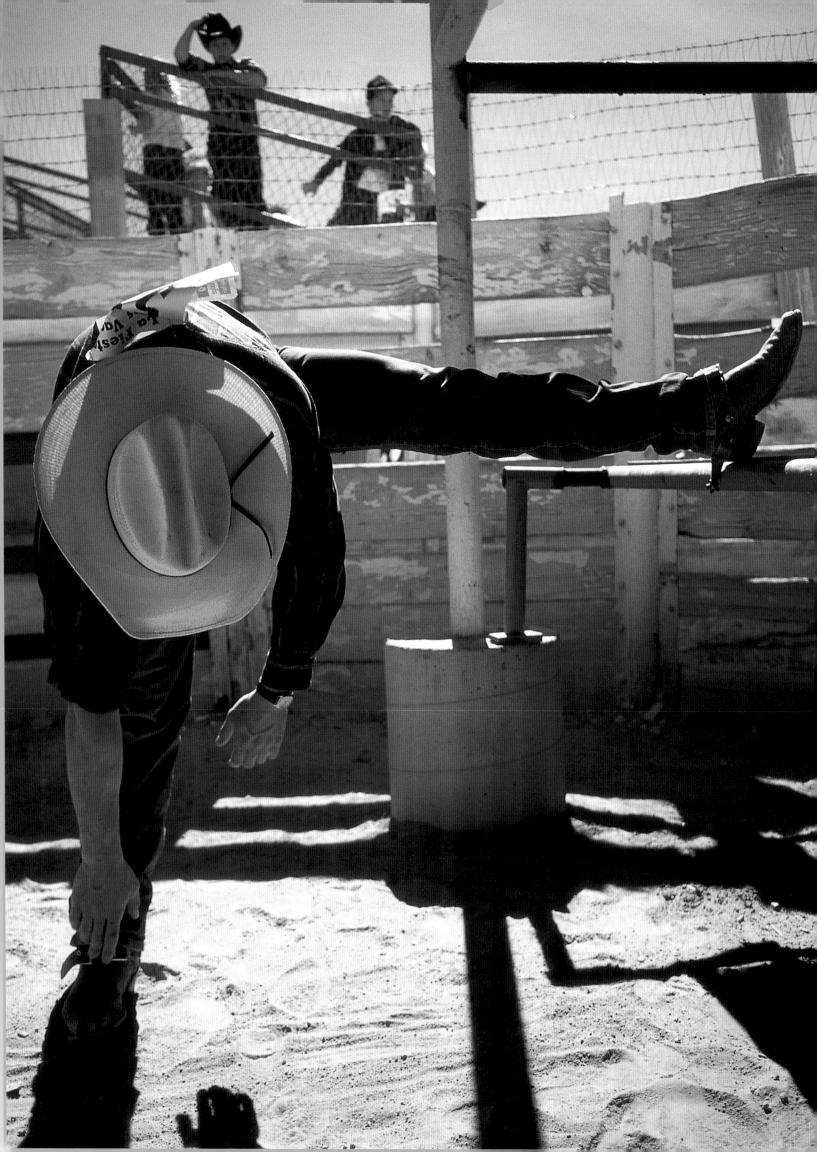

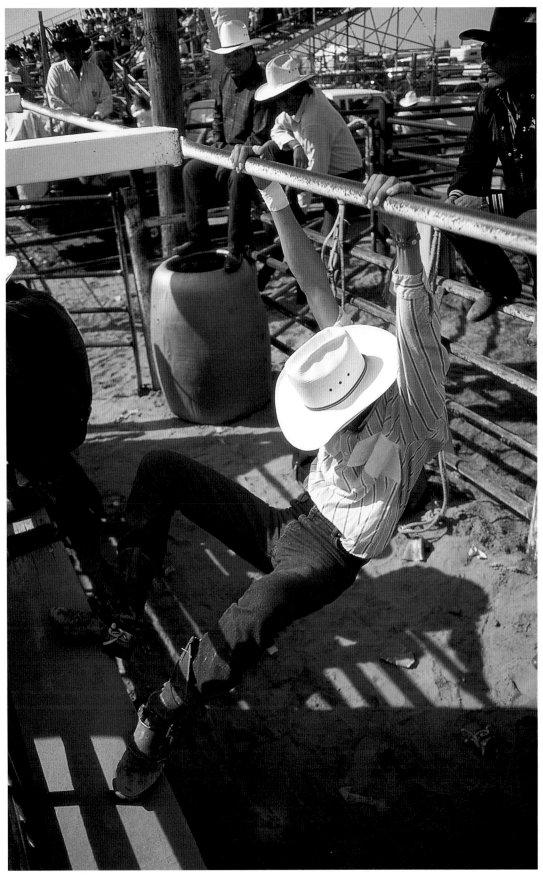

ABOVE AND LEFT: Stretching is an important part of training and warming up for today's rodeo cowboys.

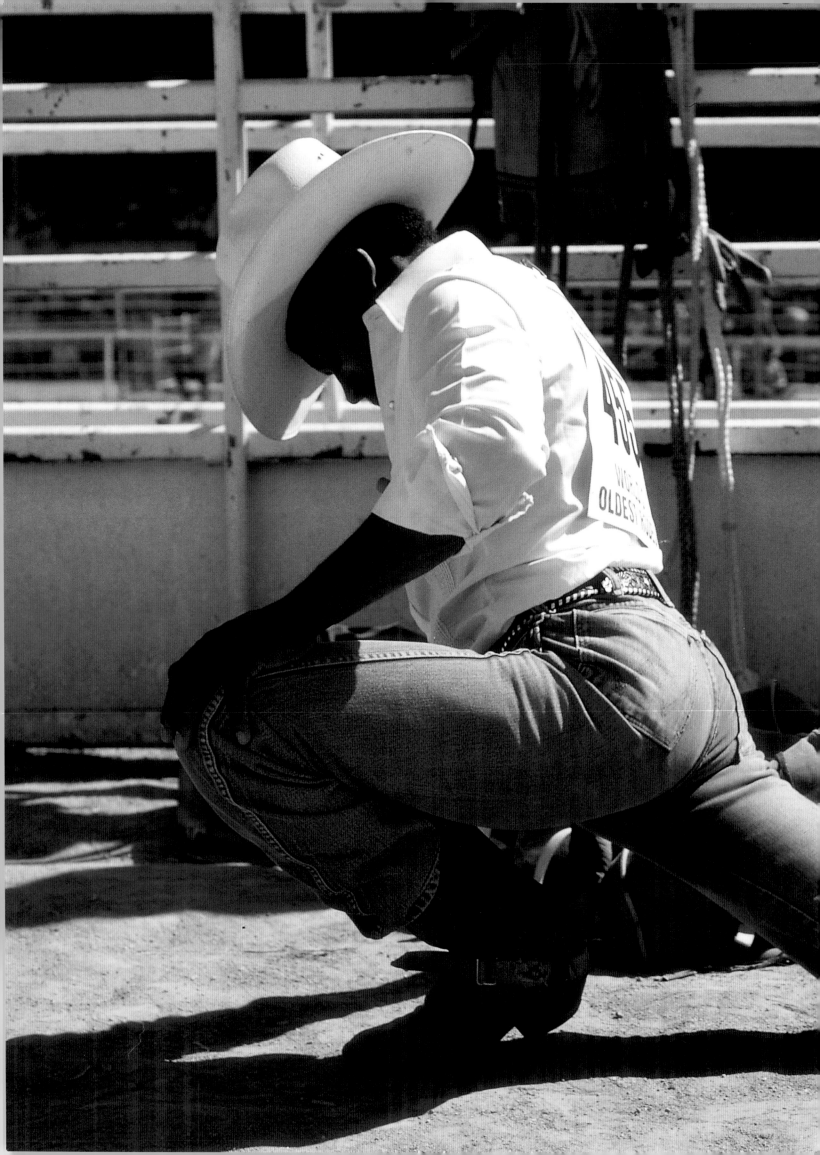

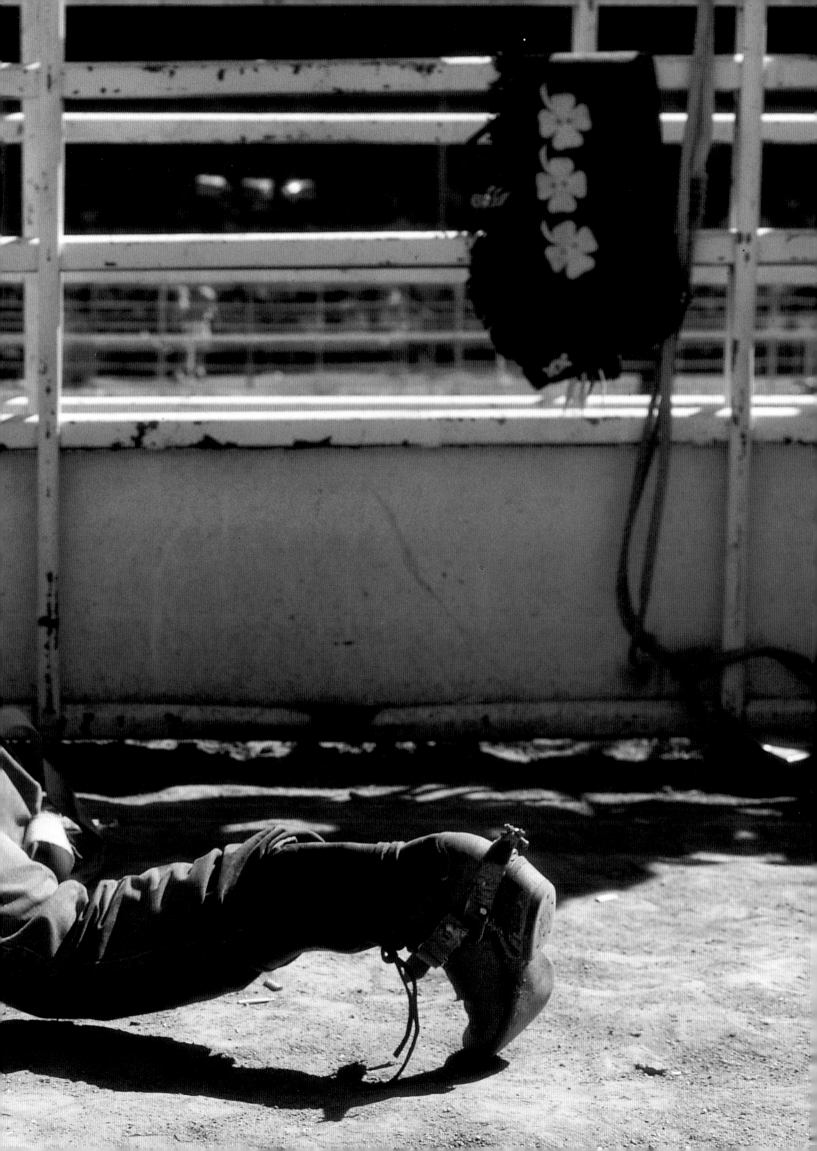

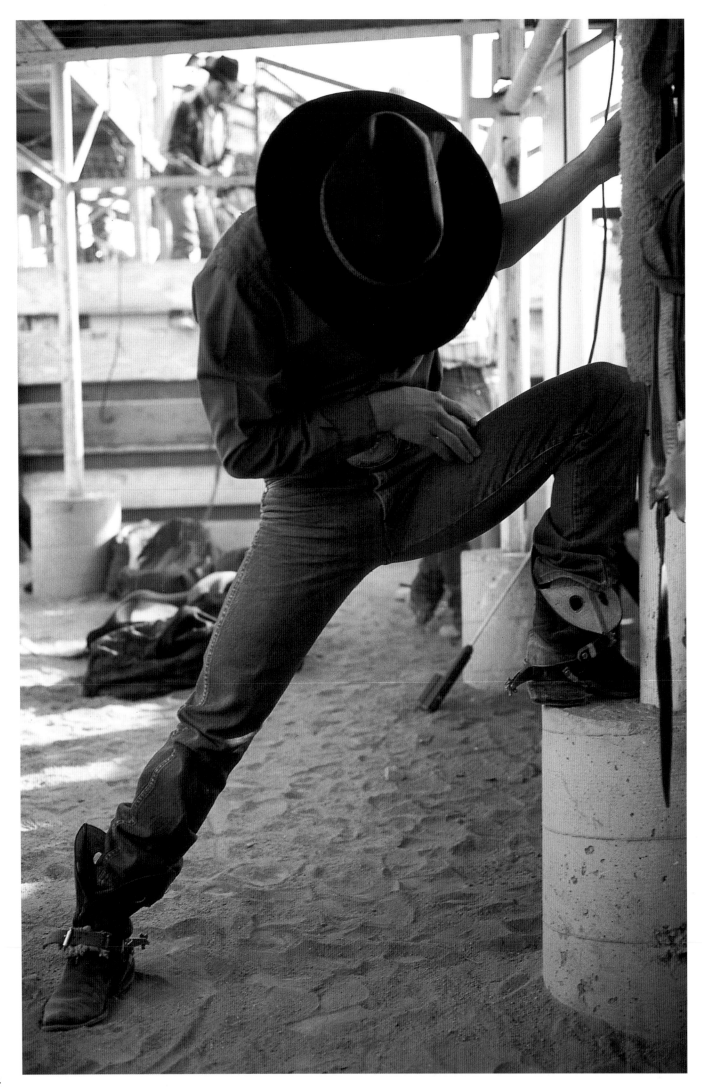

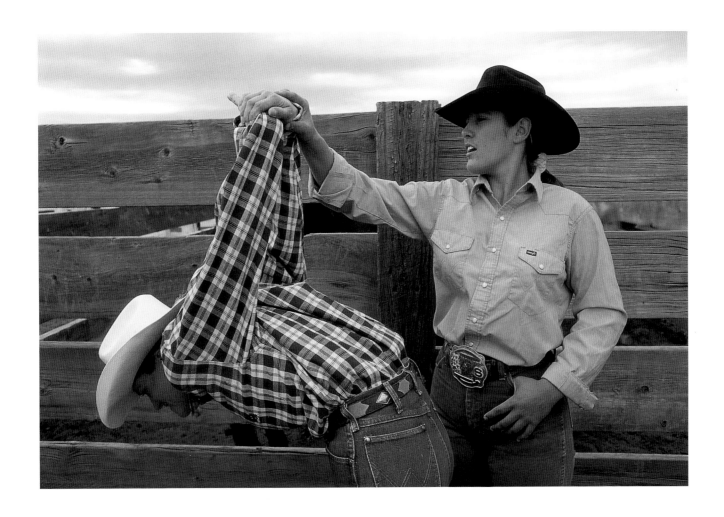

PRECEDING OVERLEAF: Stretched out, Los Angeles-born world champion Charlie Sampson follows in the footsteps of African American cowboys like Bill Pickett who first dazzled crowds at Cheyenne, Wyoming in 1910.

ABOVE: Tammy Graham (right) helps Oregon cowgirl Sally Kohopsk limber up.

OVERLEAF: Native American cowboys like S. Kaye have starred on the rodeo circuit since Blackfoot Indian Tom Three Persons became the first man ever to ride the legendary bronc Cyclone at the 1912 Calgary Stampede.

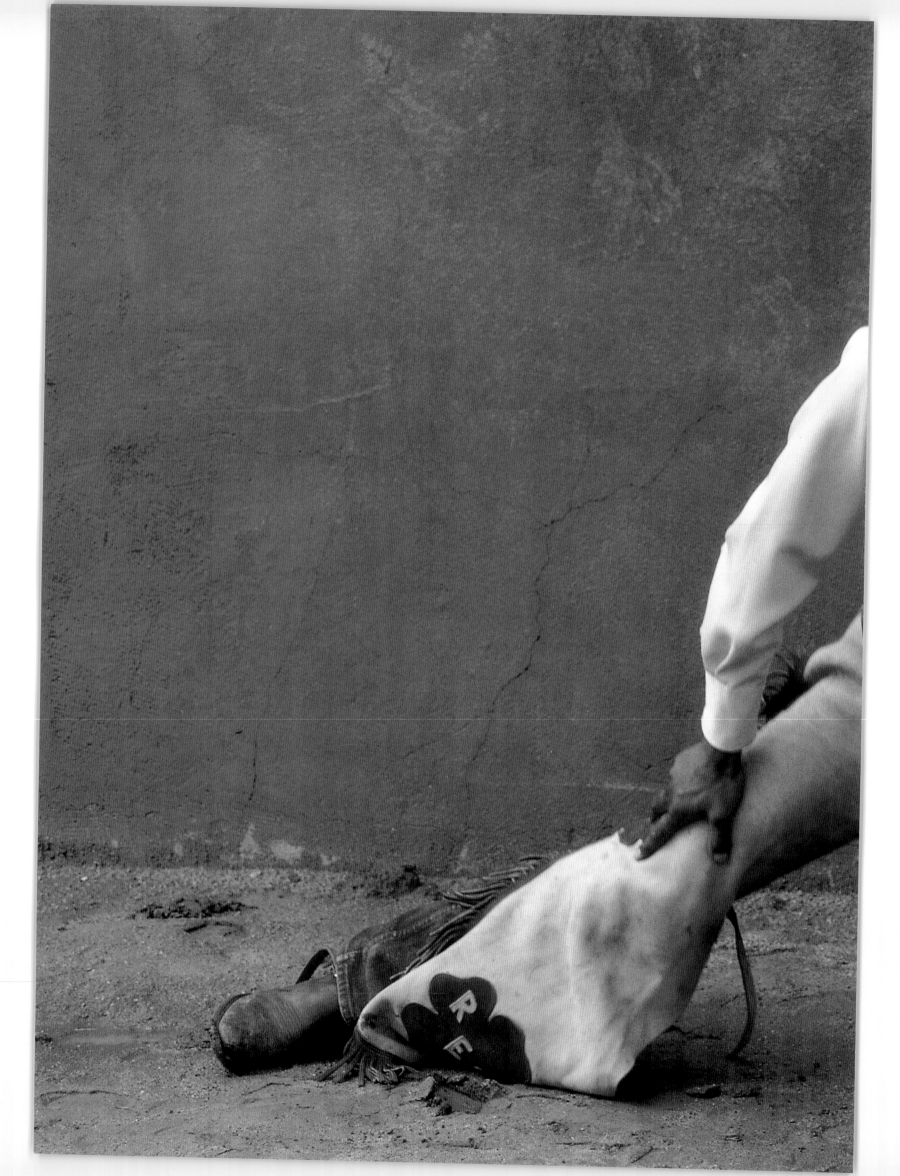

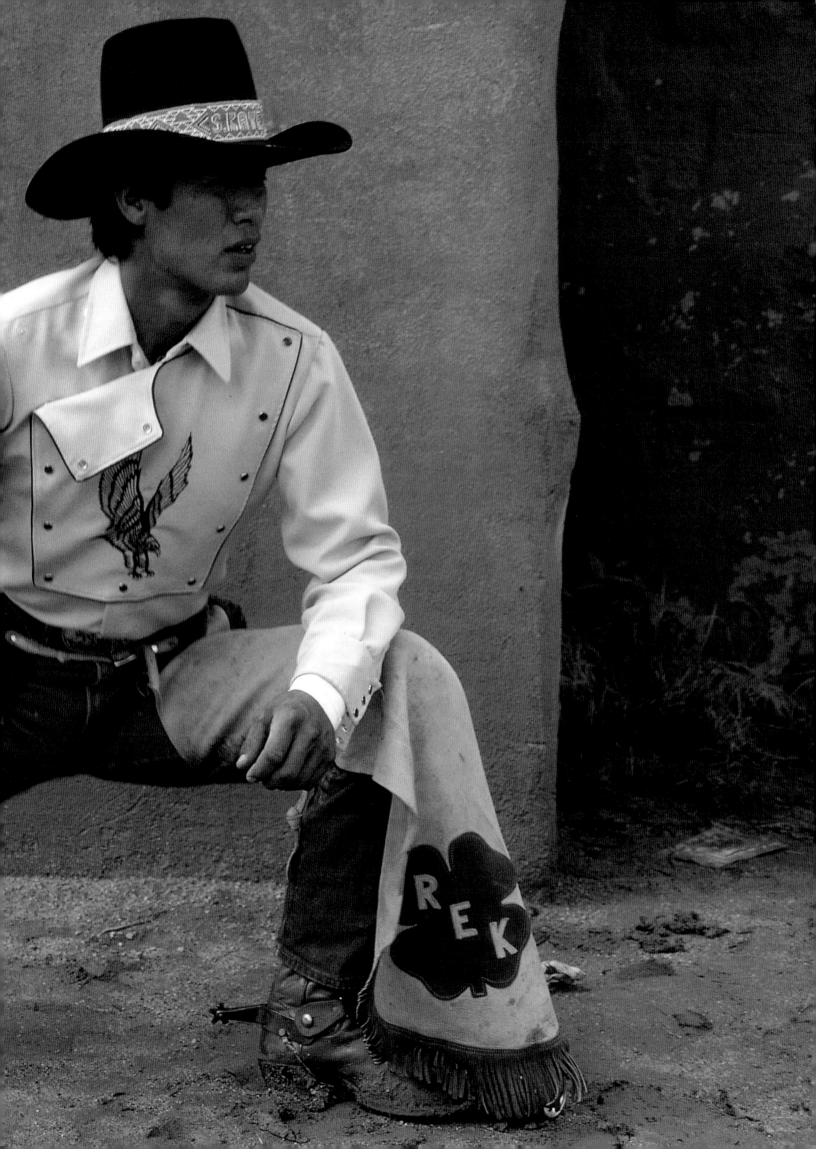

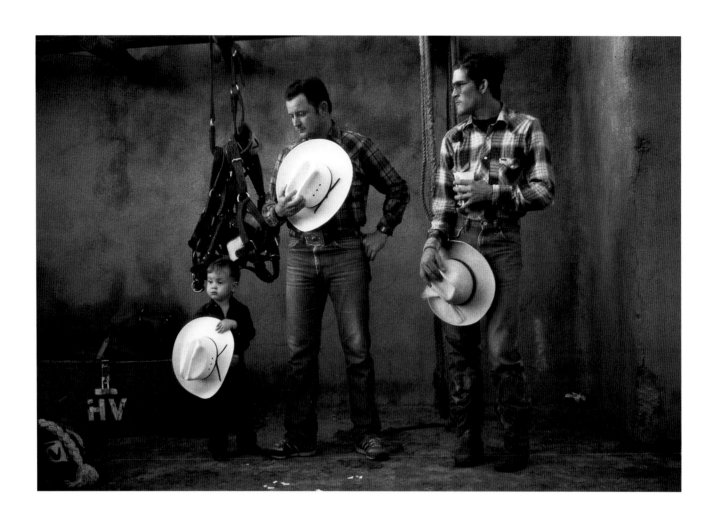

ABOVE: A father, son and friend spend a few moments in silent prayer.

RIGHT: Texas cowgirl DeeDee Crawford.

FIRST OVERLEAF: Many rodeo cowboys are religious, but praying had its limits for pioneer cattle ranchers like Teddy Blue Abbott: "You could pray all you damned pleased, but it would not get you water where there wasn't water."

SECOND OVERLEAF. Texan Ben "Legs" Stevenson "gives it up to the Lord."

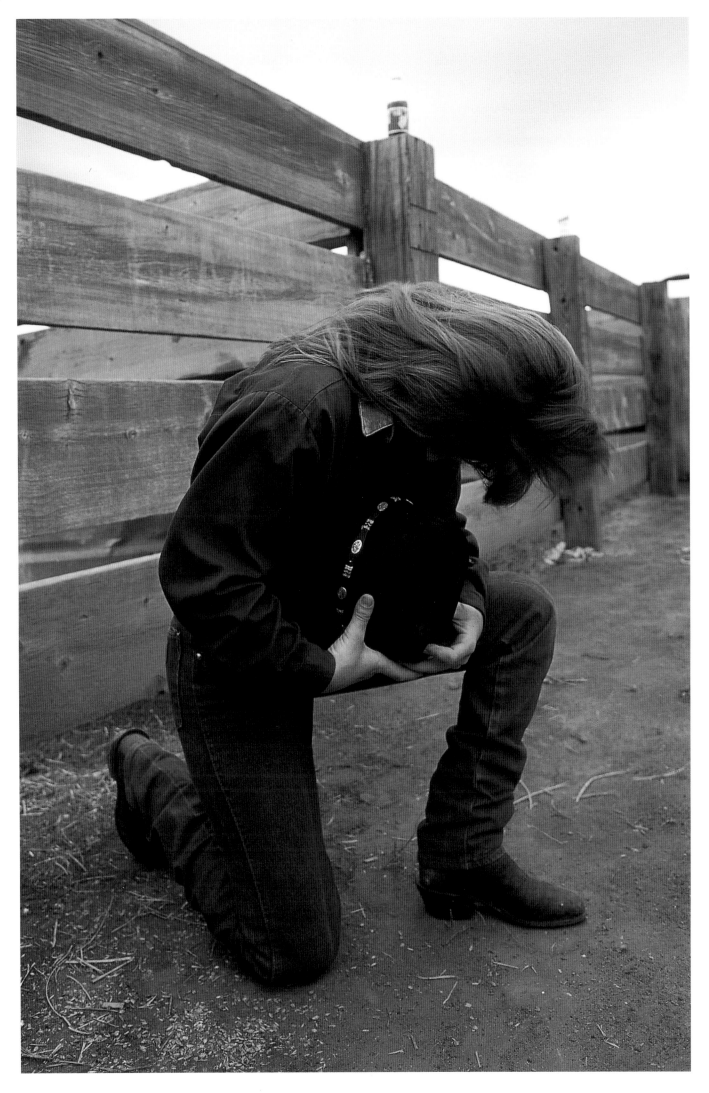

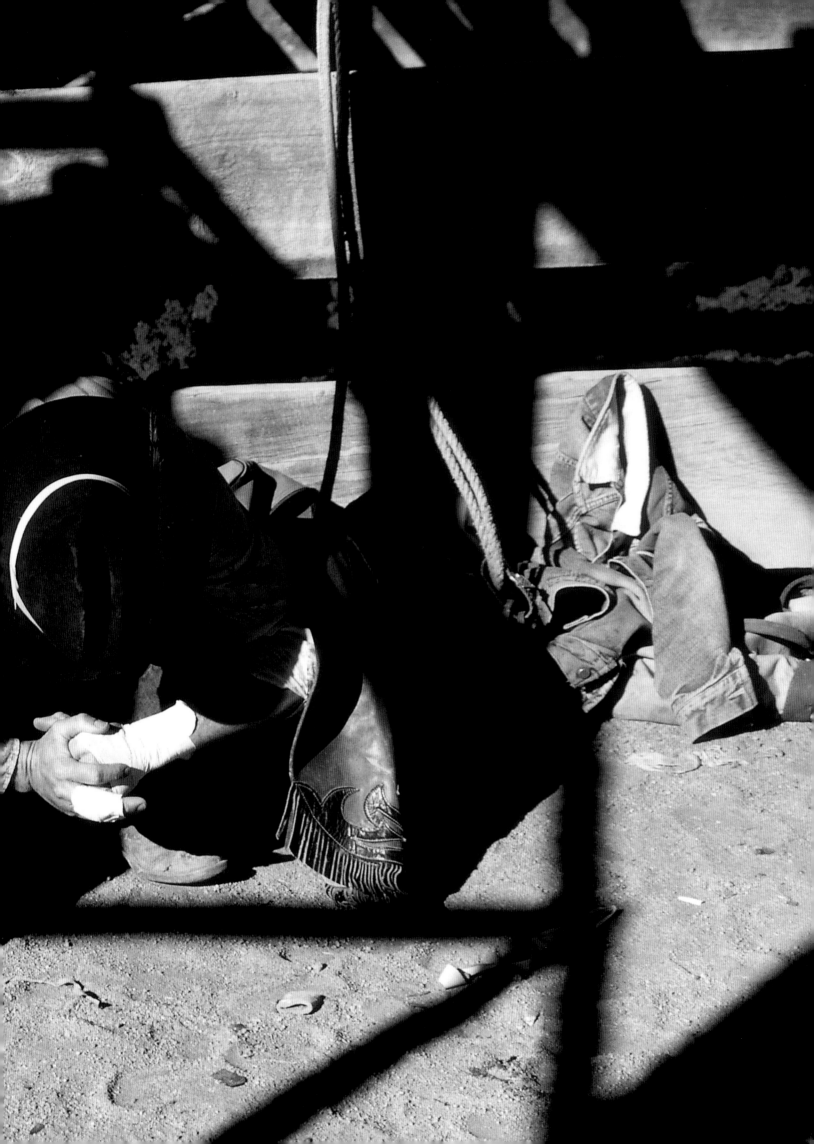

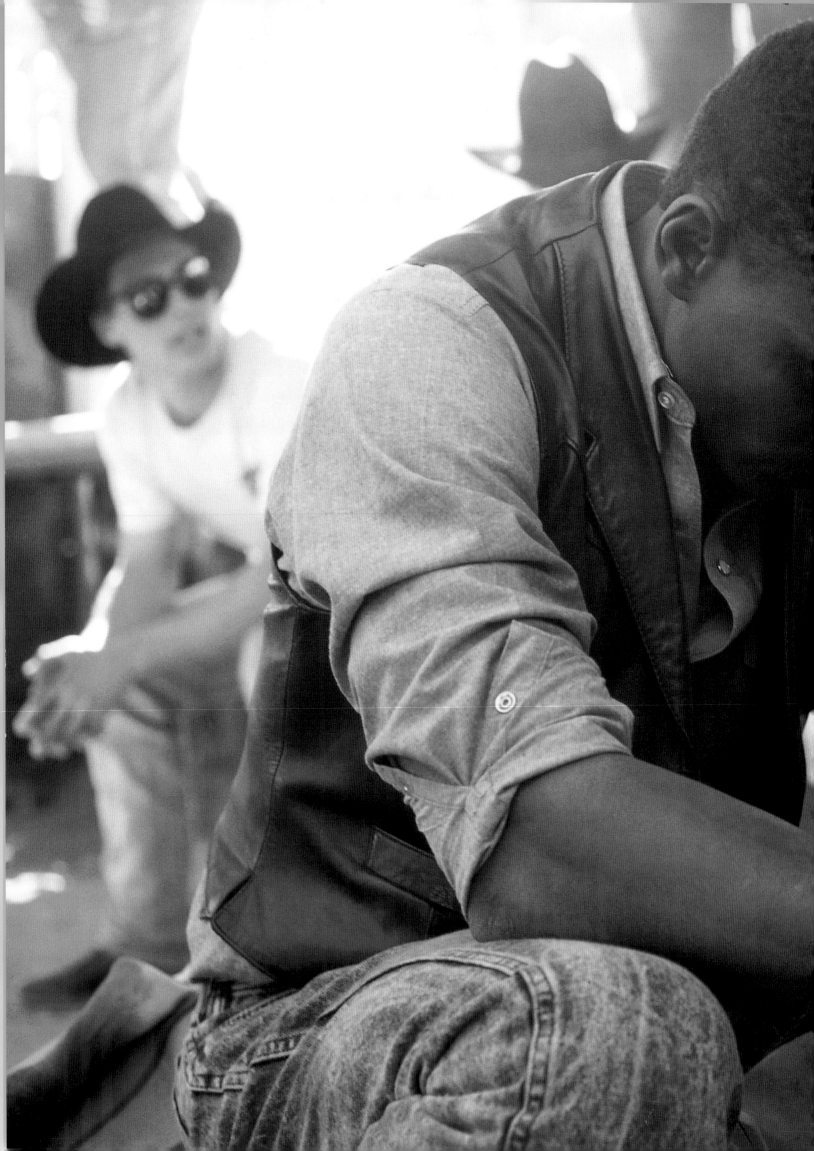

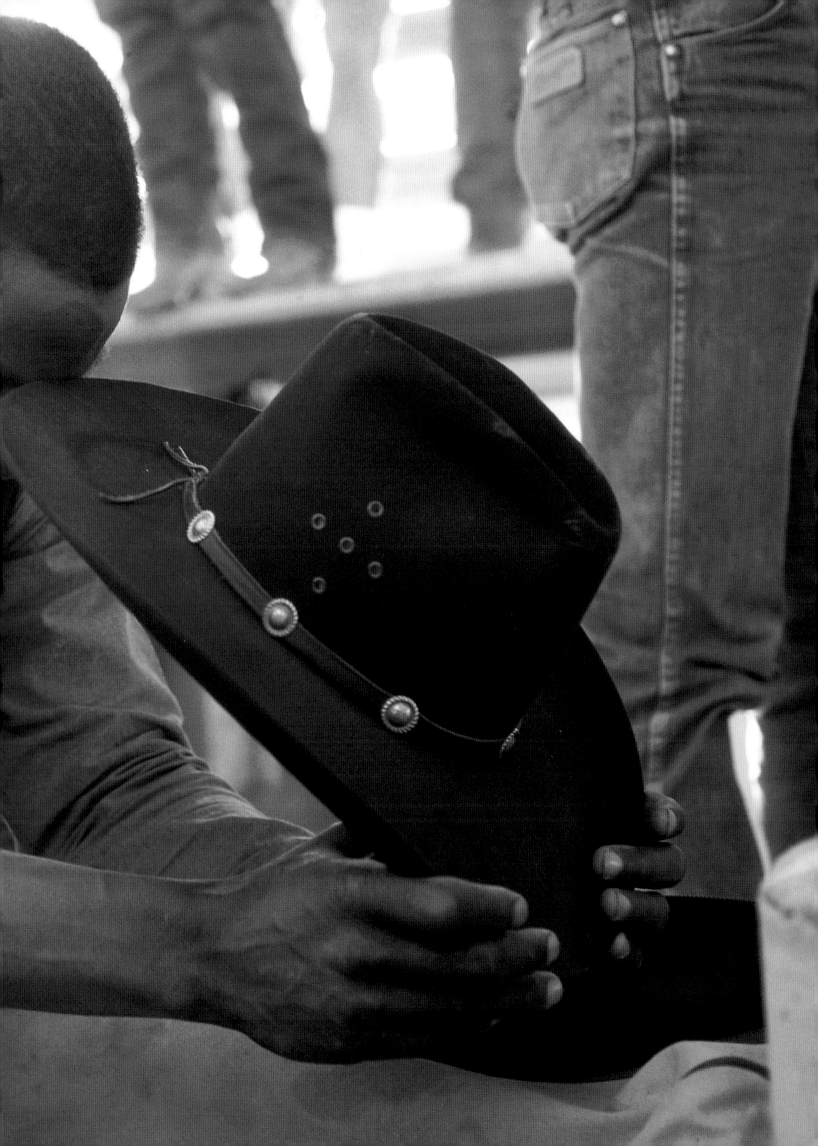

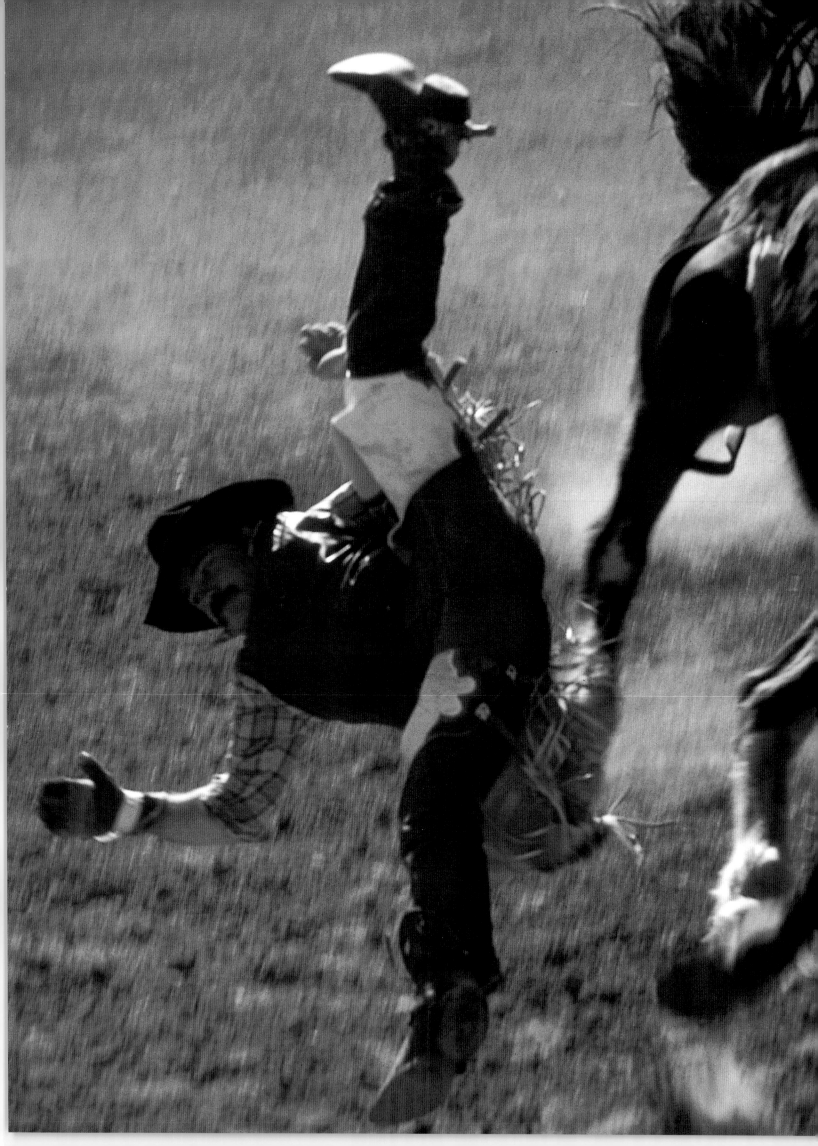

2. Bareback

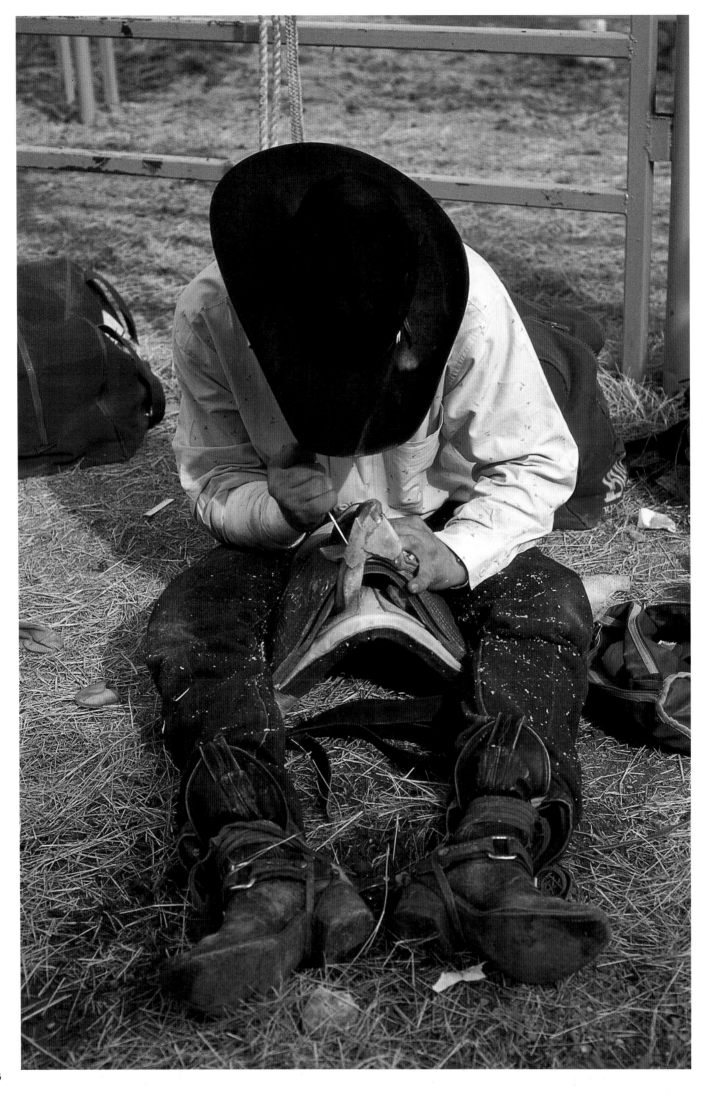

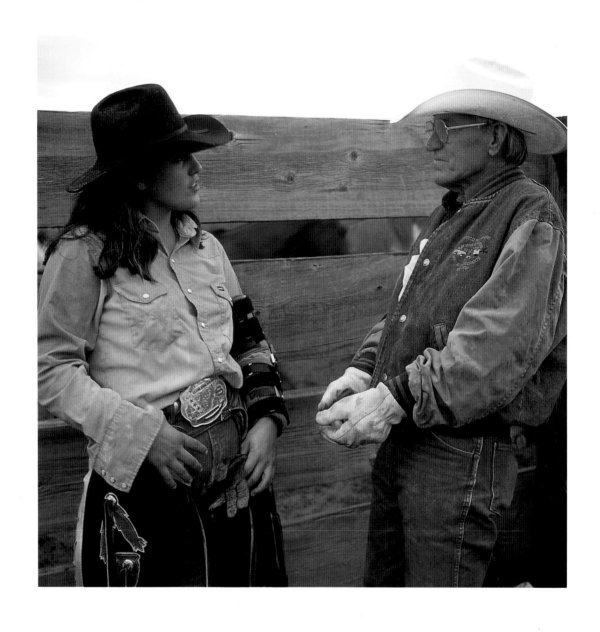

ABOVE AND RIGHT: Stock contractor Frank Kelly and Tammy Graham share bronc riding techniques.

OVERLEAF: Virginia cowboy Brother Gilder warms up for his ride.

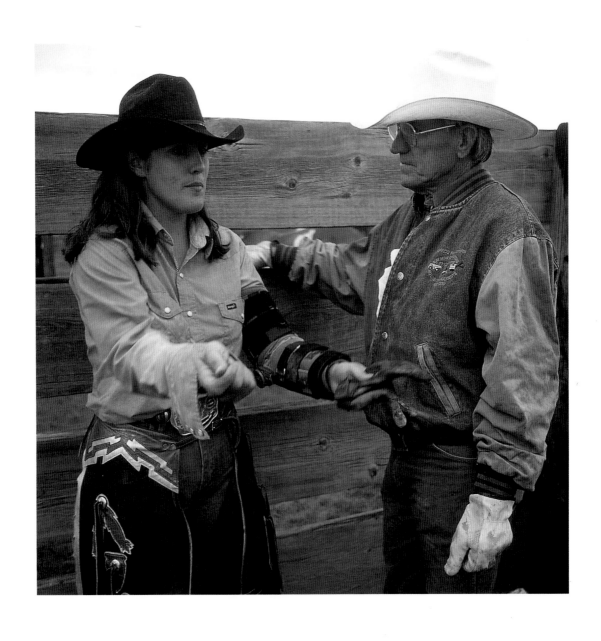

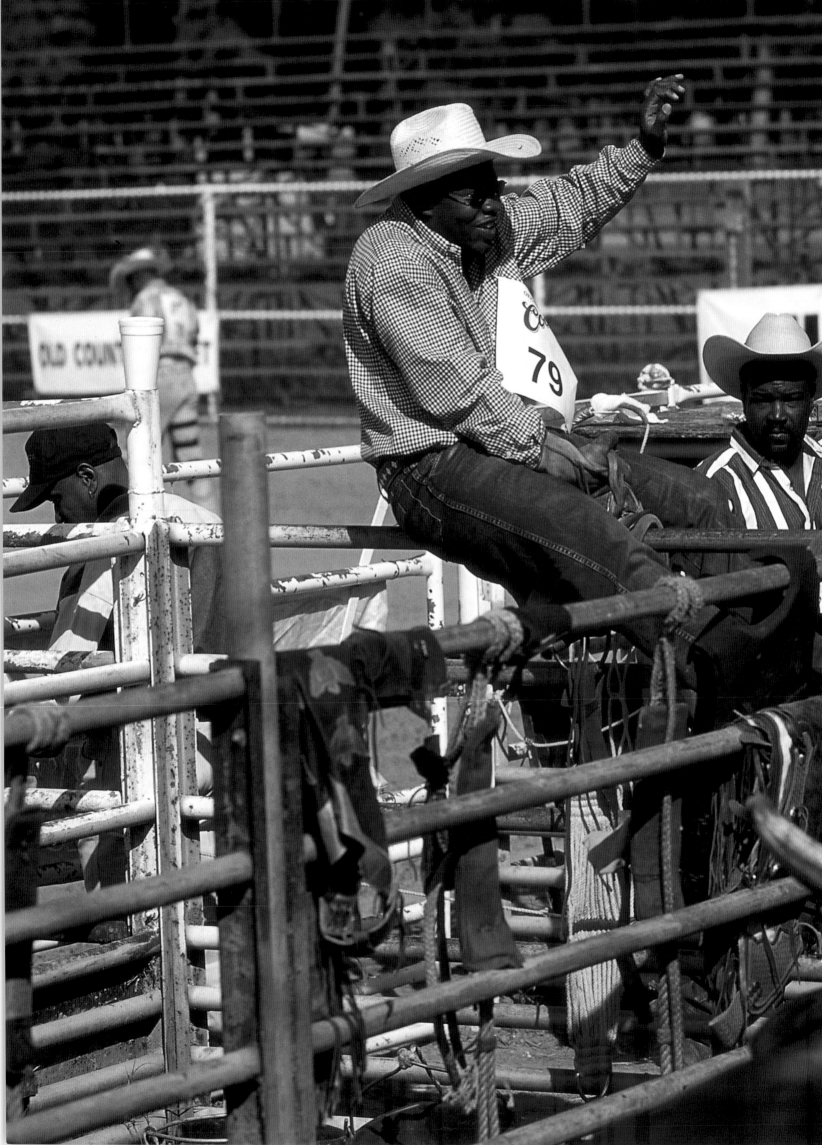

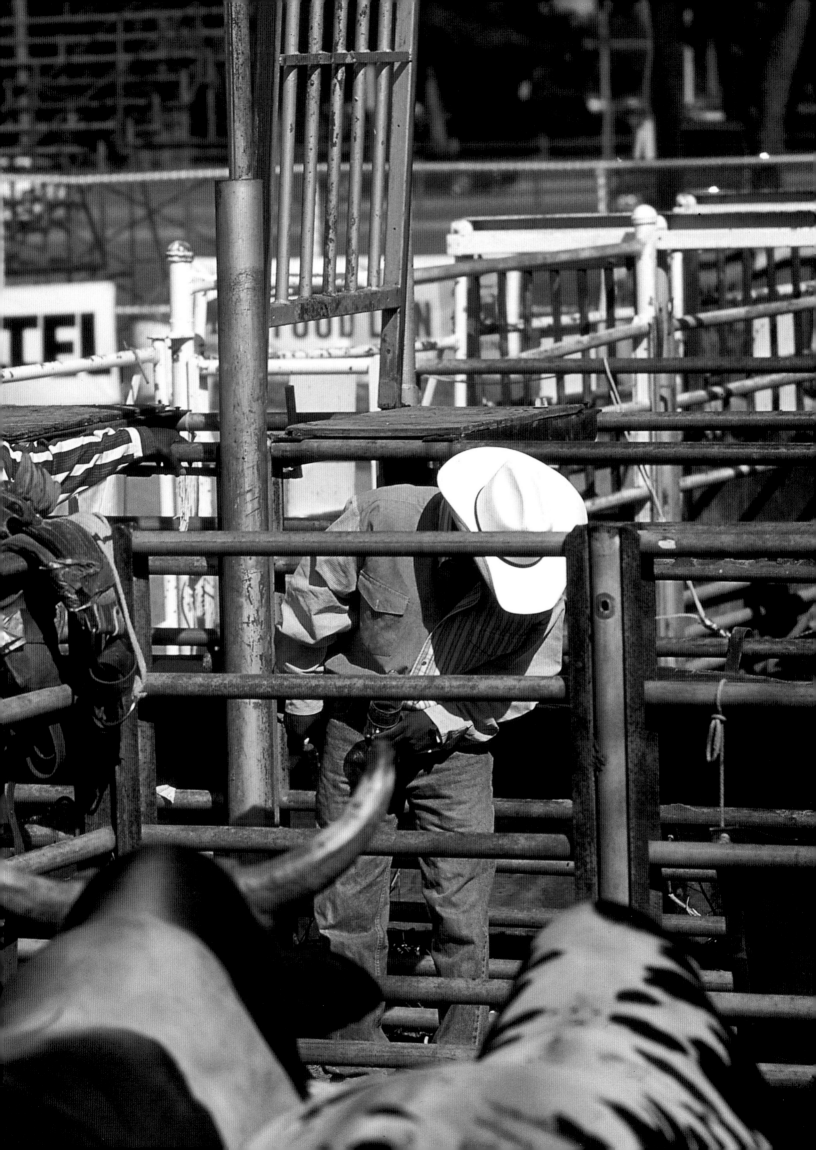

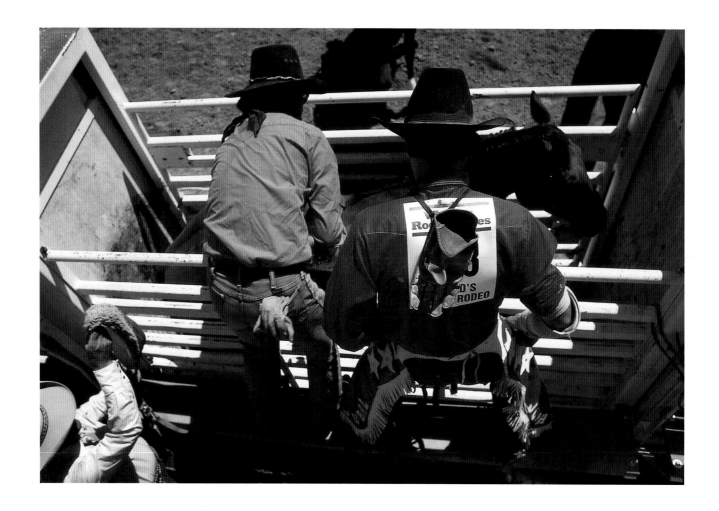

ABOVE: A flanker (left) readies a bronc for a waiting cowboy.

RIGHT: A cowboy mimes his impending ride.

FIRST OVERLEAF: Good bucking horses, said Pro Rodeo Hall of Fame stock contractor Harry Vold, "either have the will to perform or they don't." A saddle bronc rider gets a taste of Vold's prized bucking stock.

SECOND OVERLEAF, LEFT: Good flankers know the characteristics of rodeo bucking stock and give riders last minute advice.

SECOND OVERLEAF, RIGHT: A cowboy sweats out the wait before his ride.

THIRD OVERLEAF: A cowboy slides his leather glove into a handful of trouble.

FOURTH OVERLEAF: The beauty and fury of a bronc and rider.

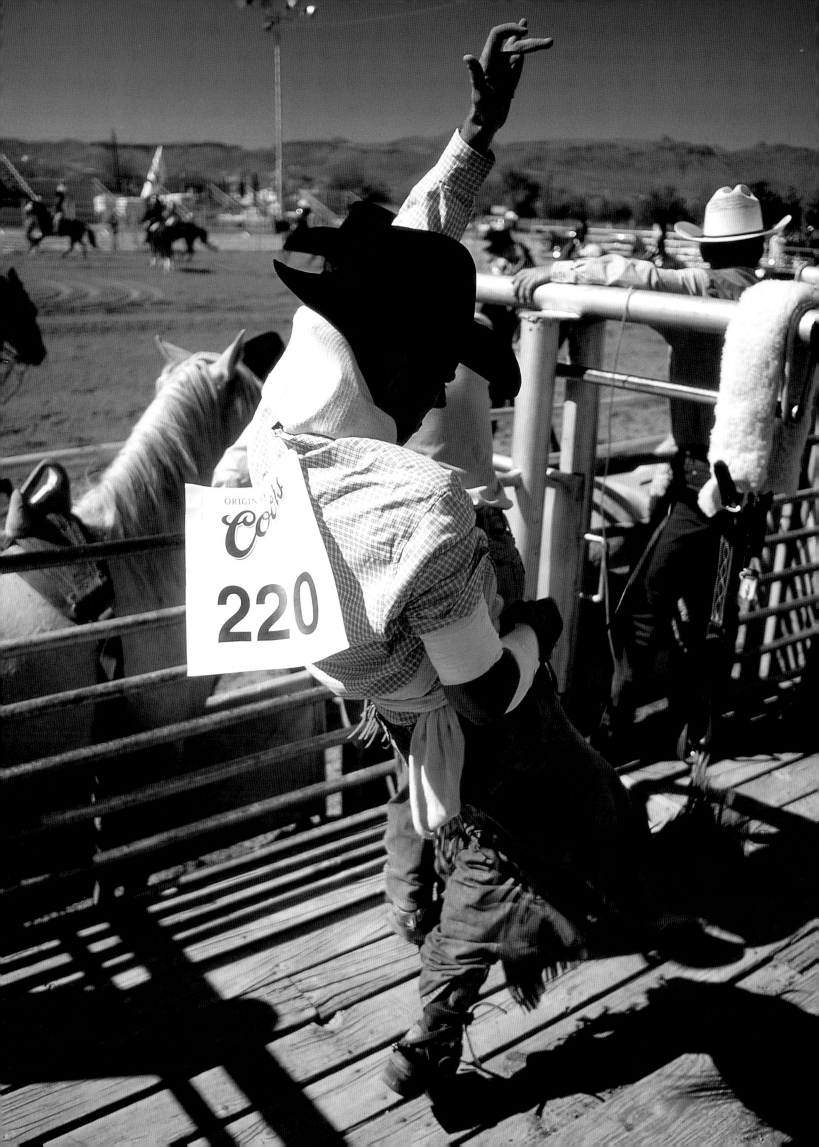

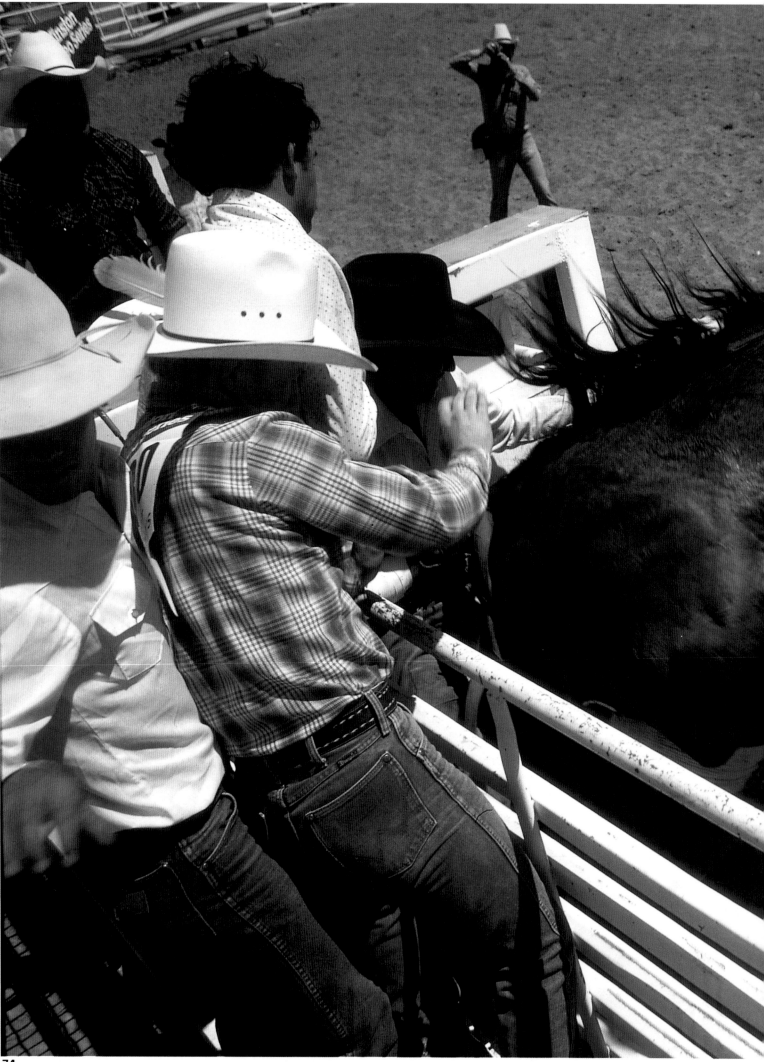

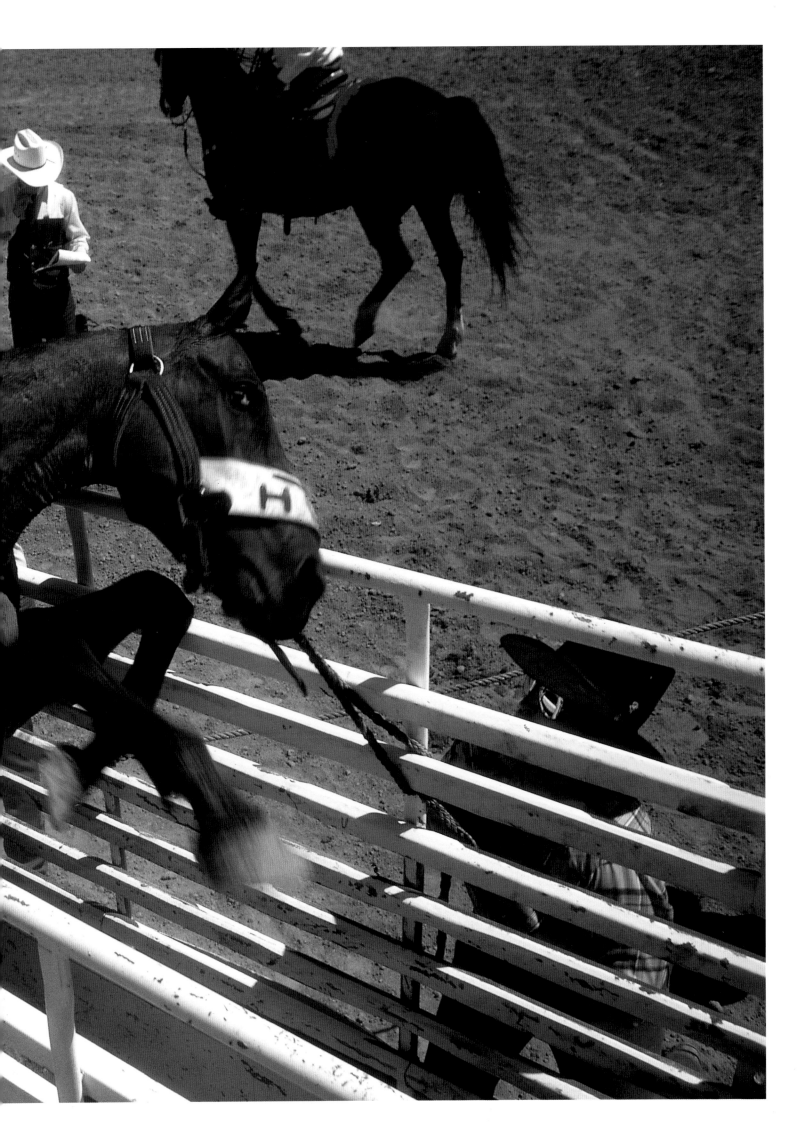

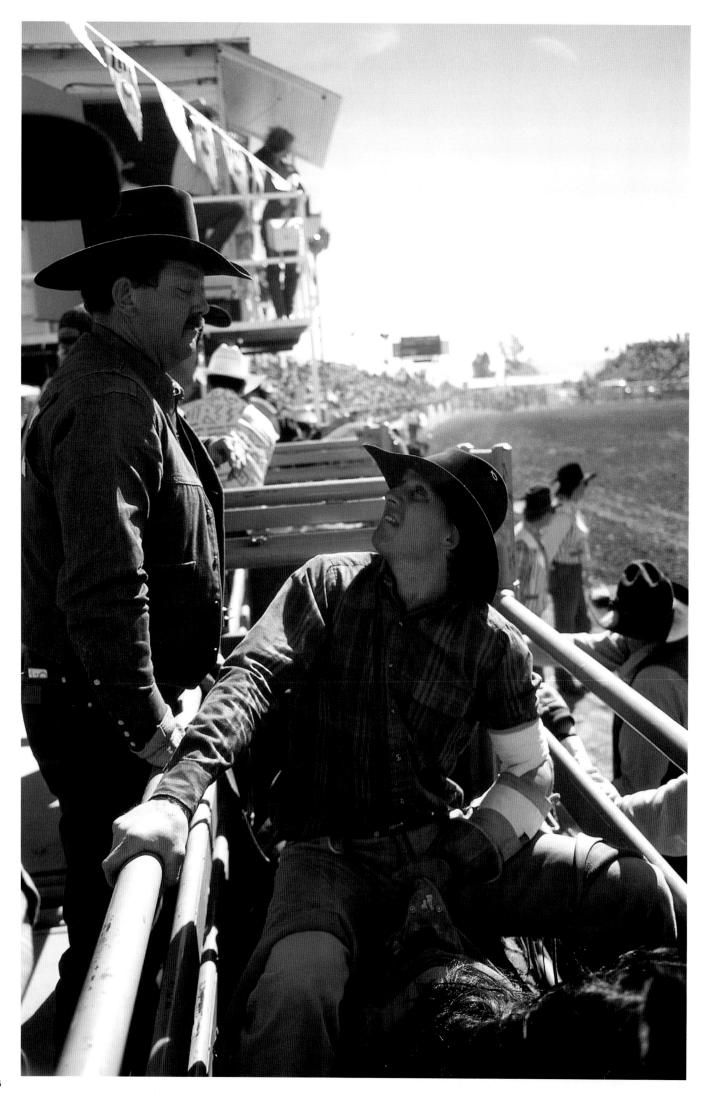

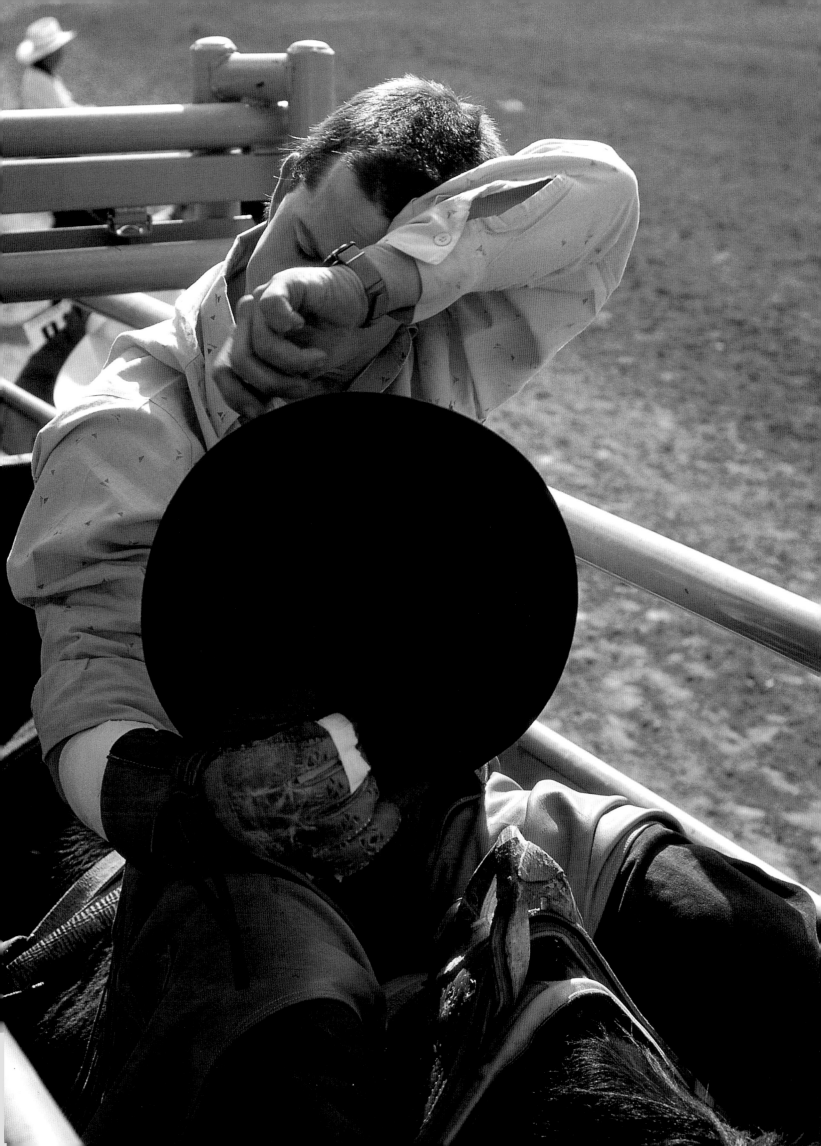

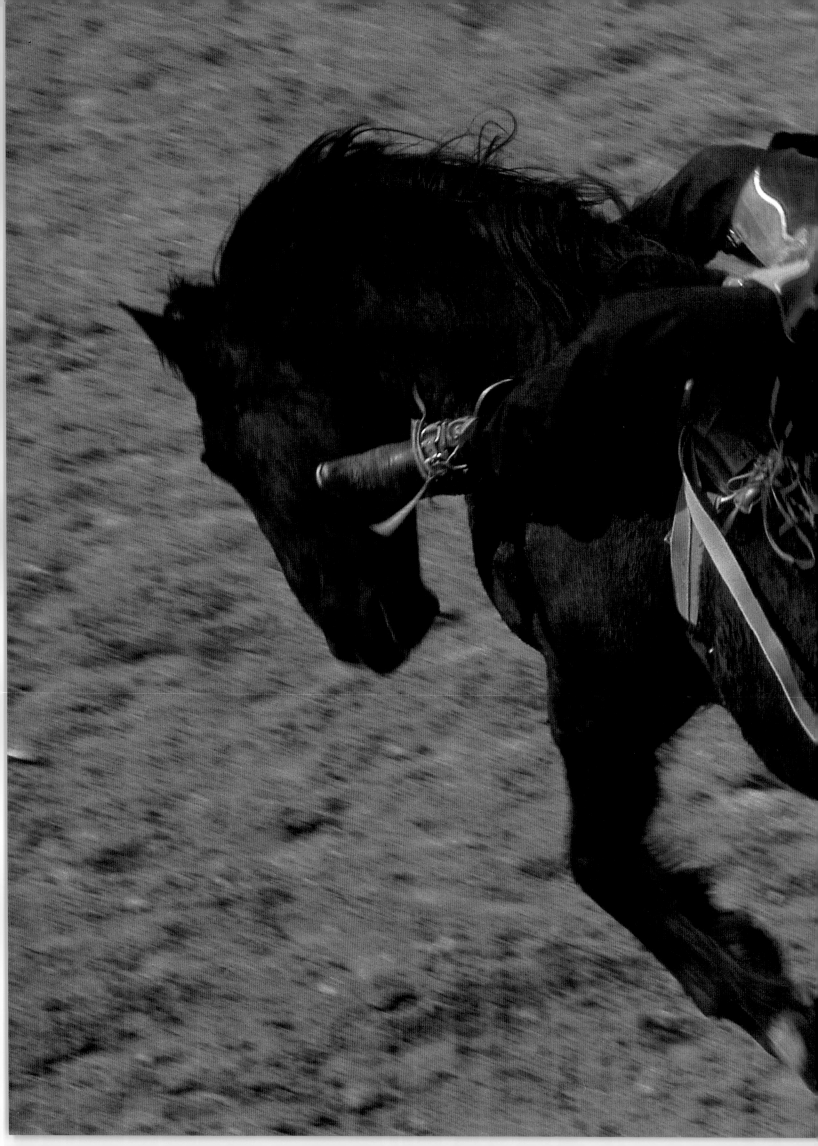

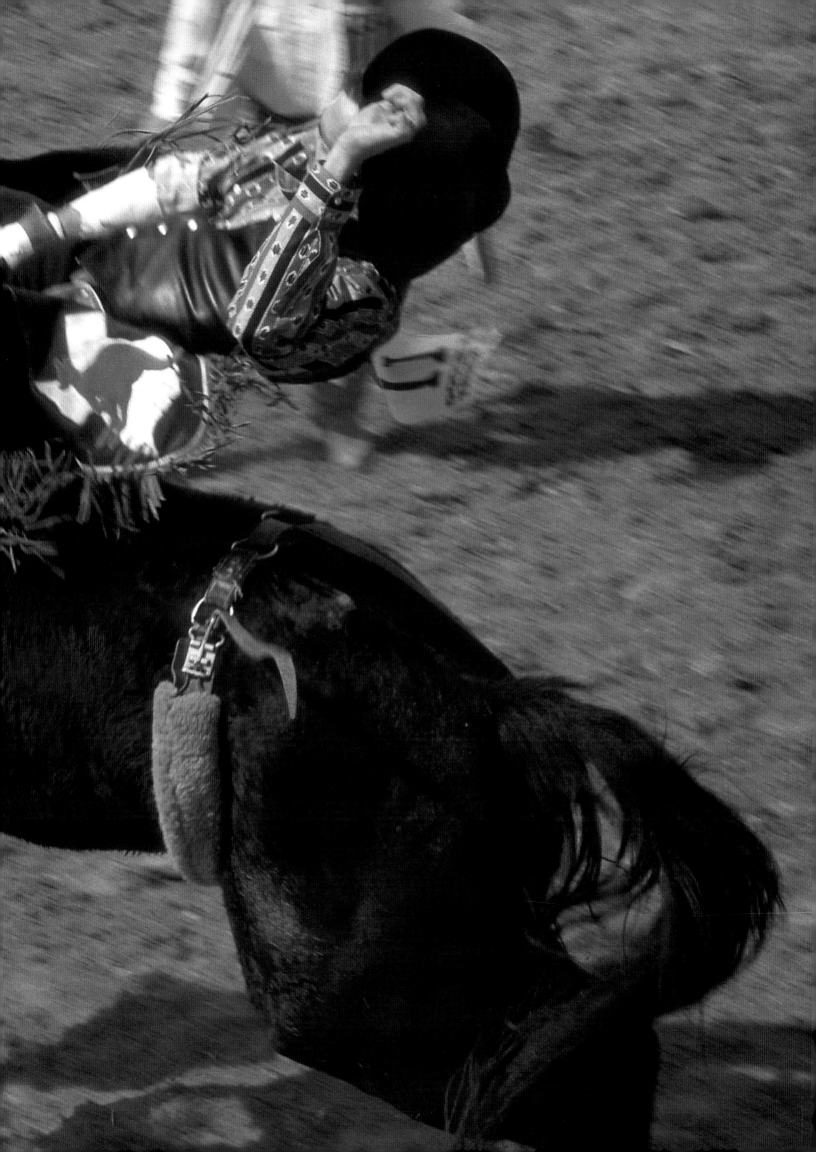

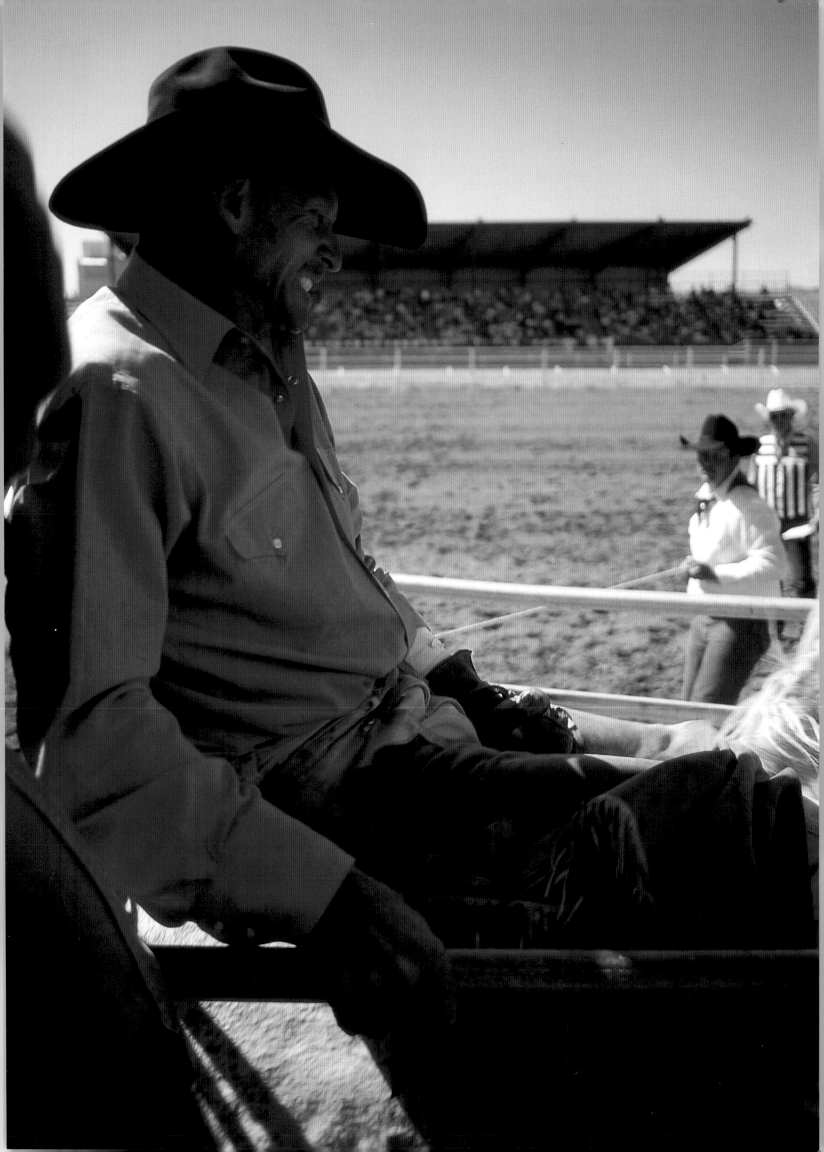

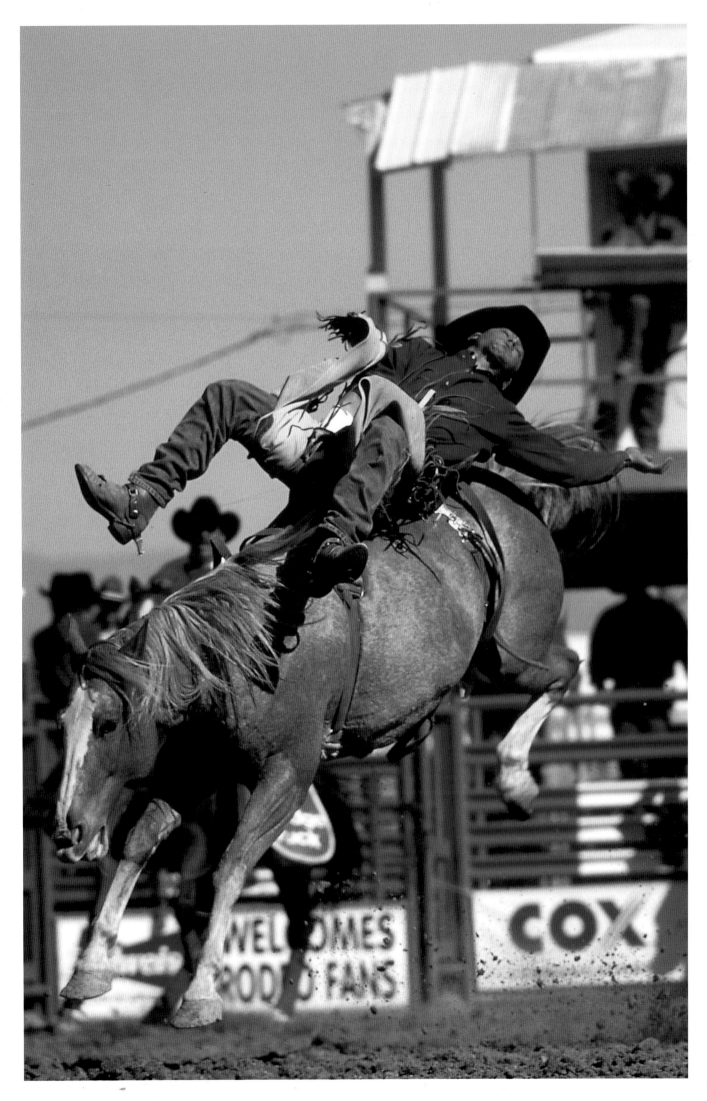

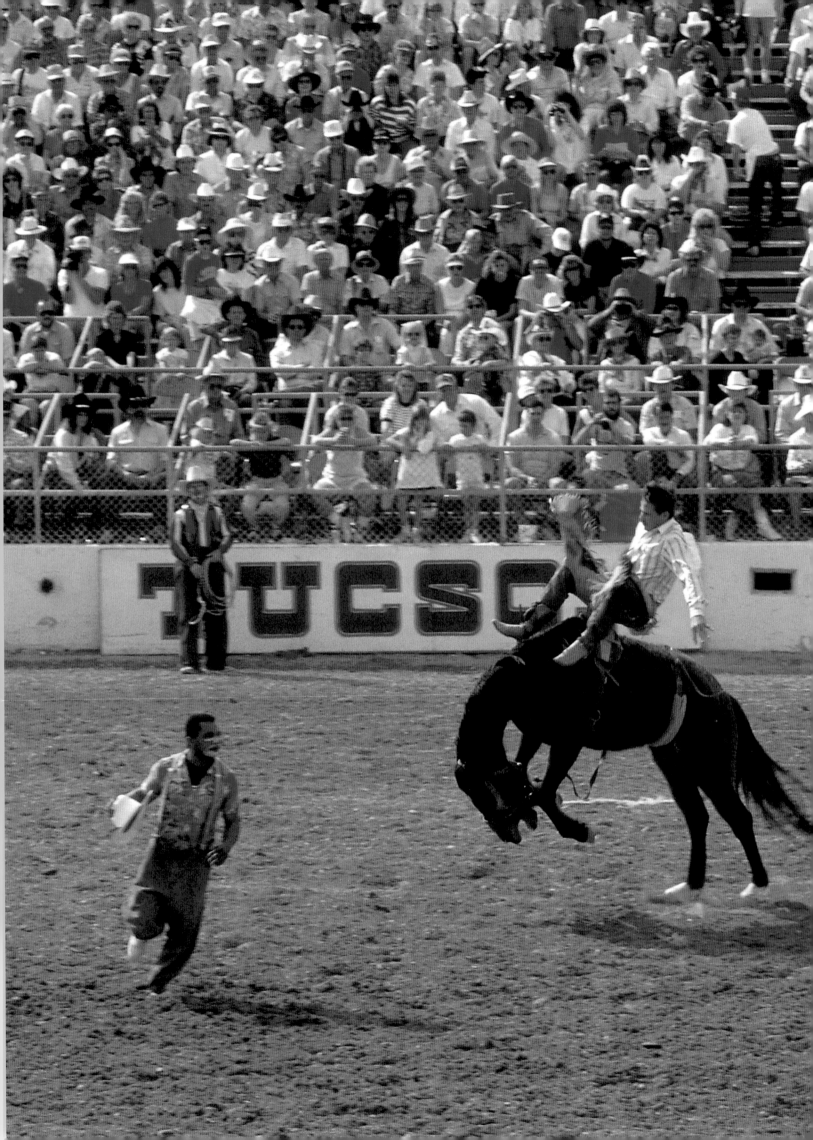

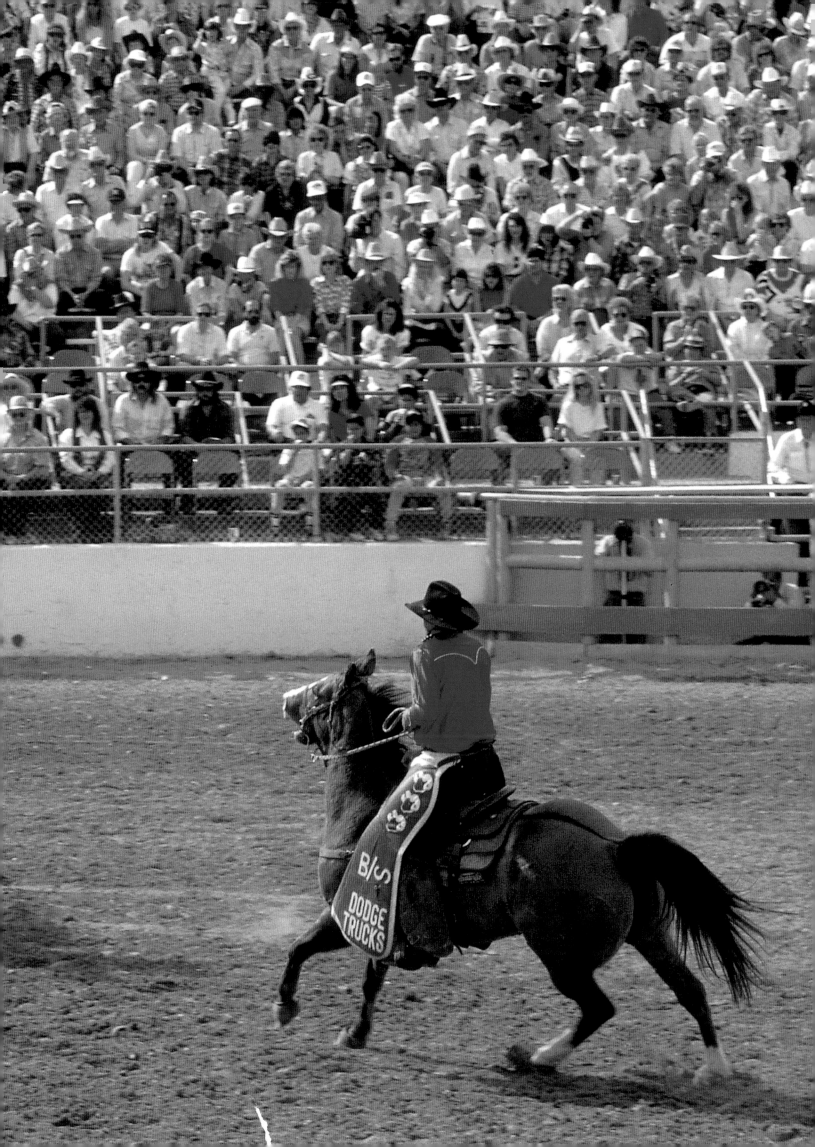

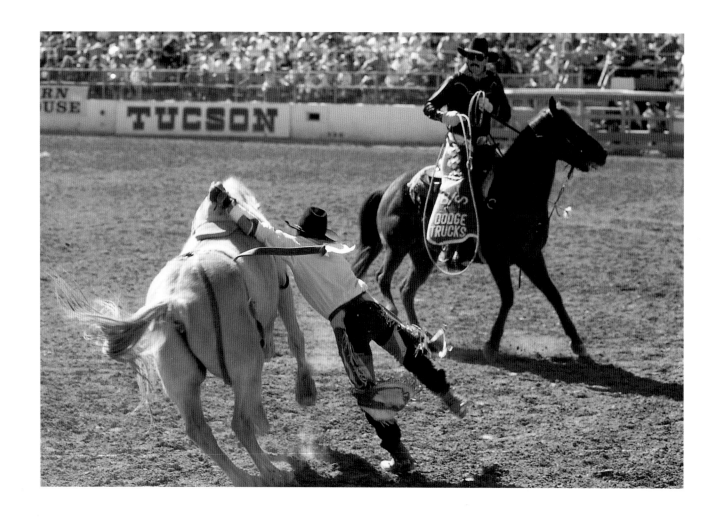

PAGE 82: Teeth clenched, a cowboy gets ready to bust out of the chutes.

PAGE 83: Riding flat out.

PRECEDING OVERLEAF: A rider takes his lumps in front of the crowd.

ABOVE: Still hung up after being bucked off, a cowboy tries to free his hand.

RIGHT: A thrown cowboy unravels the tape to assess the damage.

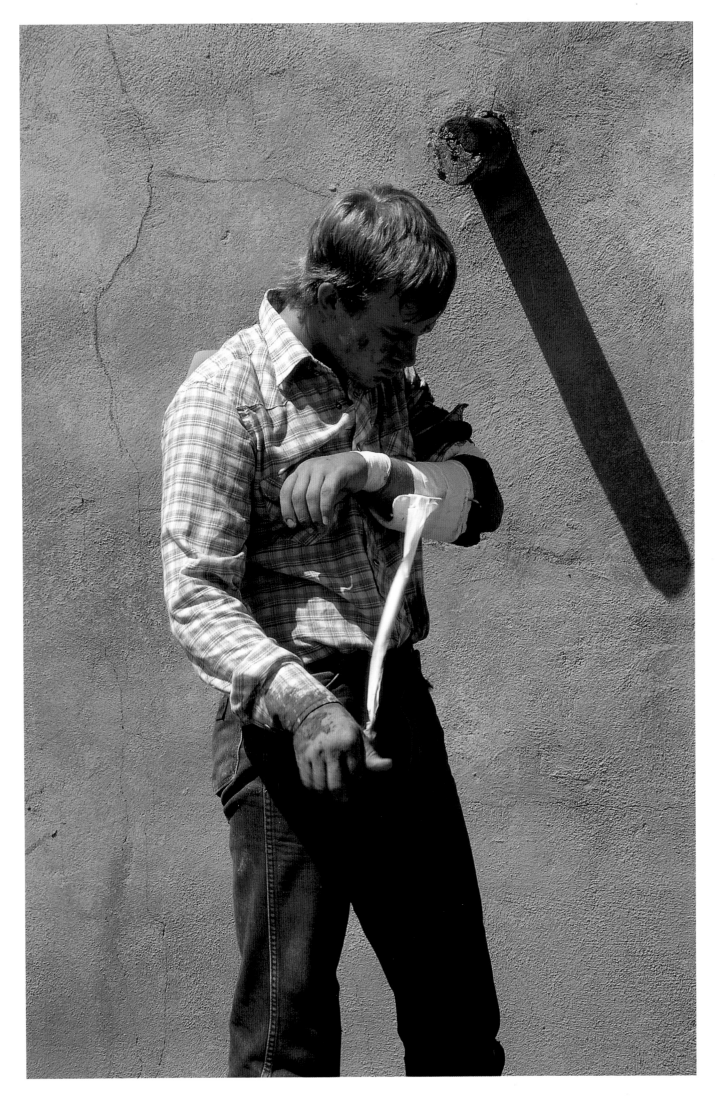

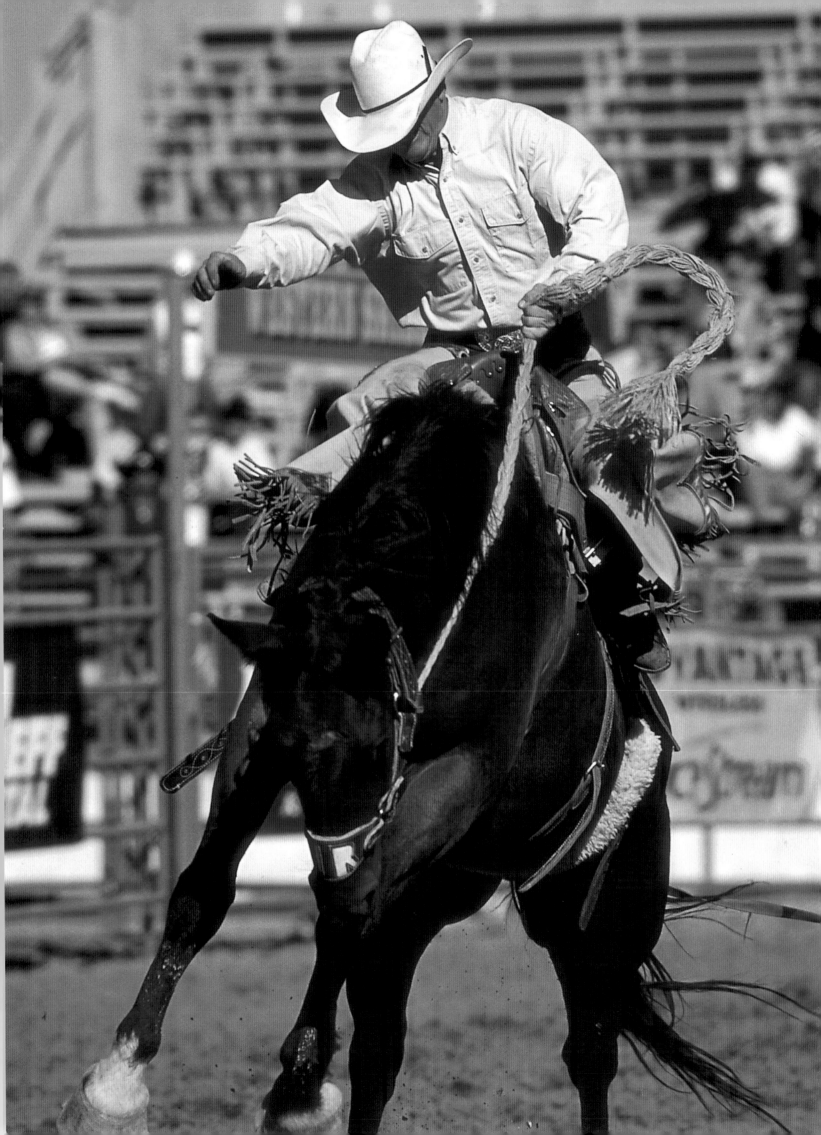

3. Saddle Bronc

LEFT: A saddle bronc and rider charge across the arena.

OVERLEAF: "Gonna saddle up old Paint for the last time. And ride," sang one balladeer.

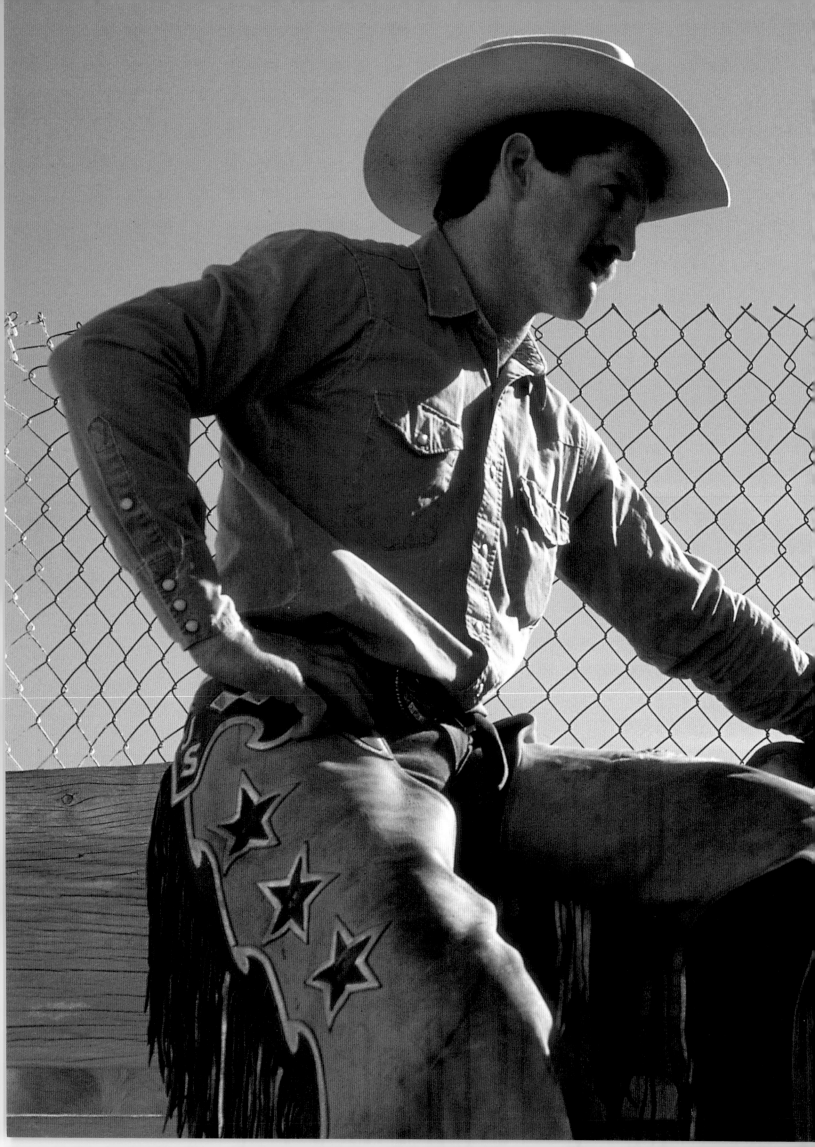

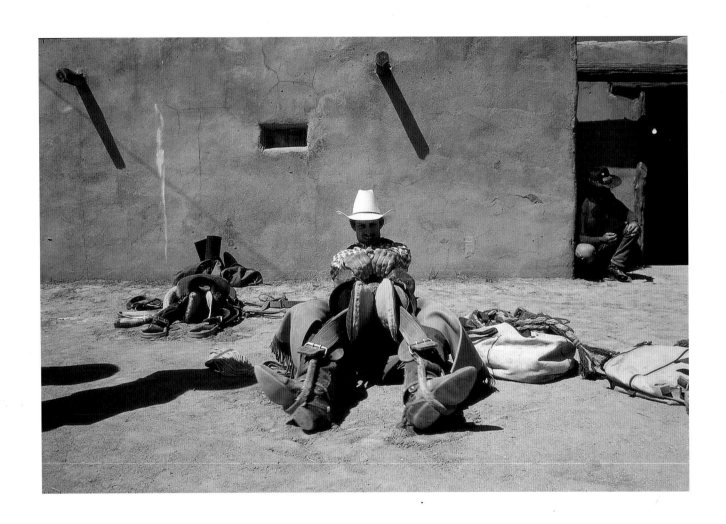

ABOVE: A bronc rider works resin between his leather chaps and saddle for a better "stick" during his ride.

RIGHT: Prescott, Arizona cowboy Milo Dewitt ponders his chances at the World's Oldest Rodeo.

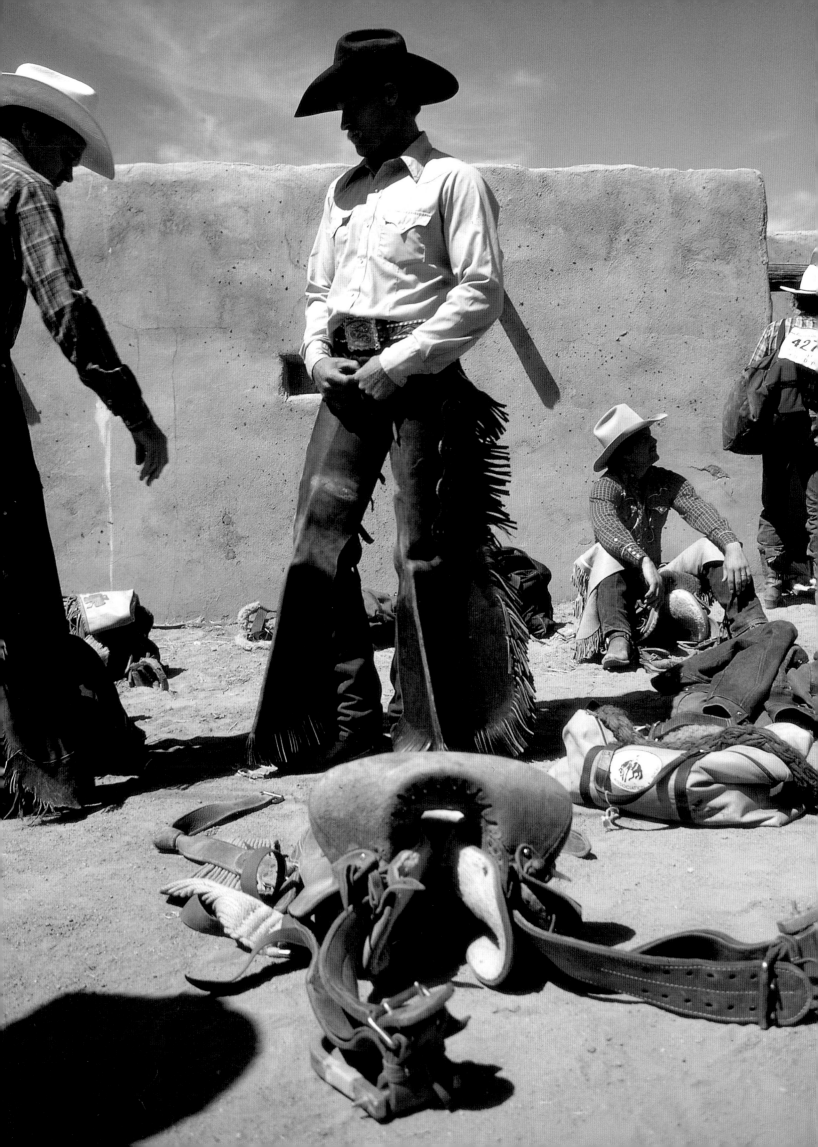

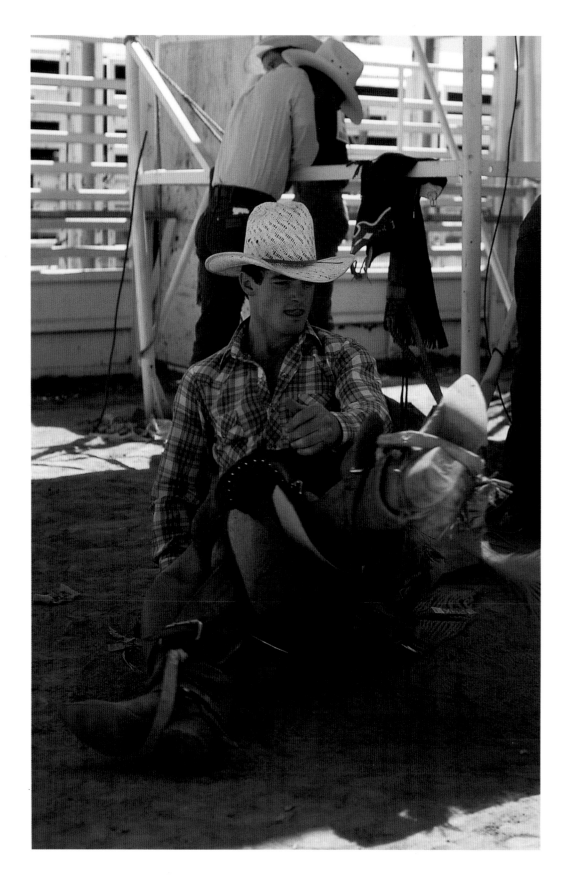

ABOVE AND RIGHT: Down in the dirt, saddle bronc riders warm up by kicking and raking their spurs.

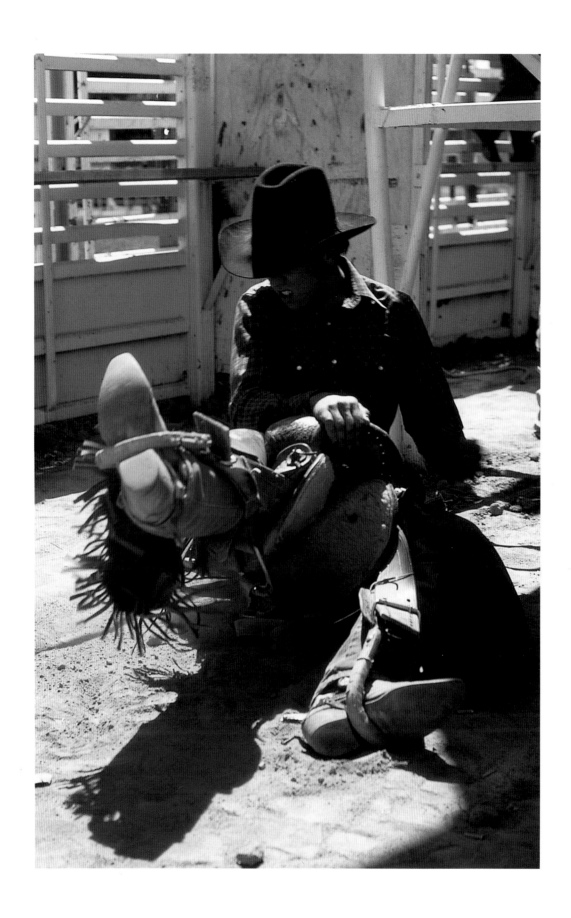

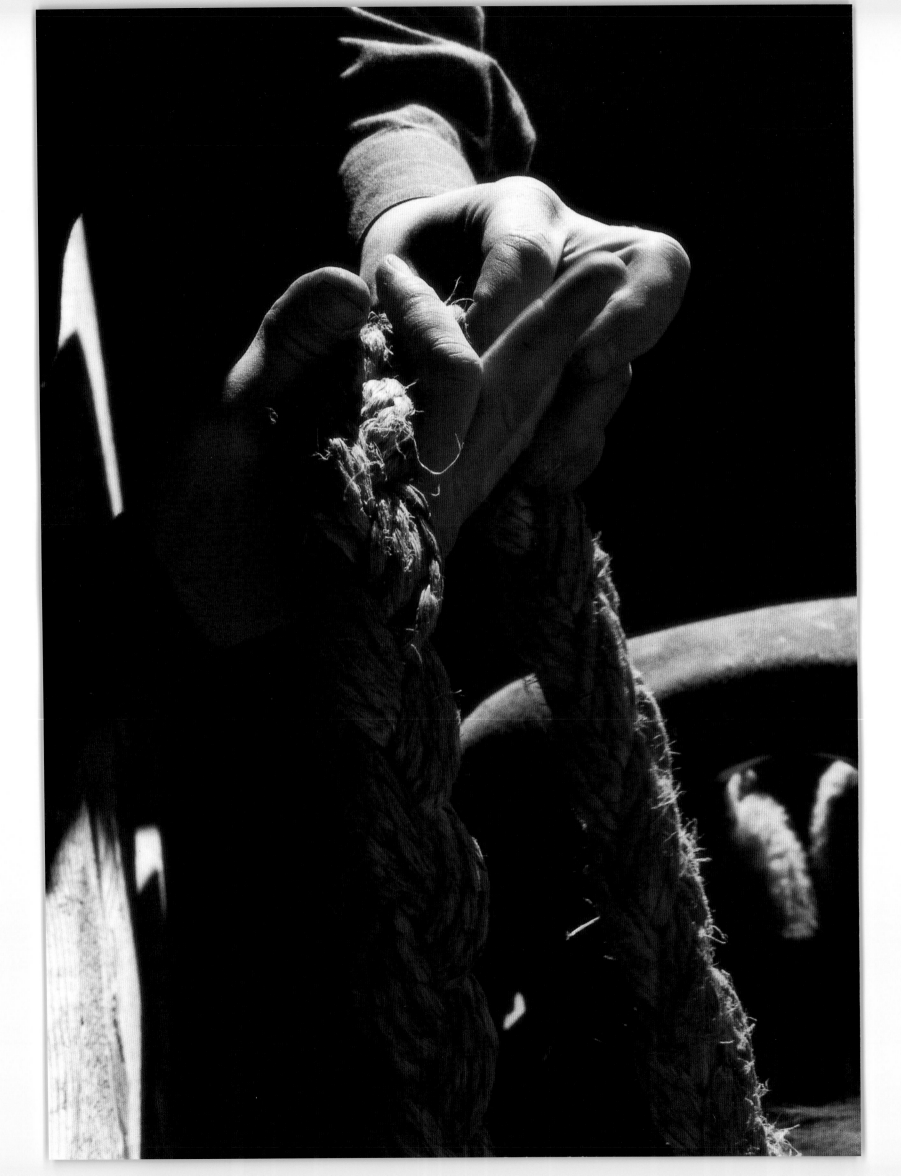

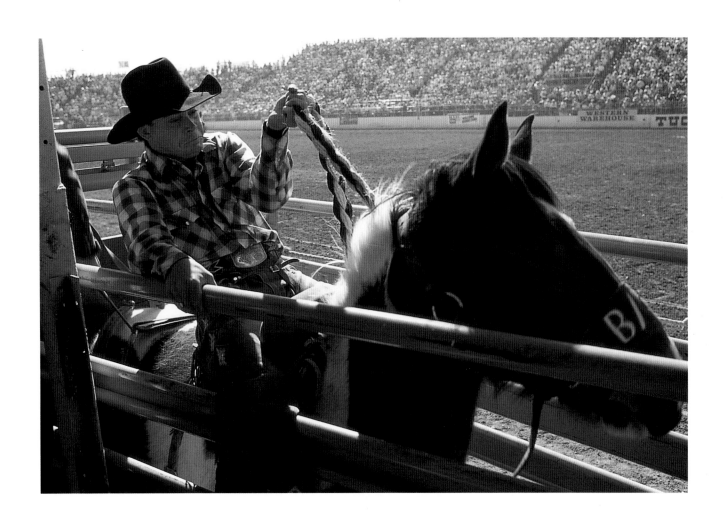

ABOVE: Ready to ride.

LEFT: An unshakable grip is essential to all three roughstock events, but whereas bareback riders hang on to a suitcase-style handle, saddle bronc riders grasp a single strand of braided rope.

OVERLEAF: A bronc and rider bust out of the chute.

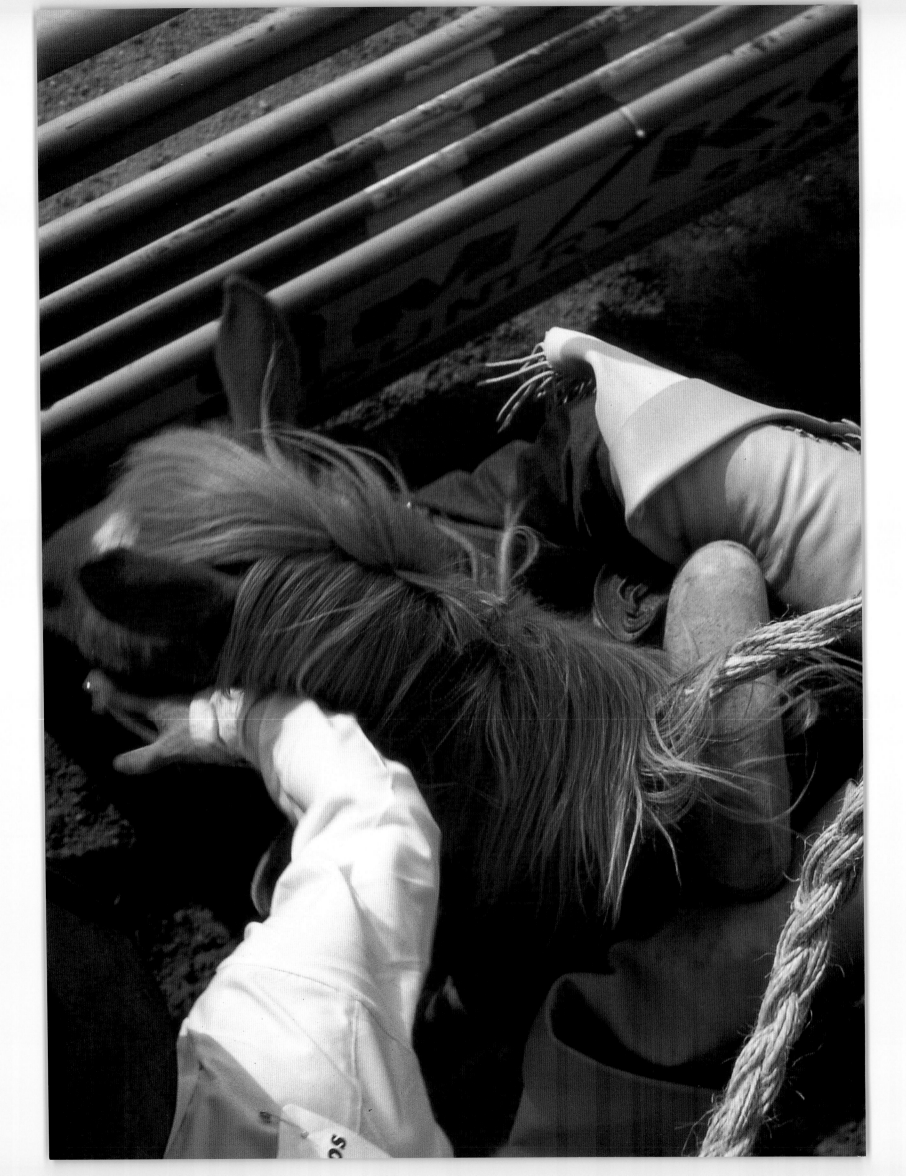

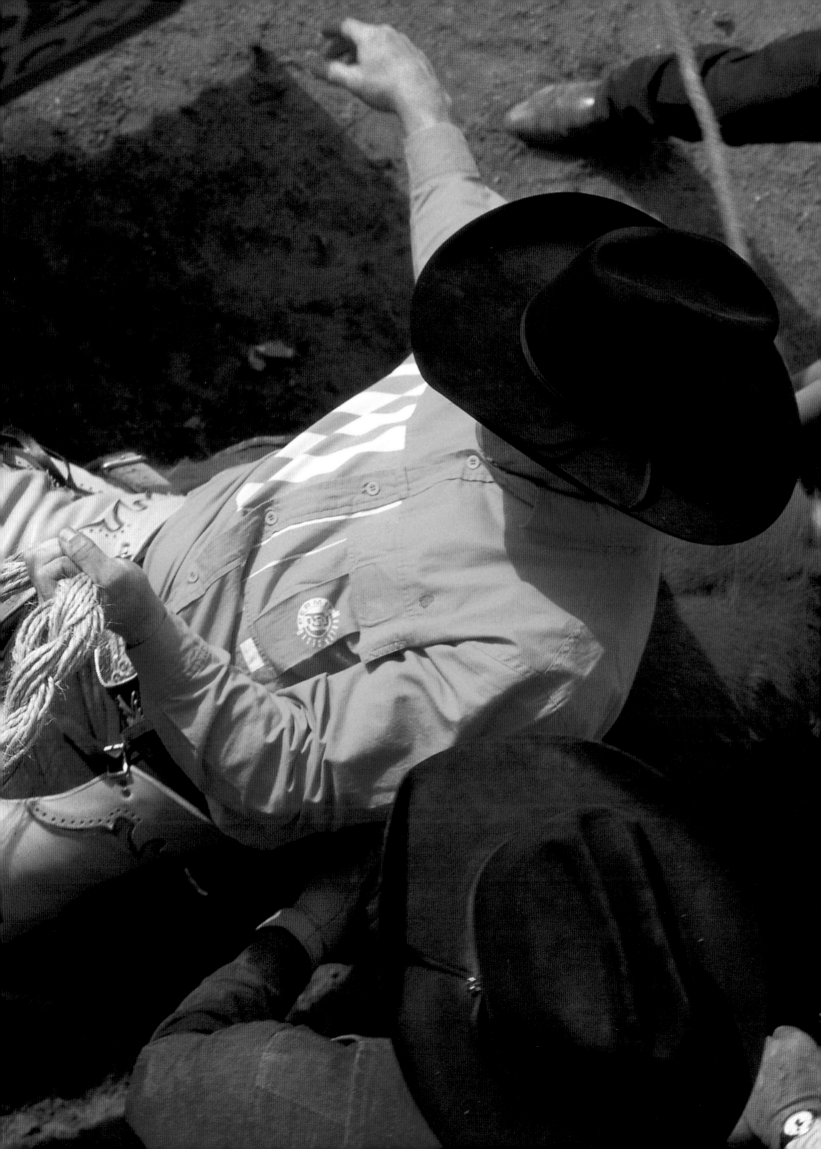

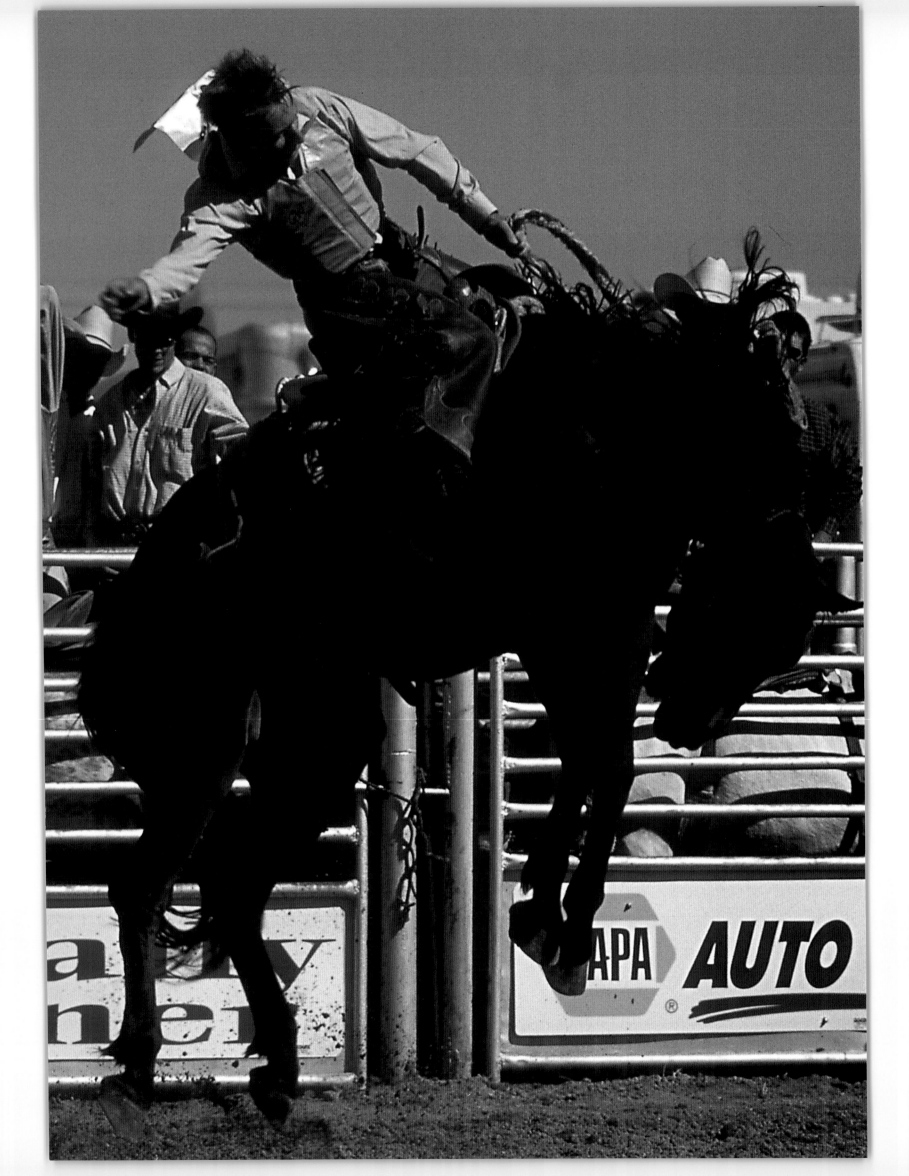

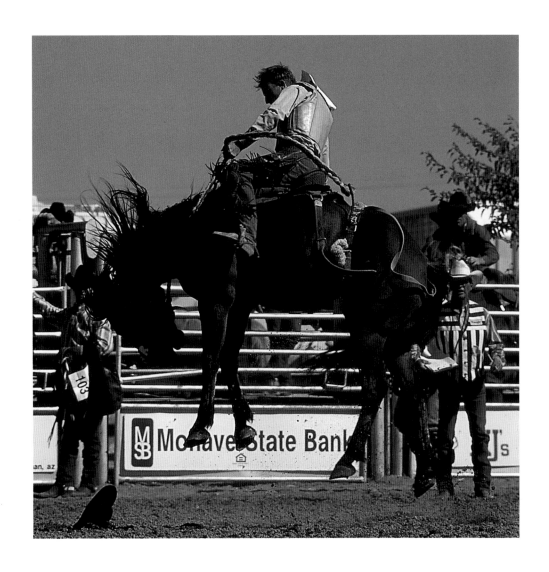

ABOVE AND LEFT: Hanging on for all he's worth, a saddle bronc cowboy rides for the eight-second buzzer.

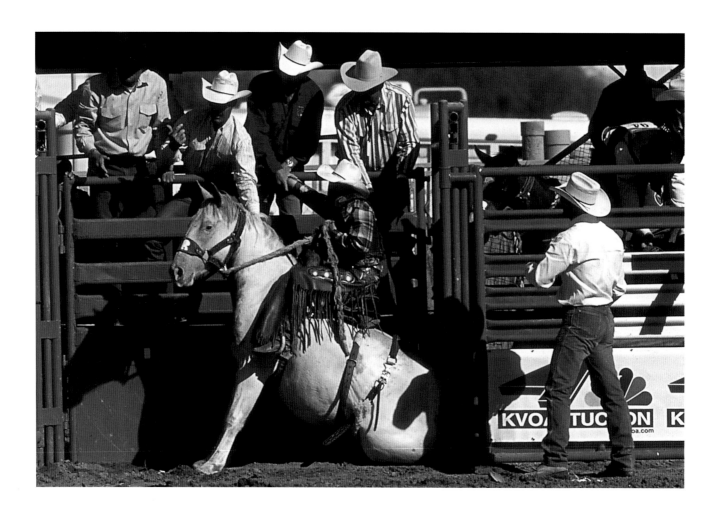

ABOVE: A stubborn bronc tries to sit one out.

RIGHT: A flanker adjusts the chute at an Old Timers Rodeo.

OVERLEAF, LEFT AND RIGHT: A saddle bronc rears up on its hind legs, before tearing up the dirt.

OVERLEAF: Riding for a high score on a golden bronc.

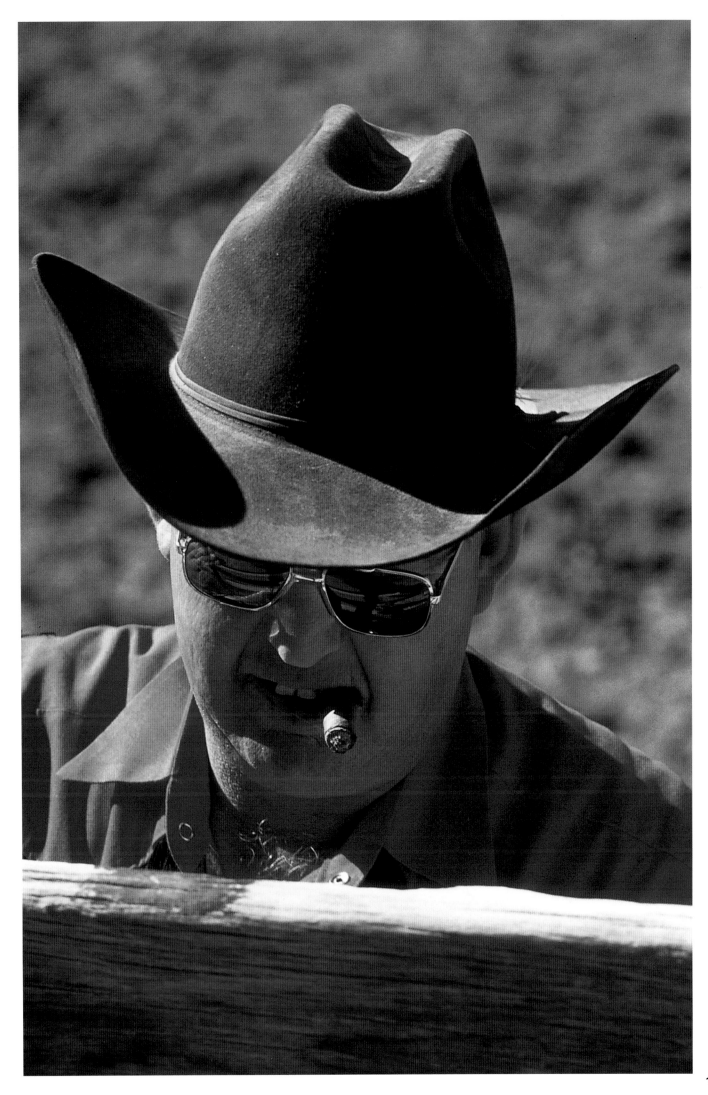

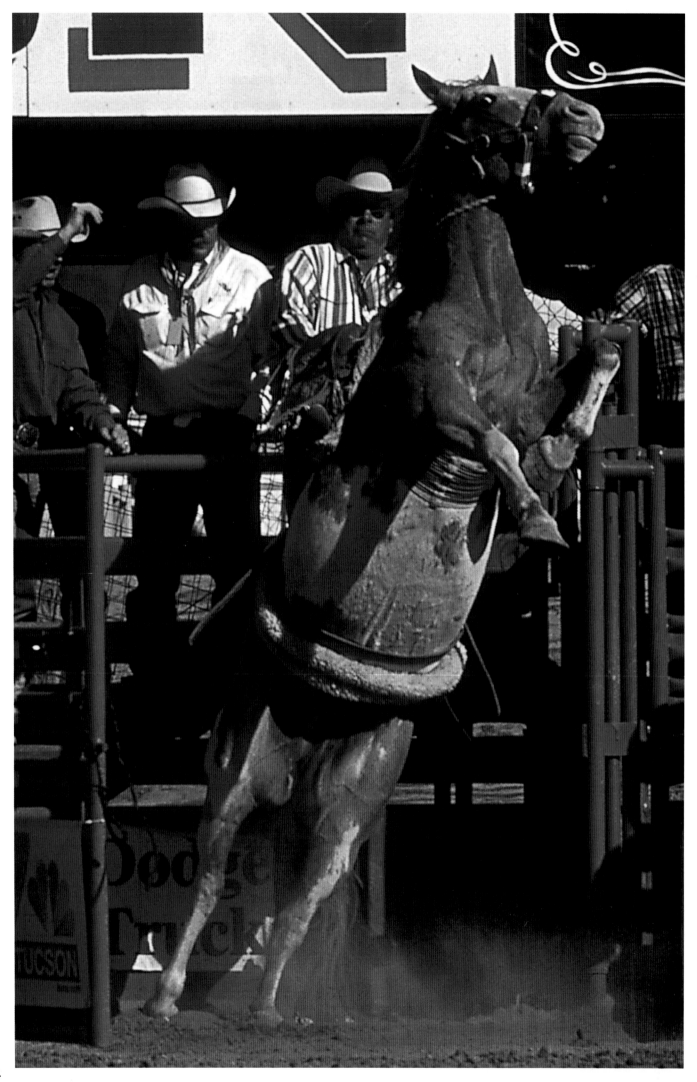

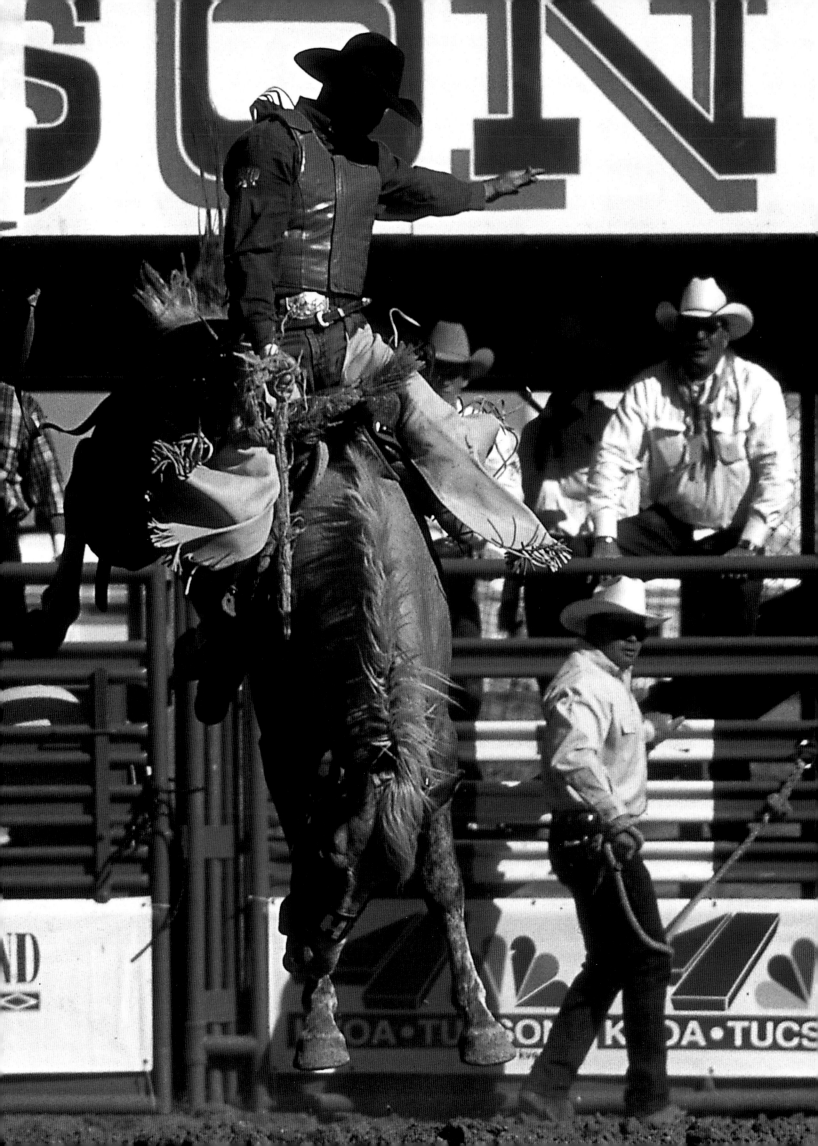

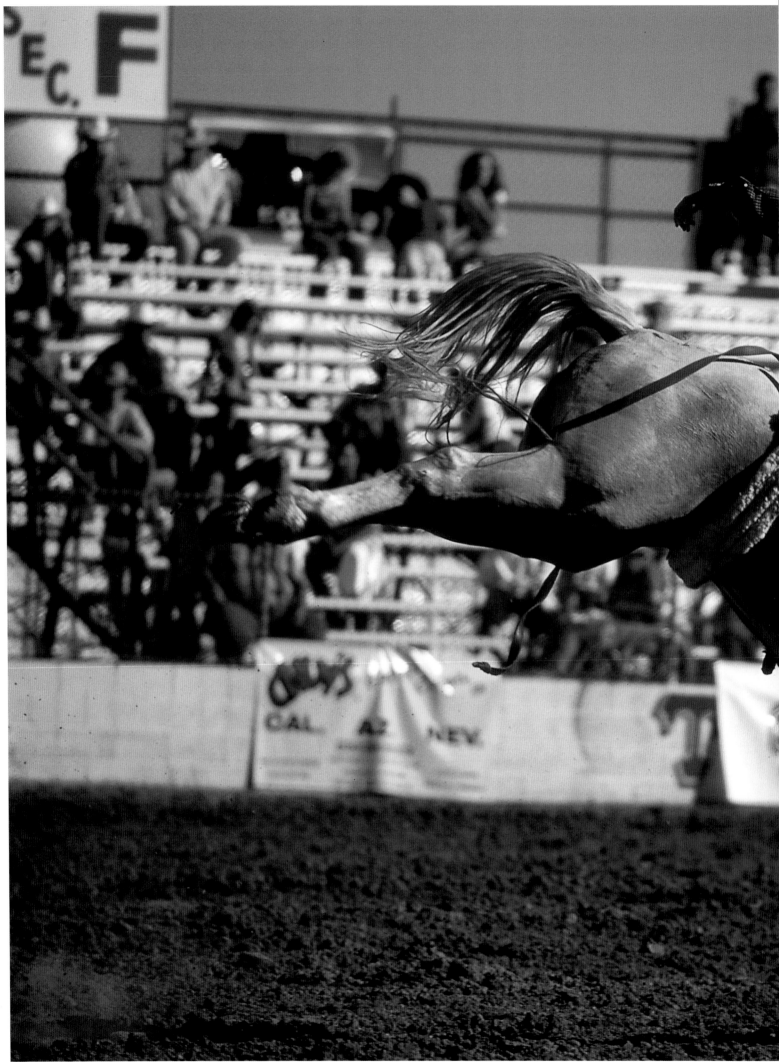

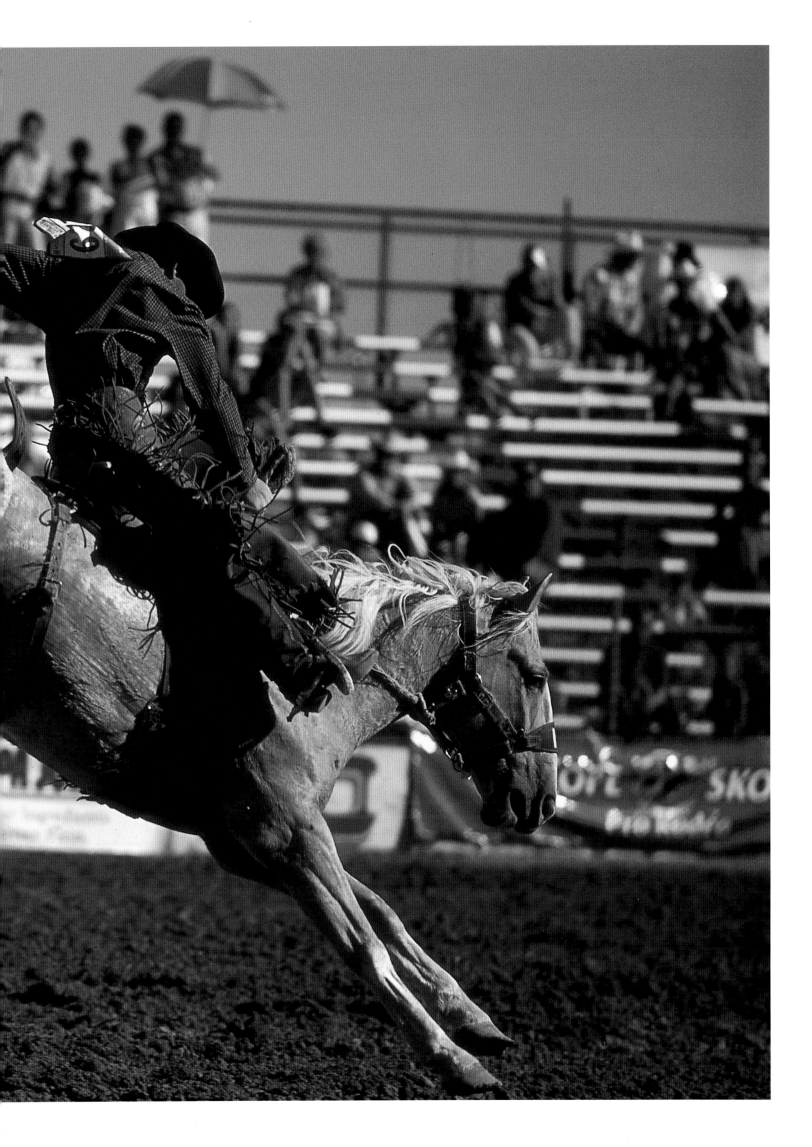

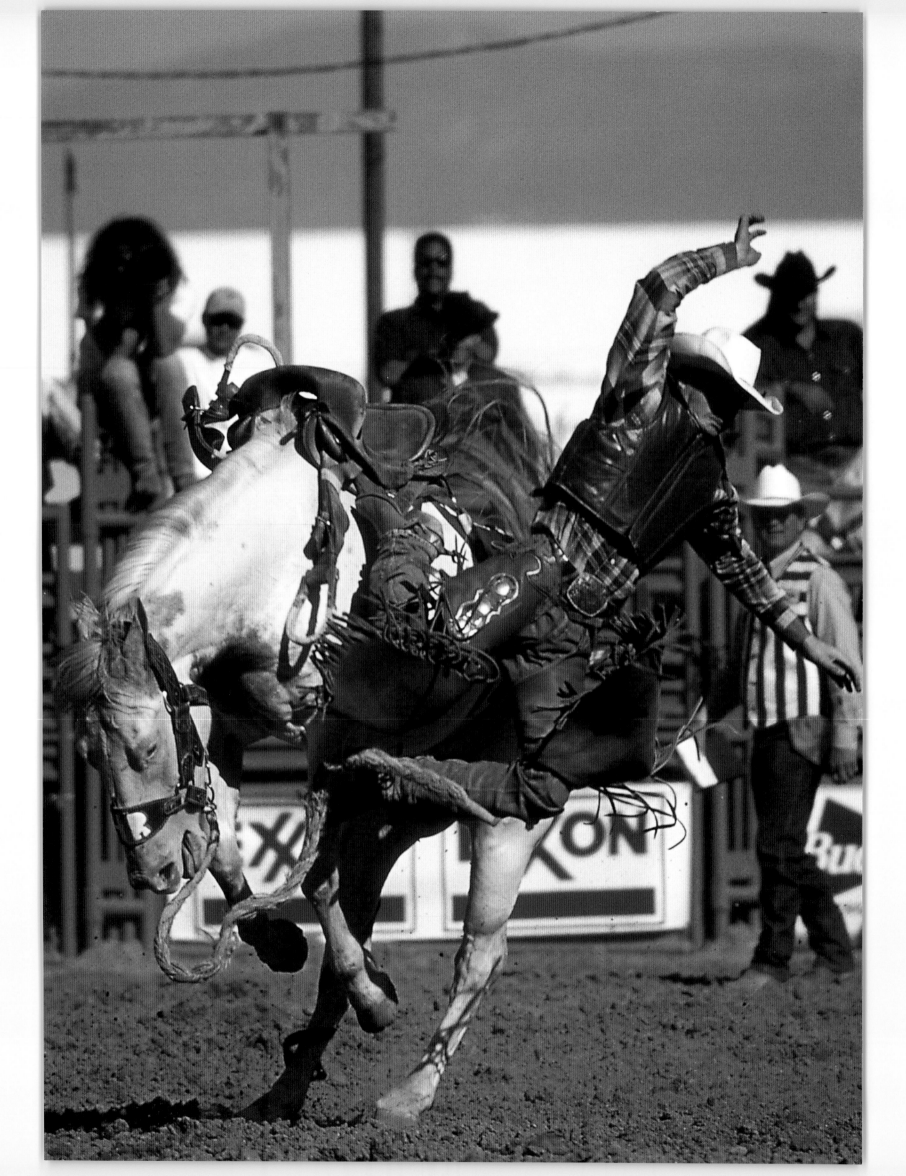

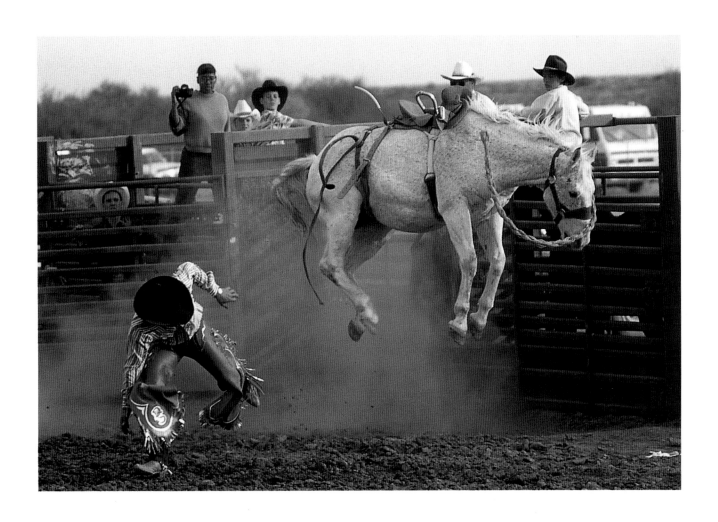

ABOVE: "There never lived a cowboy he couldn't toss."

LEFT: Bucked off by a good saddle bronc, a cowboy tumbles toward the ground.

OVERLEAF, LEFT: Win, lose or draw, a cowboy's saddle is "his kingly throne."

OVERLEAF, RIGHT: Saddle bronc riders get ready to head down the road to the next rodeo.

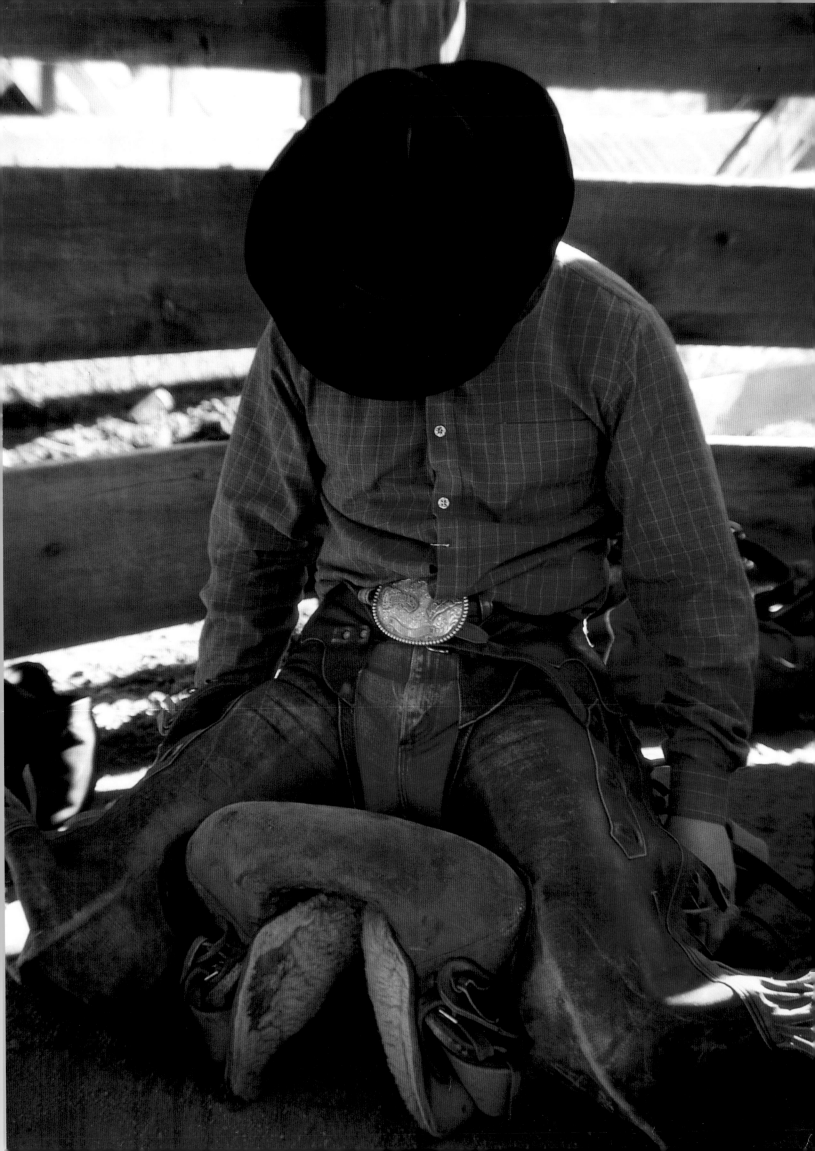

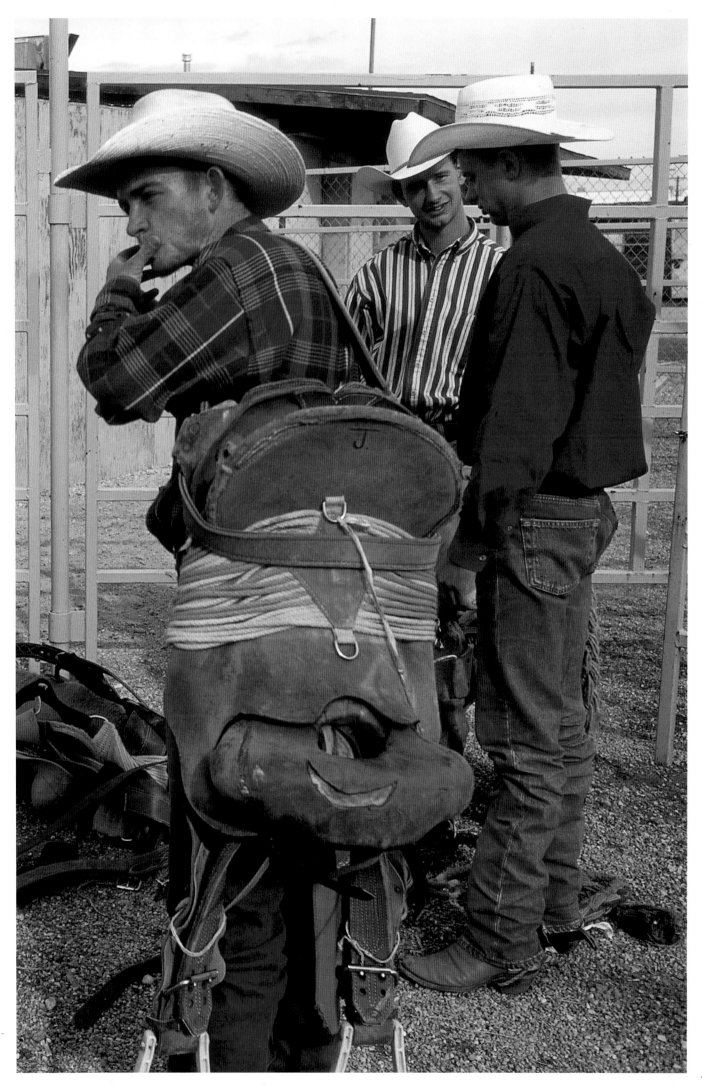

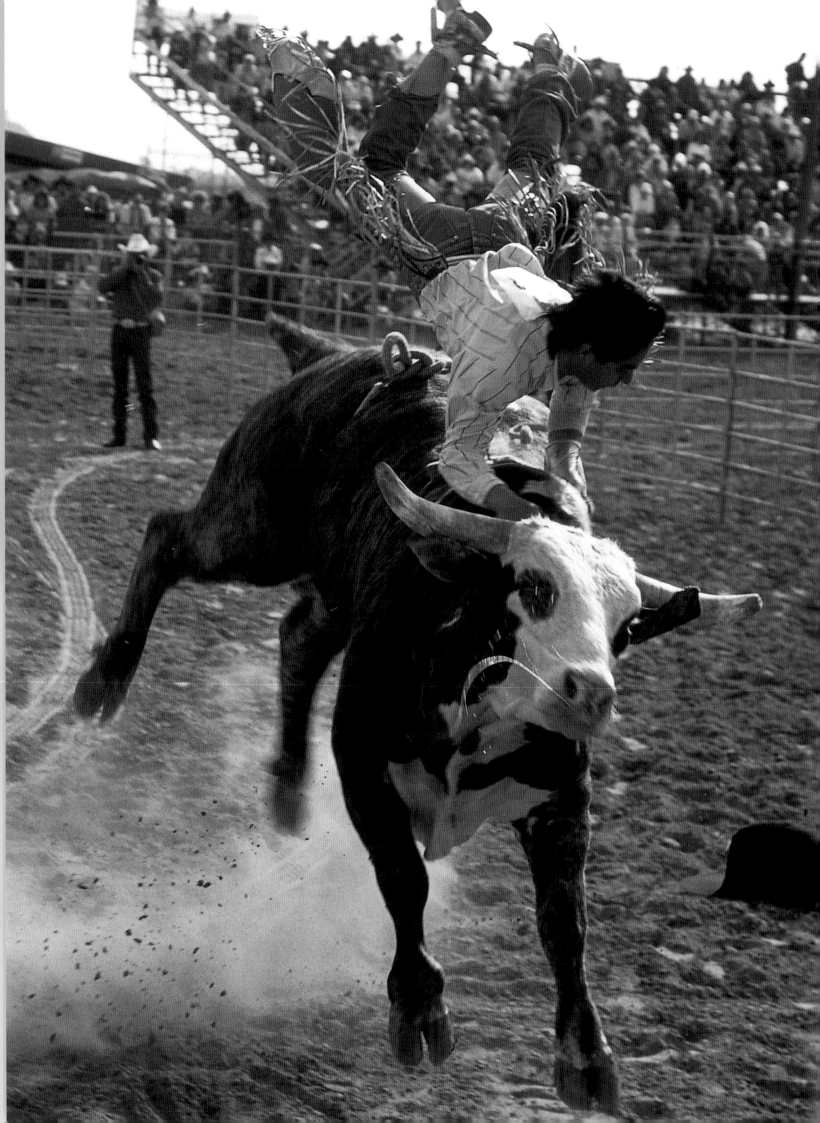

4. Bulls

LEFT: A Pima Indian cowboy hangs on with both hands for a wild ride.

OVERLEAF: Face to face before the bull riding begins, Pro Rodeo Hall of Fame bull rider Charlie Simpson (left) and bullfighter Dwayne Hargo.

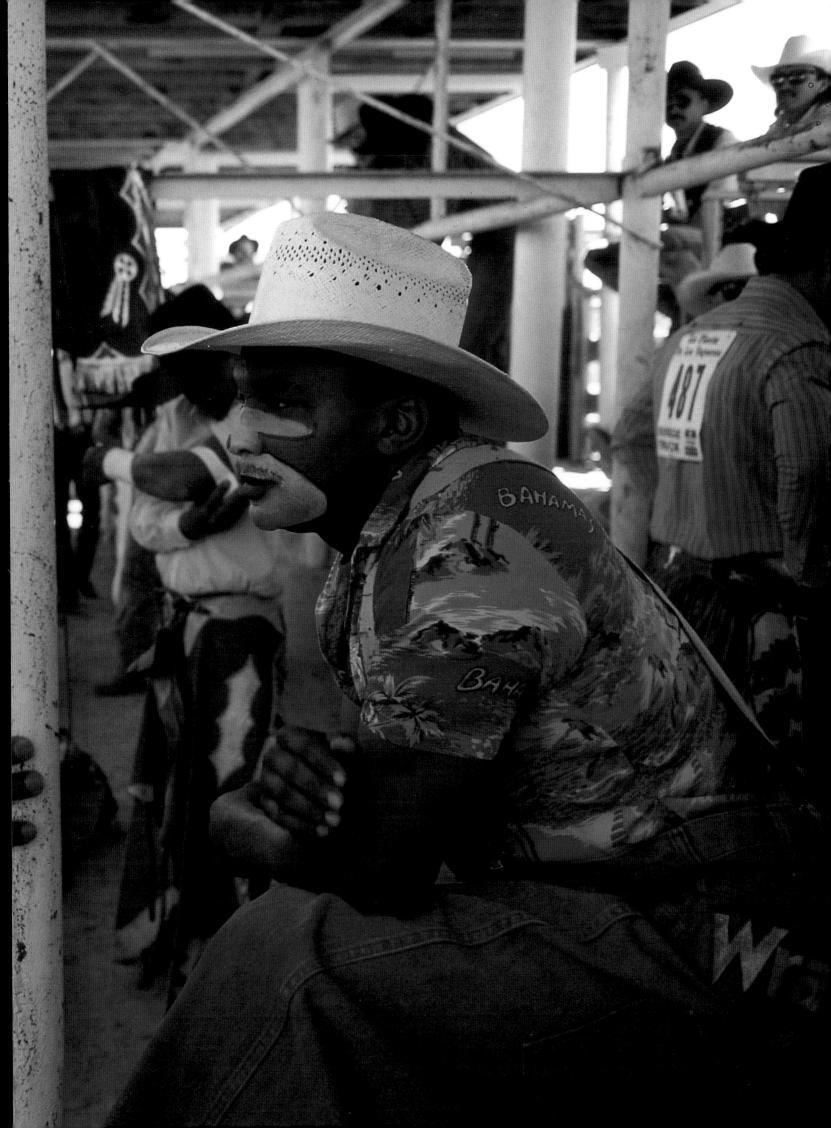

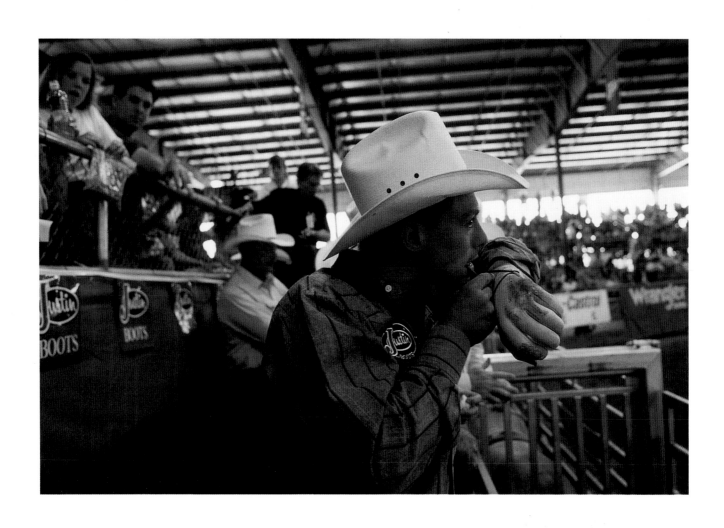

ABOVE: Champion Aaron Semas ties on his riding glove.

RIGHT: A bull rider uncoils his rigging.

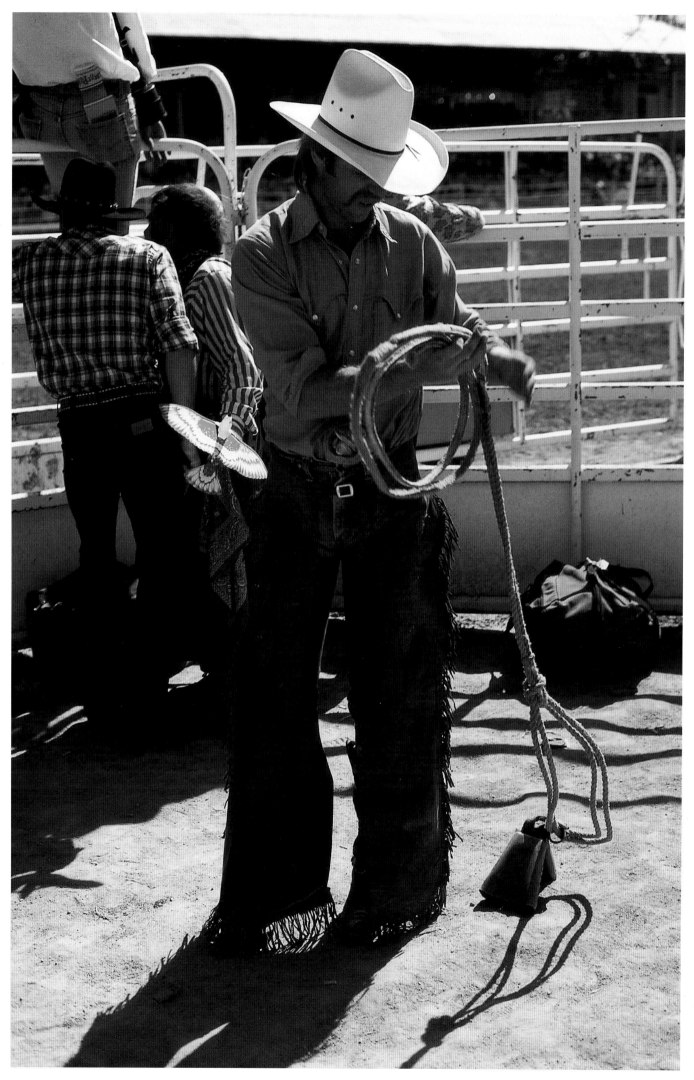

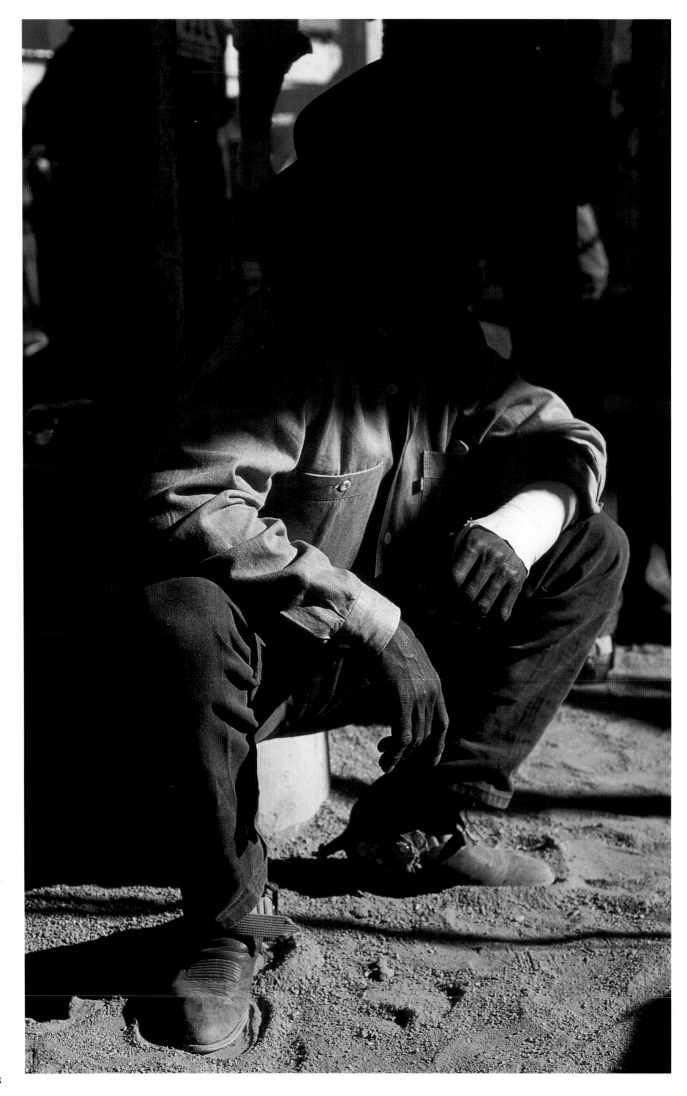

ABOVE: The flame from a lighter cures the resin on this cowboy's glove.

LEFT: Charlie Sampson waits in the shadows to show the crowd the champion bull rider he is.

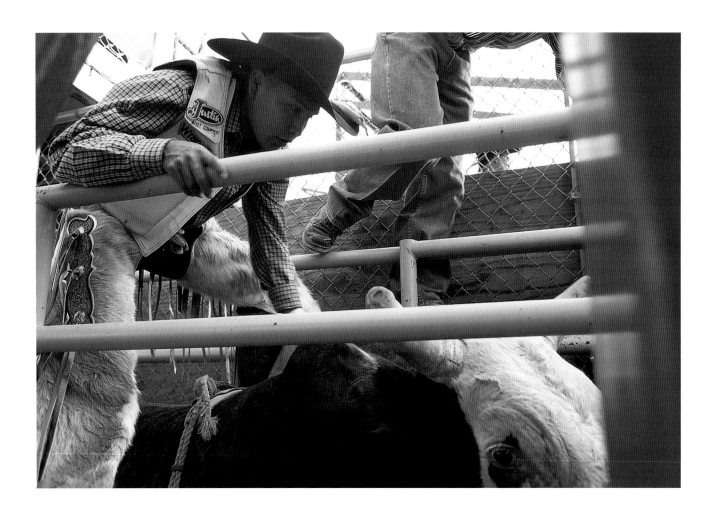

ABOVE: A cowboy climbs into the chute to cinch on his rigging and look over the bull he's drawn. "I looks that bull over and to my surprise, it's a foot-and-a-half in between his two eyes."

RIGHT: Wearing trademark zebra-skin chaps, Spook Wiggins says a prayer on the back of a bull.

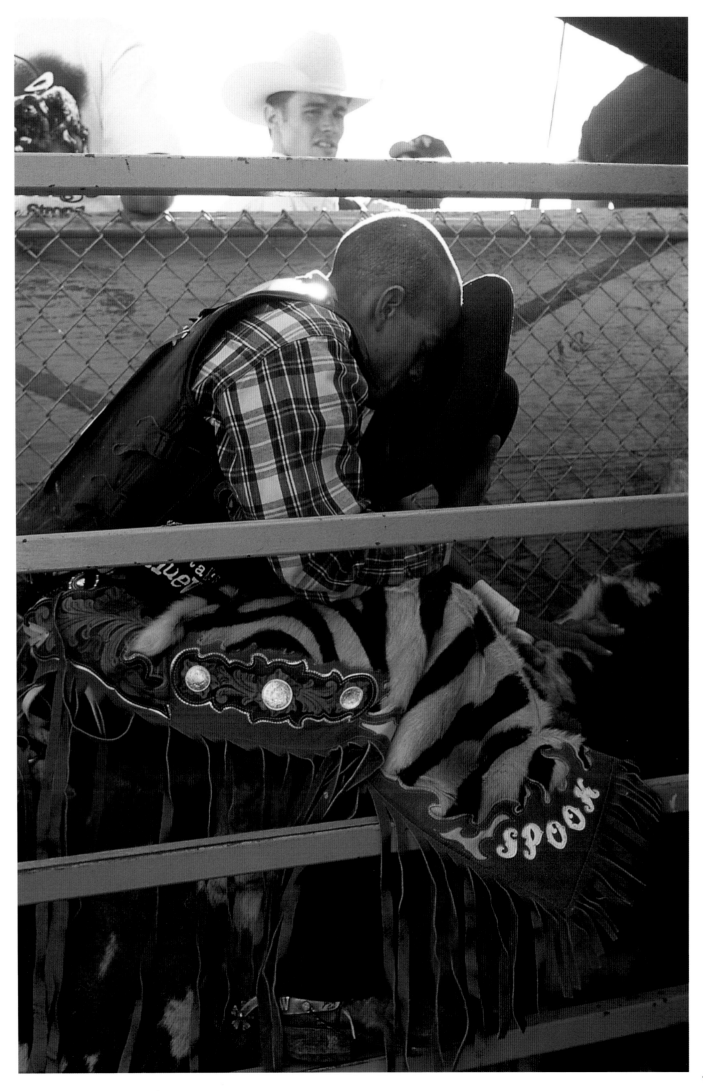

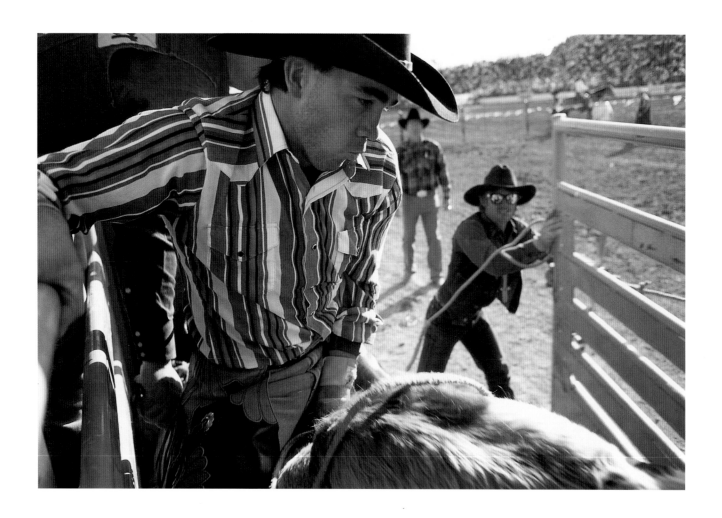

ABOVE: As the gate swings open, a cowboy hunkers down for the ride.

RIGHT: Anchored by a plaited leather handhold wrapped around a glove, bull riders hang on to a rope cinched around the bull.

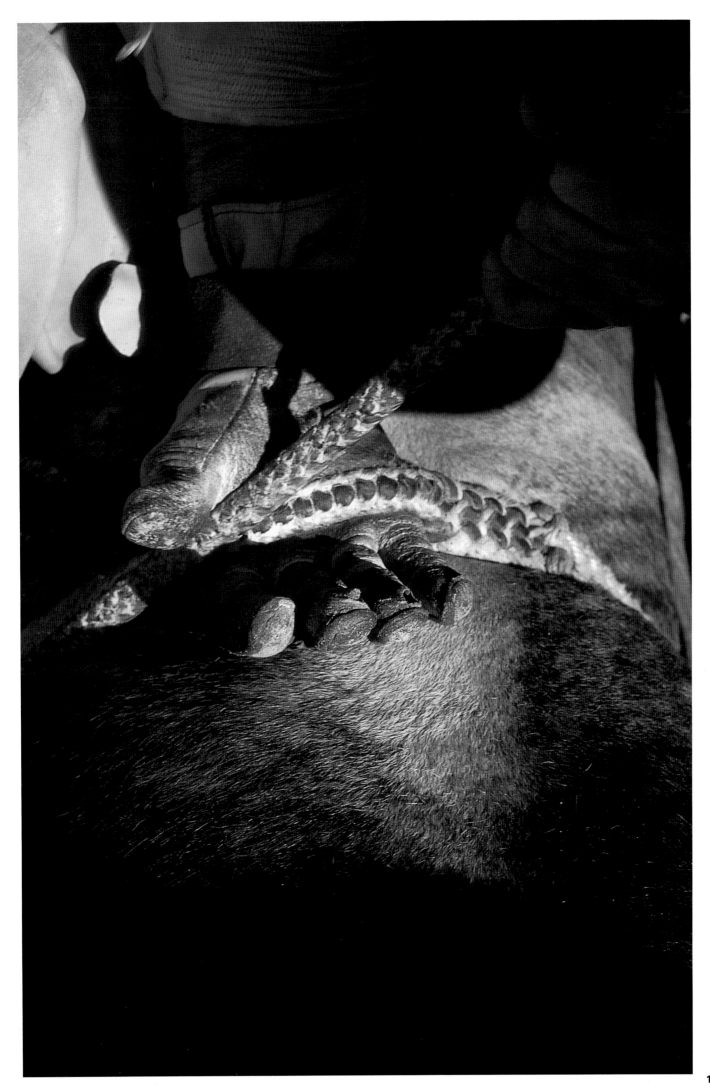

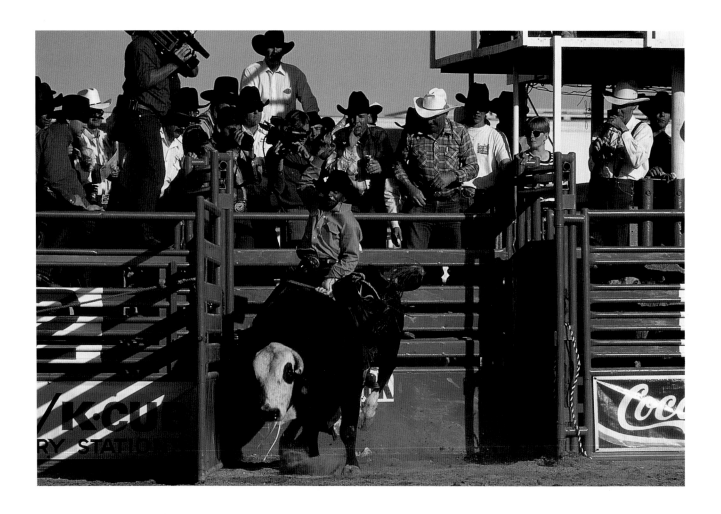

ABOVE: Charlie Sampson's ride

RIGHT: A cowboy rides for the money at the Fiesta de Los Vaqueros Rodeo.

OVERLEAF: Hung up in his rigging, a cowboy gets thrown to his knees by a rank bull.

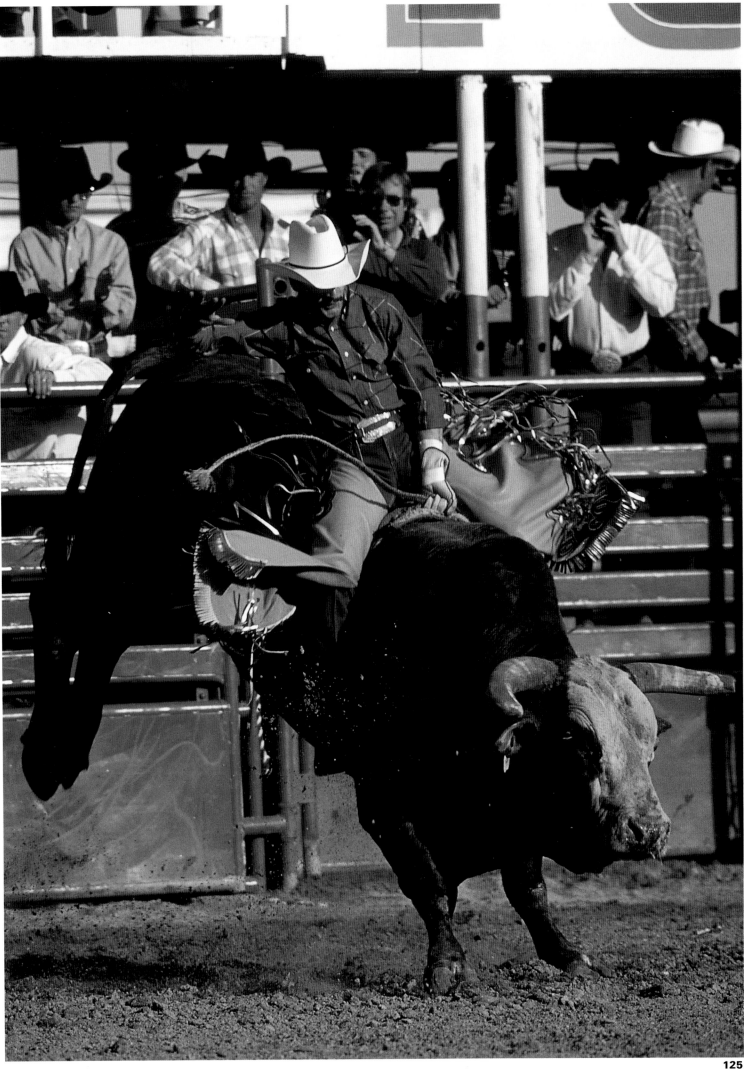

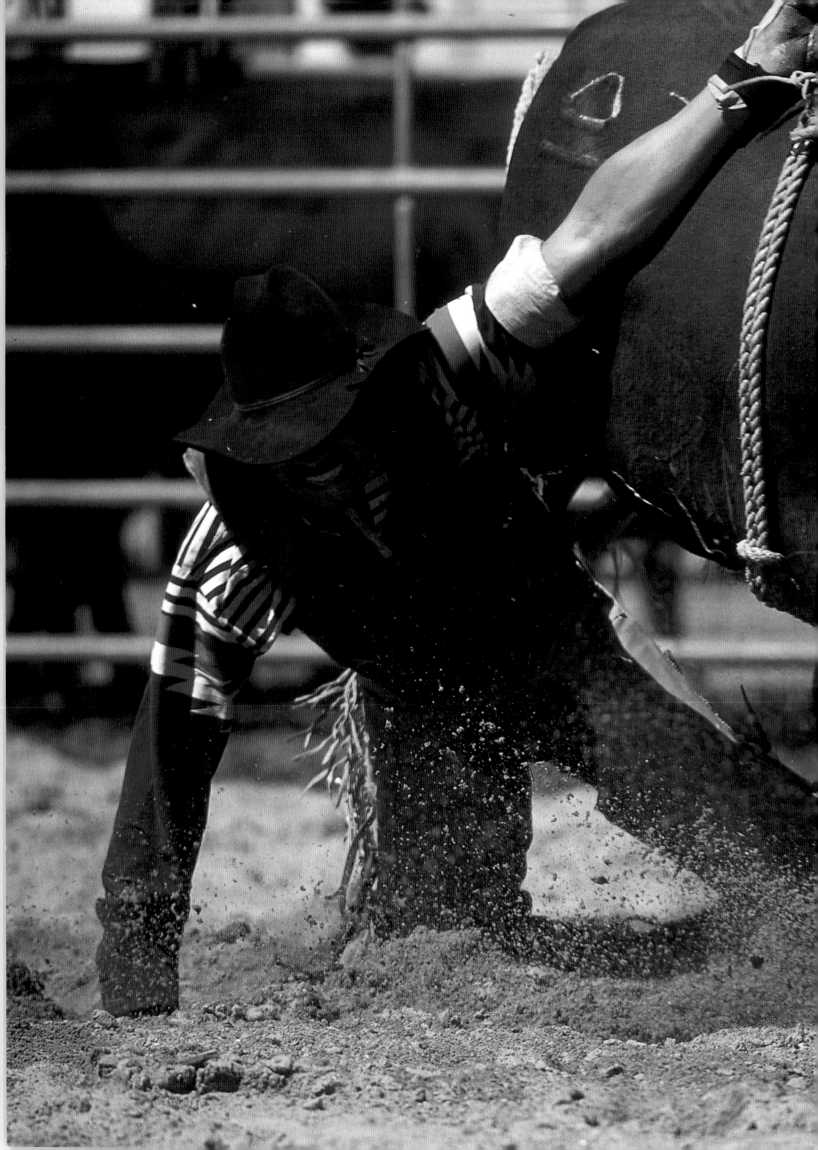

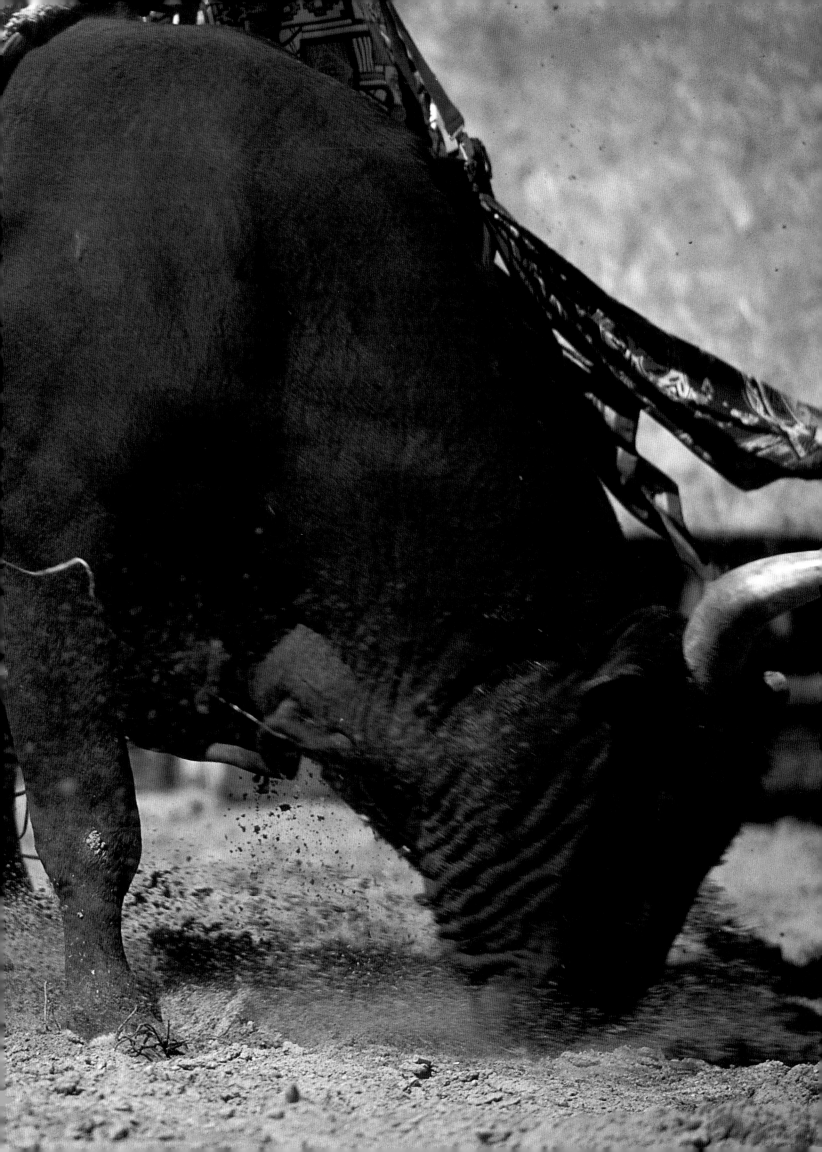

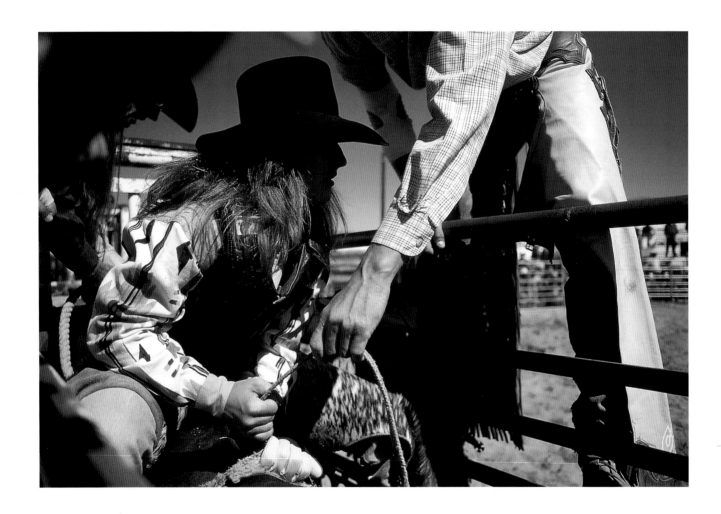

ABOVE: Willie Nelson once sang, "Mammas don't let your babies grow up to be cowboys." Nelson could have added a line about rodeo cowgirls to the song: tough women like DeeDee Crawford who've broken male taboos by riding bulls.

RIGHT: Fingernails polished pink to match her chaps, a woman bull rider cinches her rope around her rawhide glove.

OVERLEAF: Dallas cowgirl Courtney Stevens matches kicks with a bull while trying to free up her riding hand.

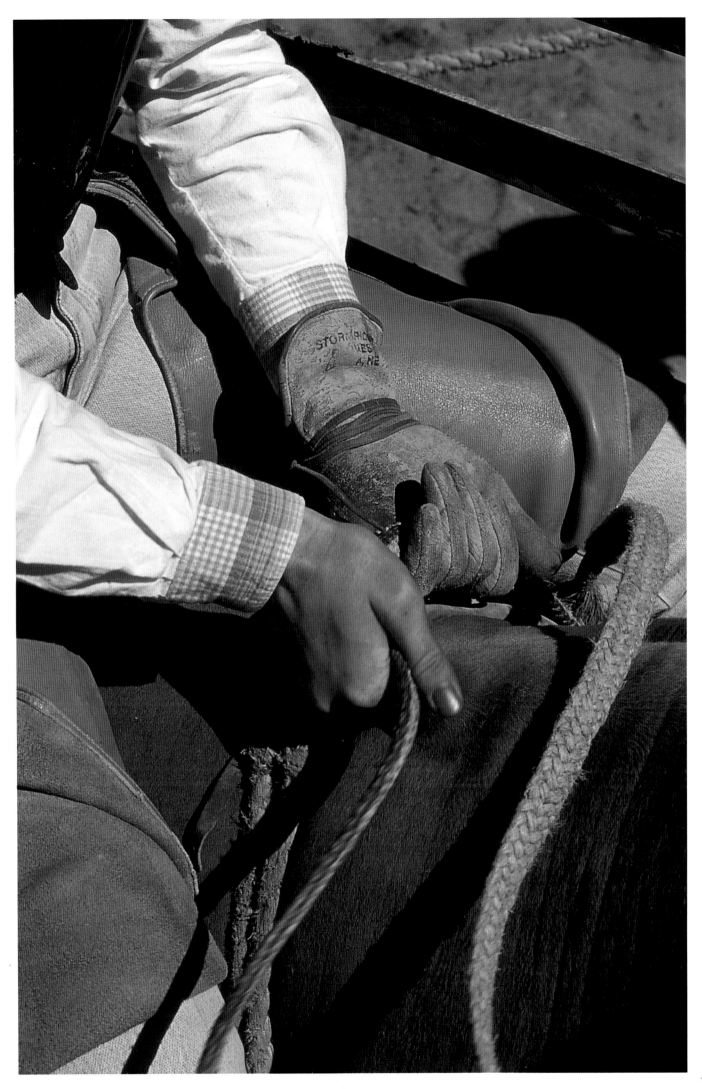

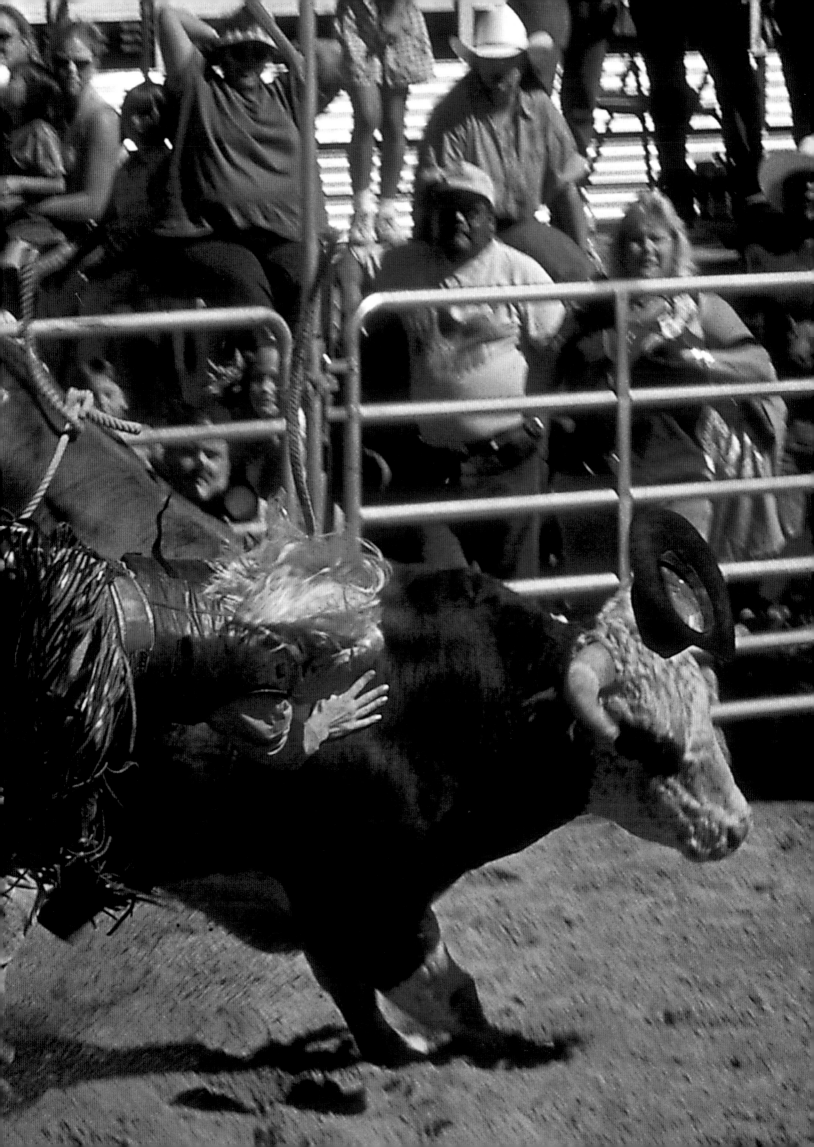

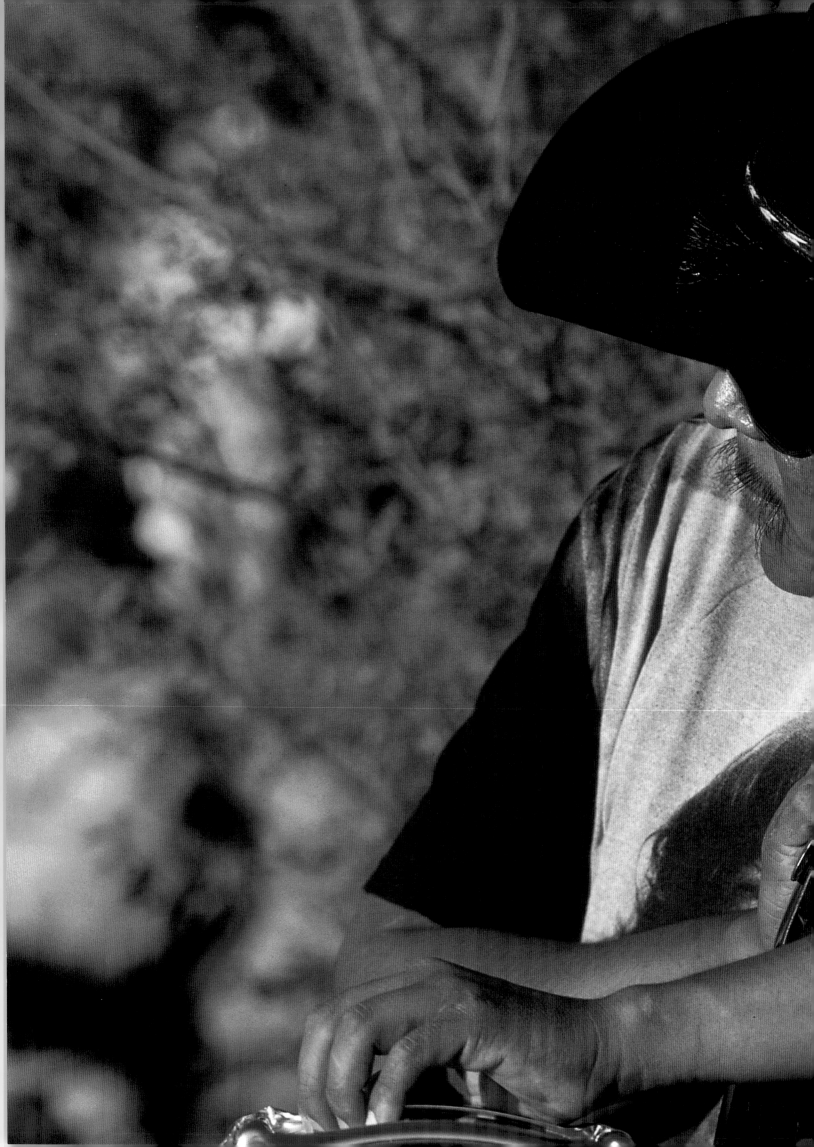

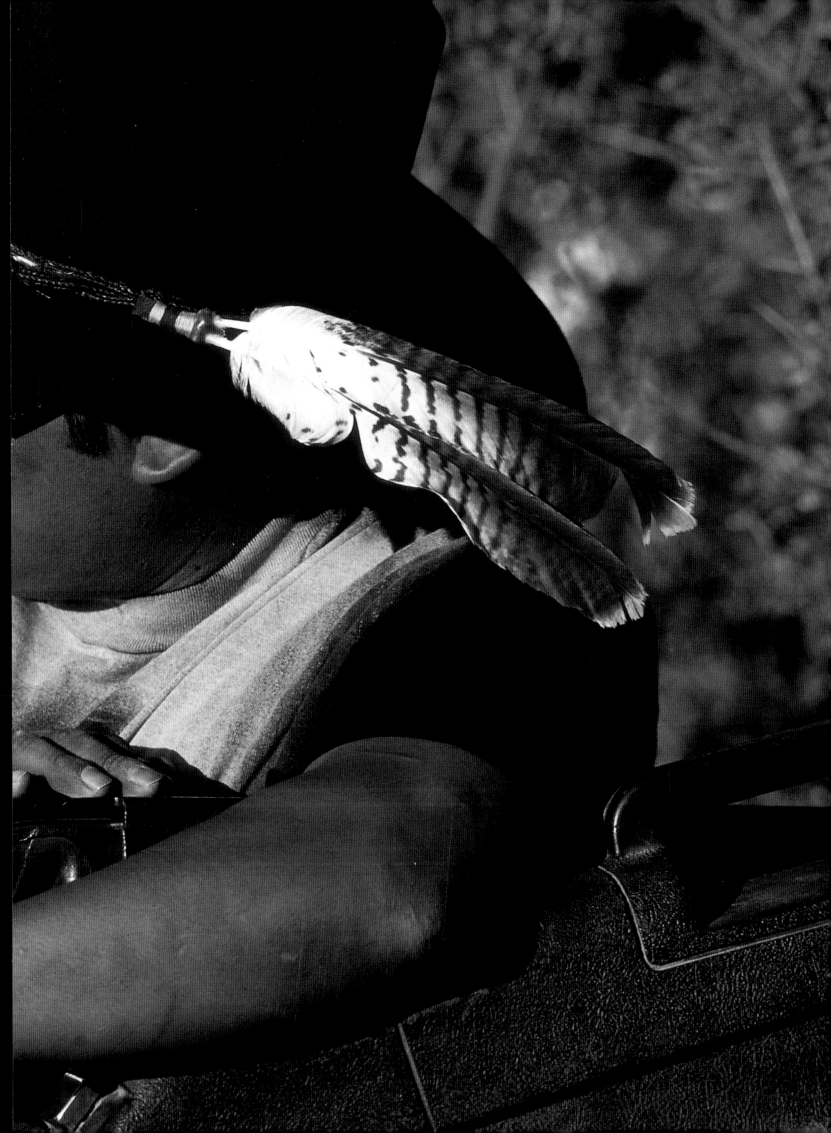

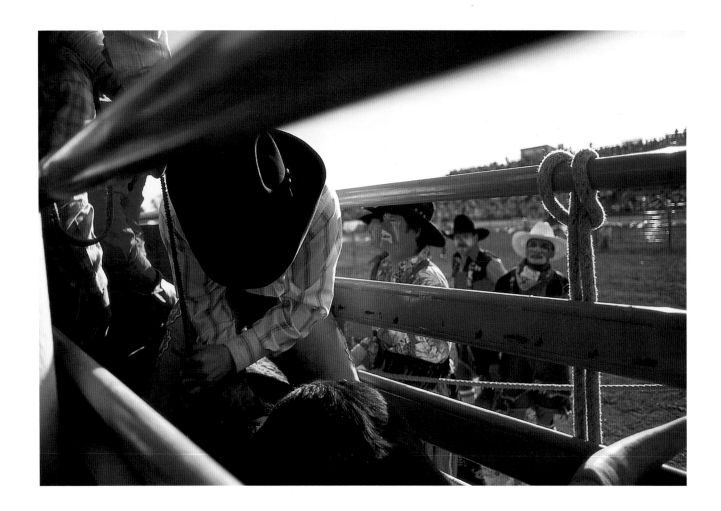

OVERLEAF PRECEDING: The myth-shattering Indian cowboy.

ABOVE AND RIGHT: In the chutes, flankers help cowboys cinch on their rigging behind the bull's hump.

OVERLEAF: A Native American bull rider whirls out of the chute.

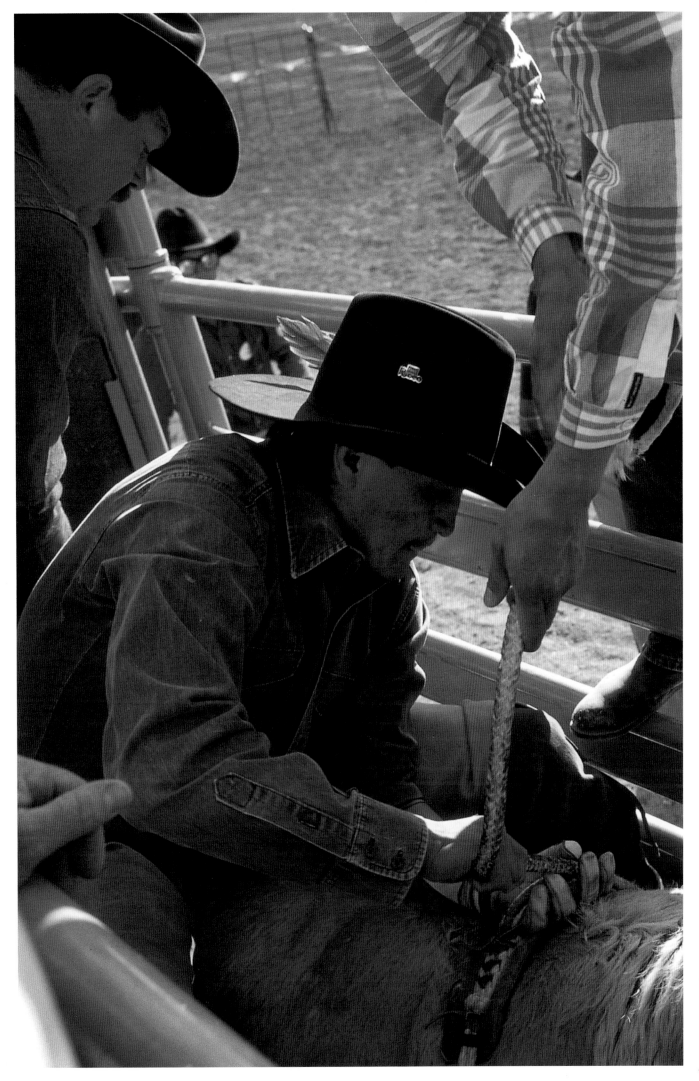

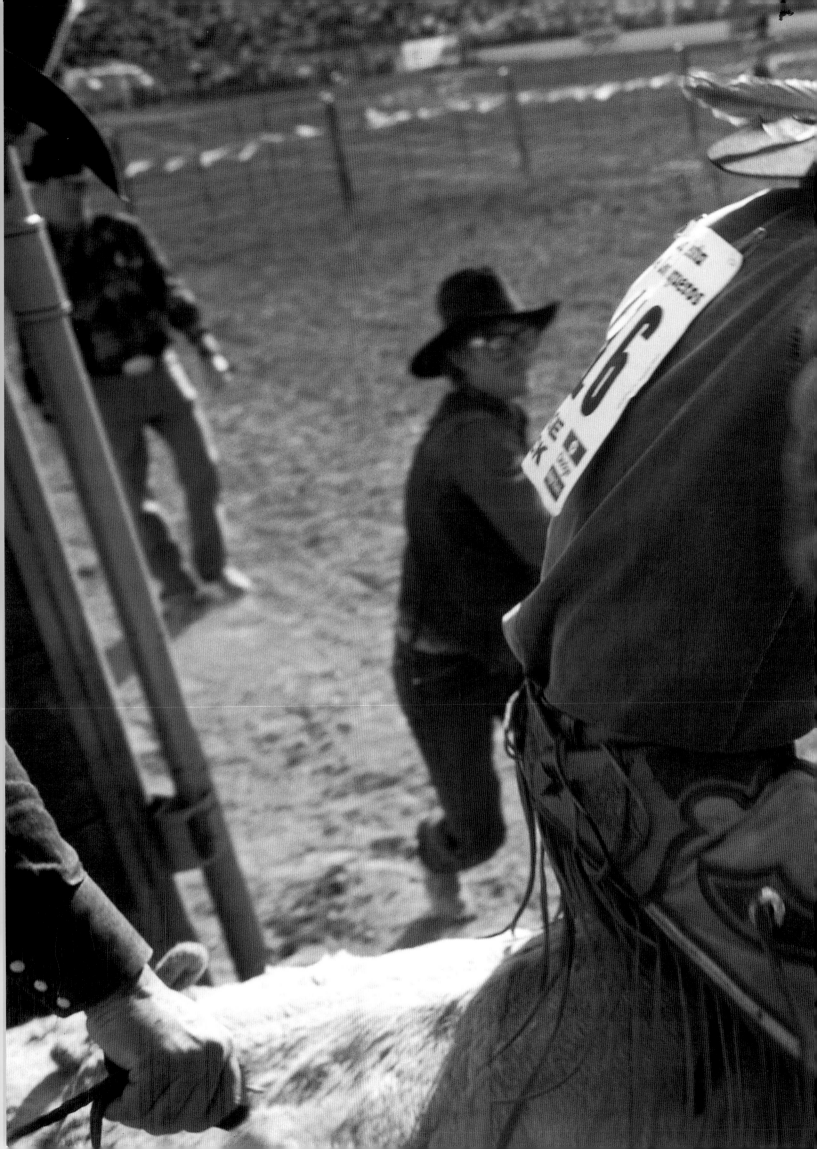

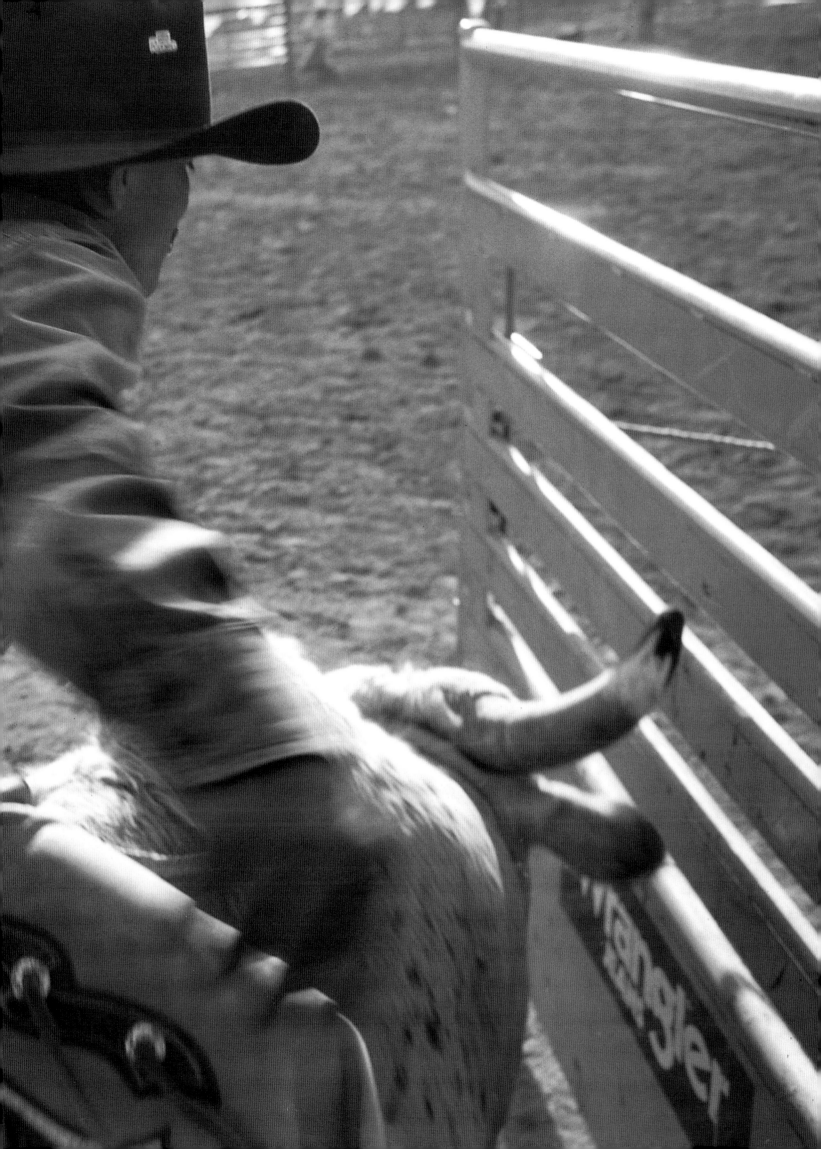

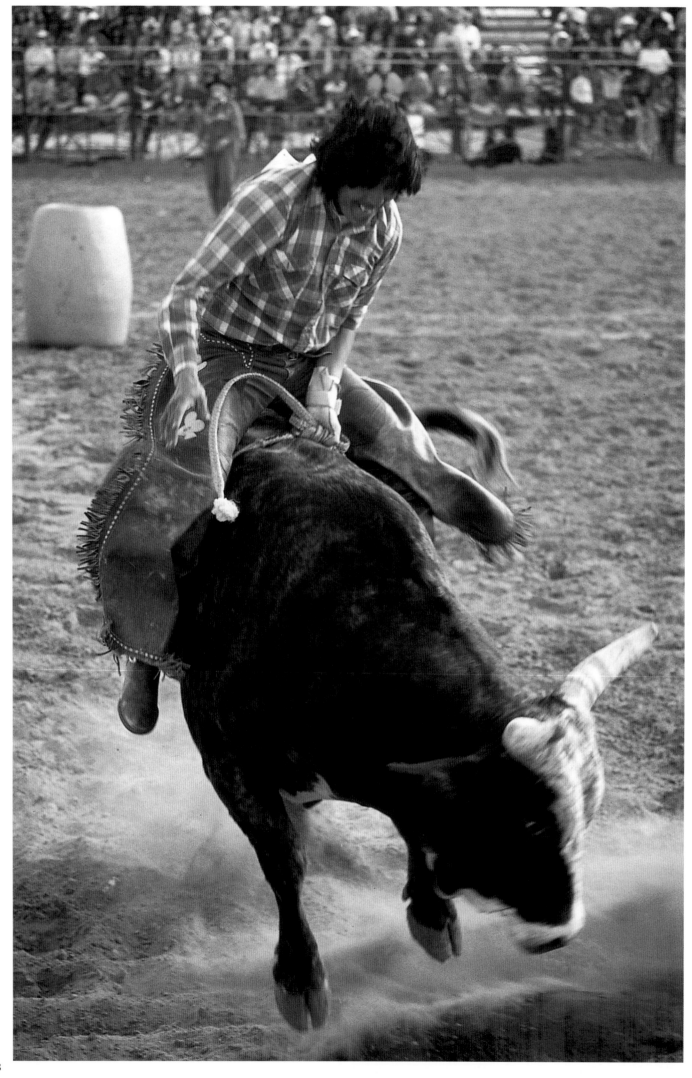

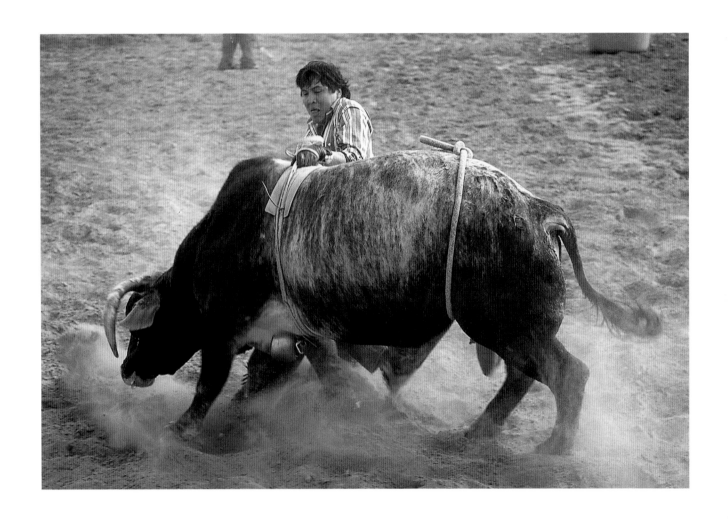

ABOVE: A cowboy tries desperately to free his hand.

LEFT: A bull rider enjoys his ride: a rarity in the most dangerous event in sports.

OVERLEAF: Eight seconds is an eternity for a bull rider hung up in his rigging.

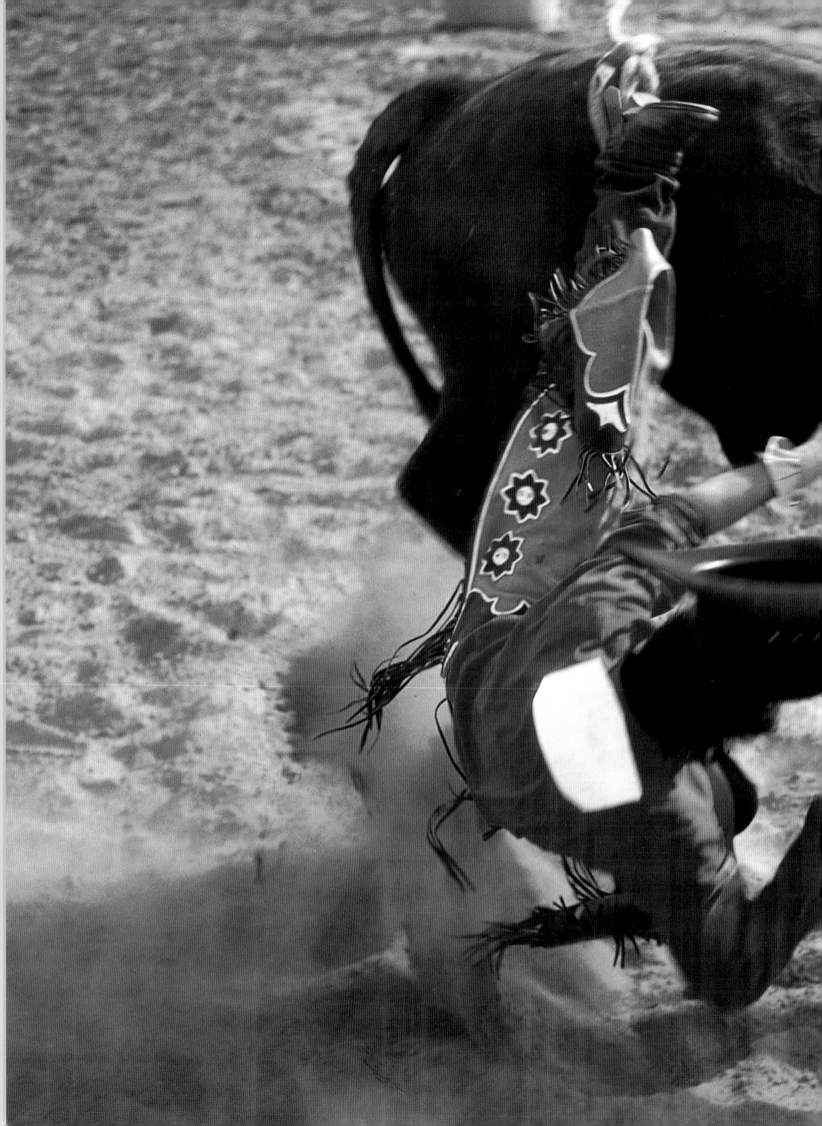

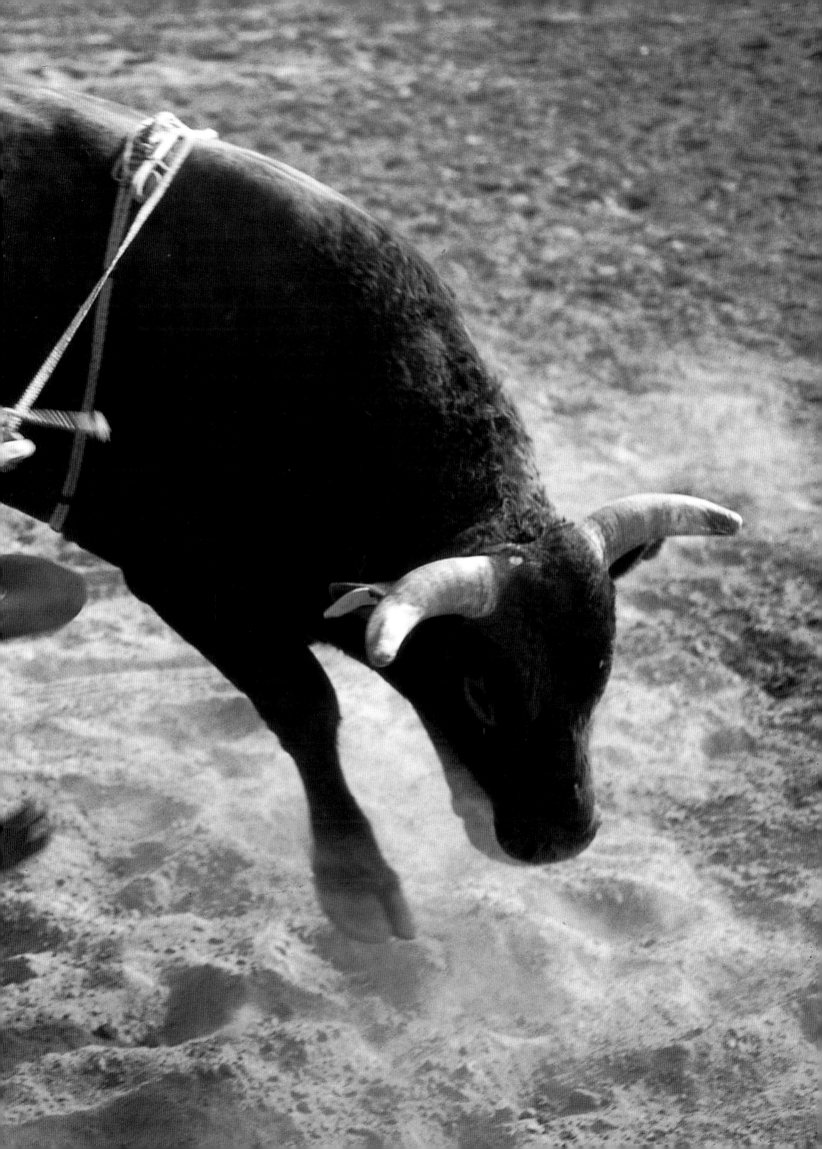

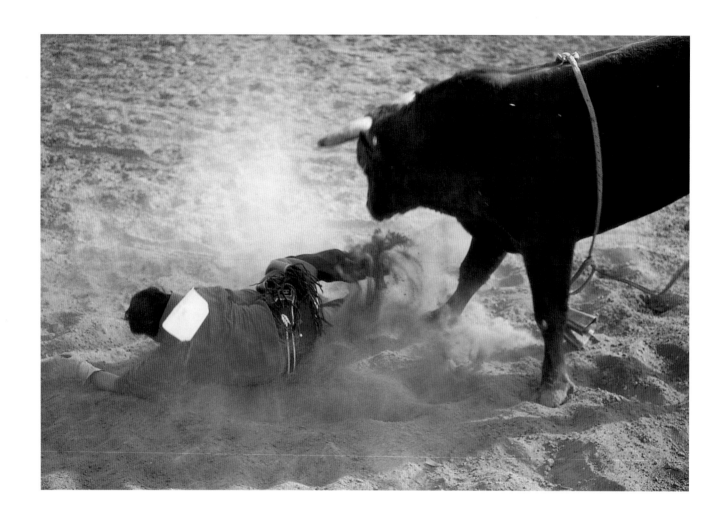

ABOVE: His rider thrown to the ground, a bull moves in for the kill.

RIGHT: Hung up in a "suicide knot," a cowboy tries to free his hand before he's maimed or killed.

OVERLEAF: A blur of dust and horns engulfs a fallen rider and clown.

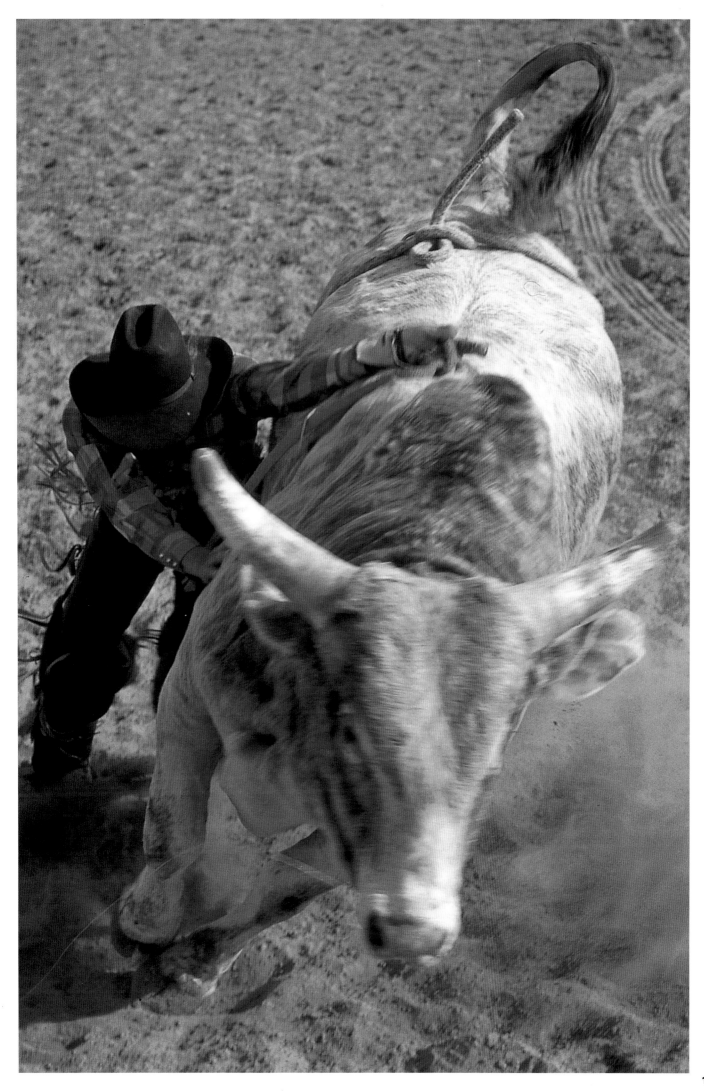

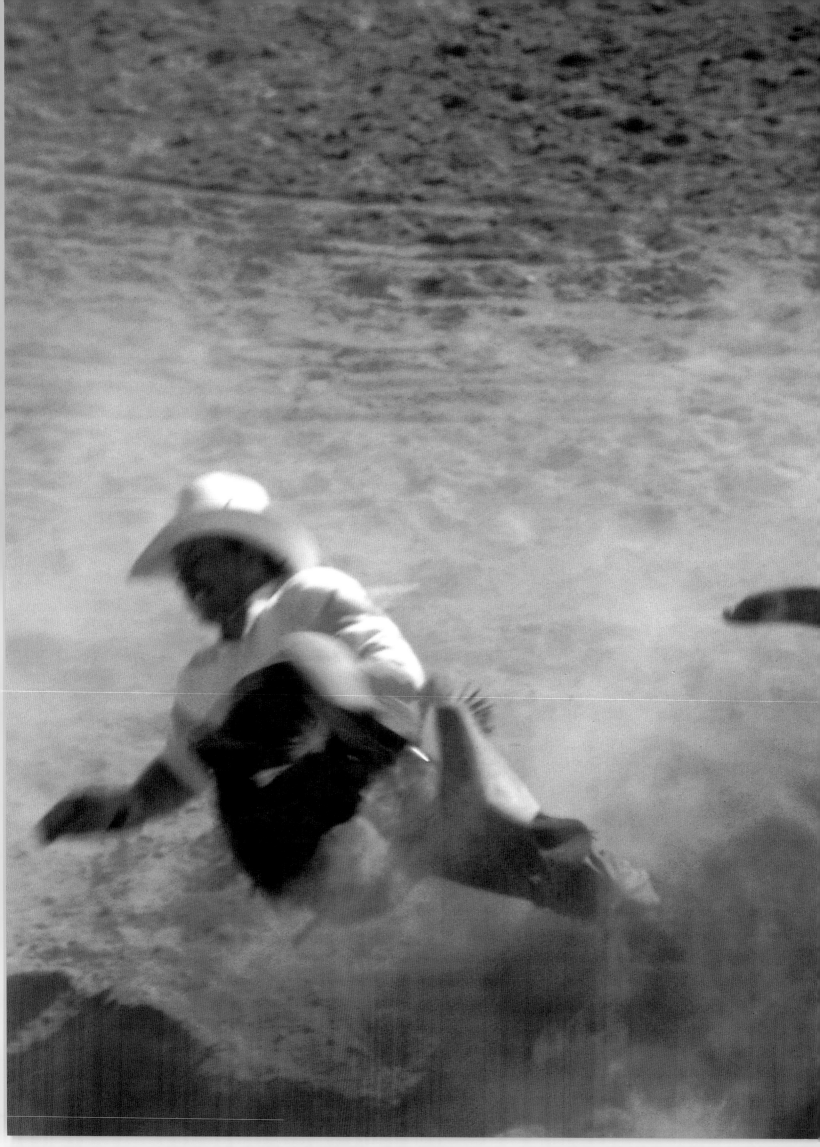

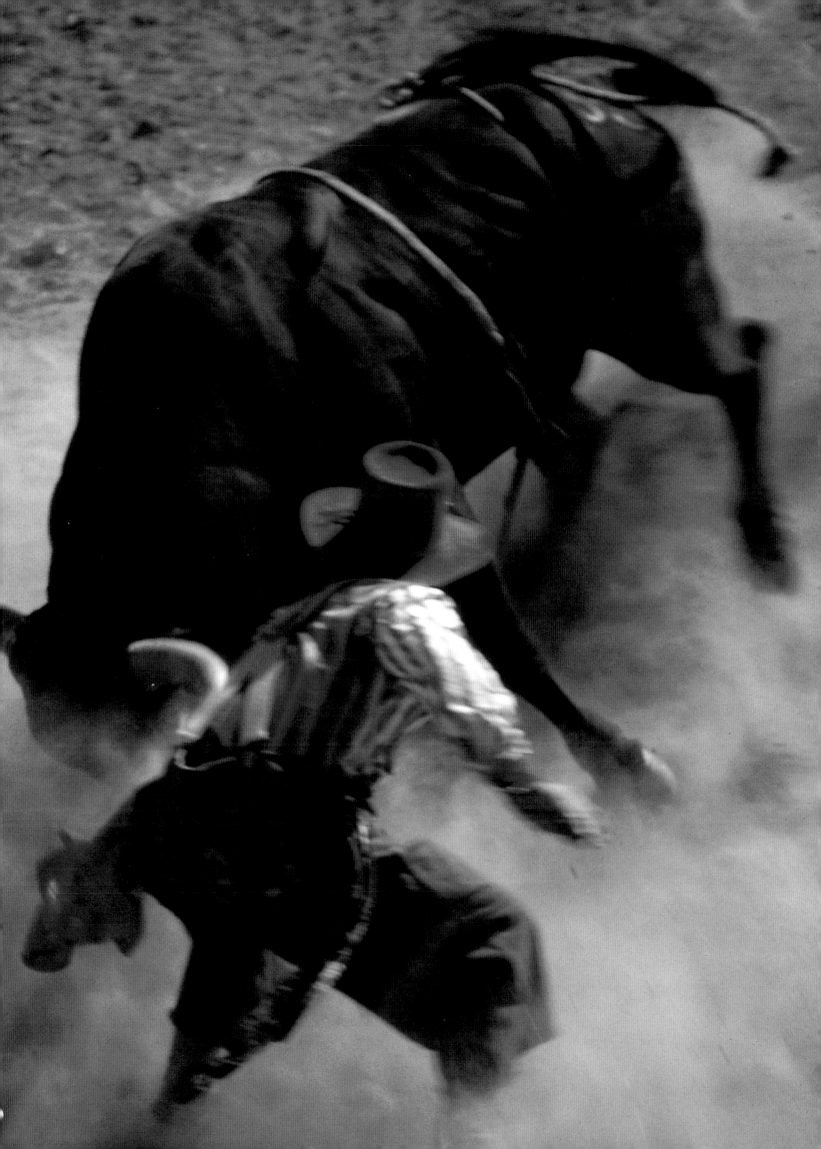

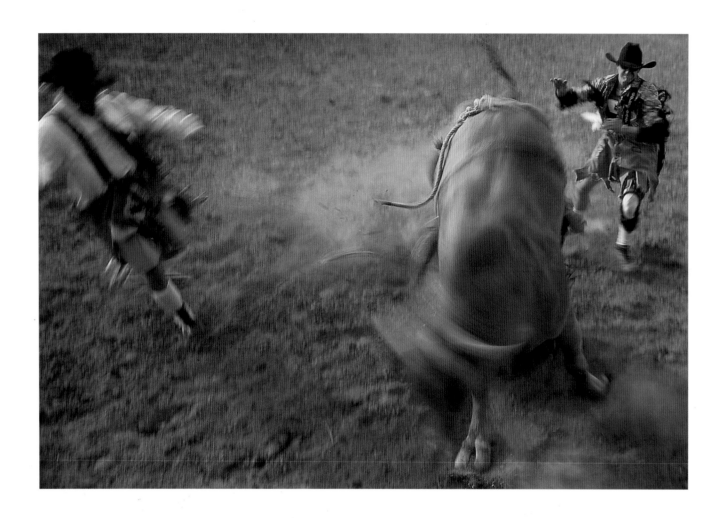

ABOVE AND RIGHT: Bulls are the only animal in the roughstock events that will hunt down a fallen rider to gore, trample and kill him.

OVERLEAF: A rider cartwheels off a bull before being saved by bull-fighting clowns.

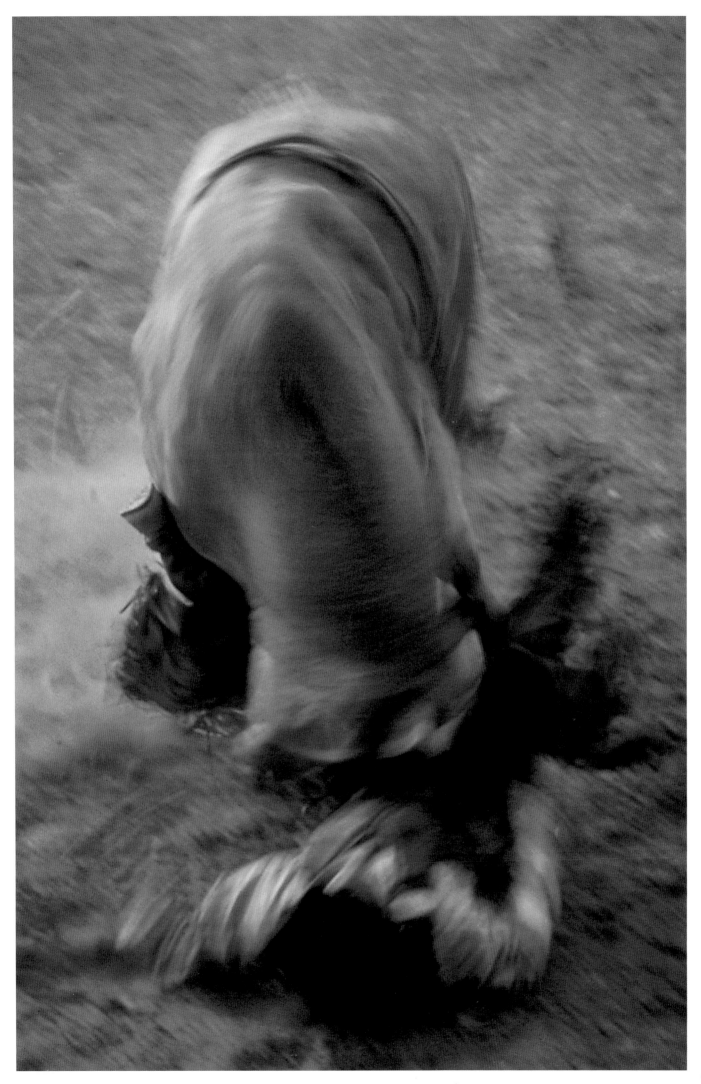

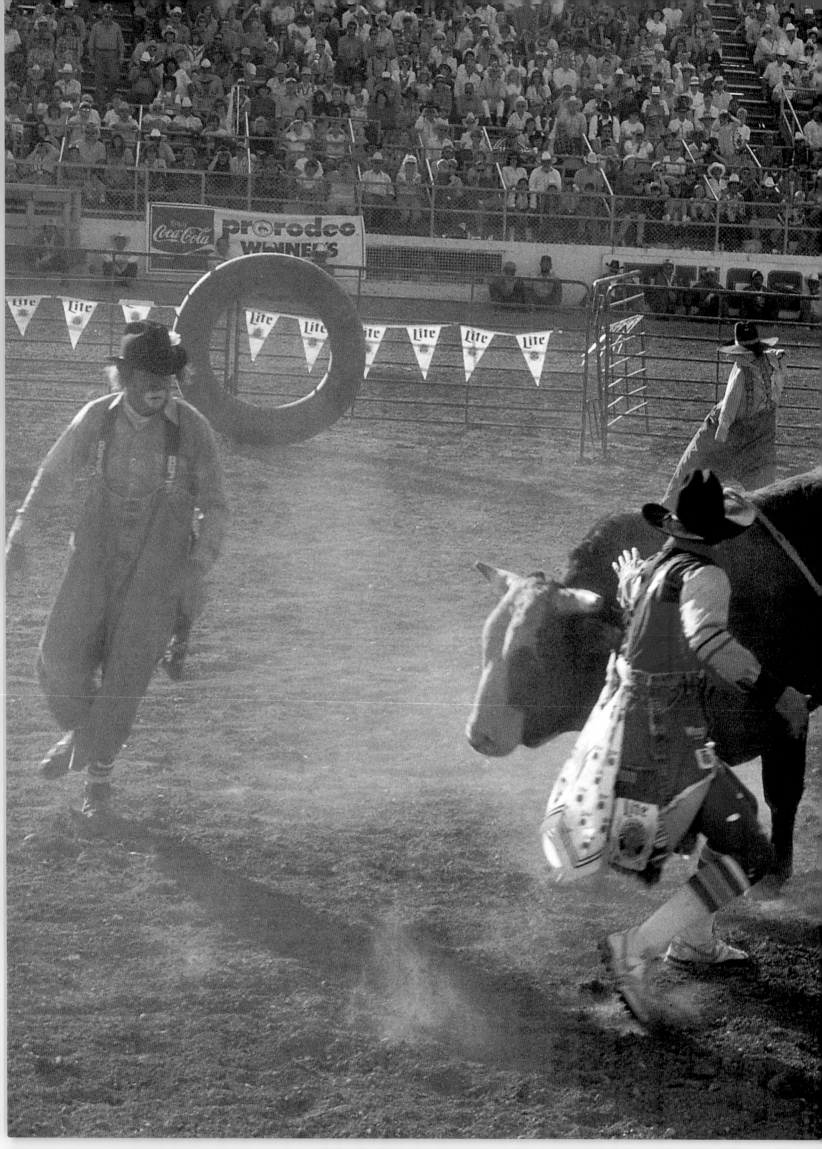

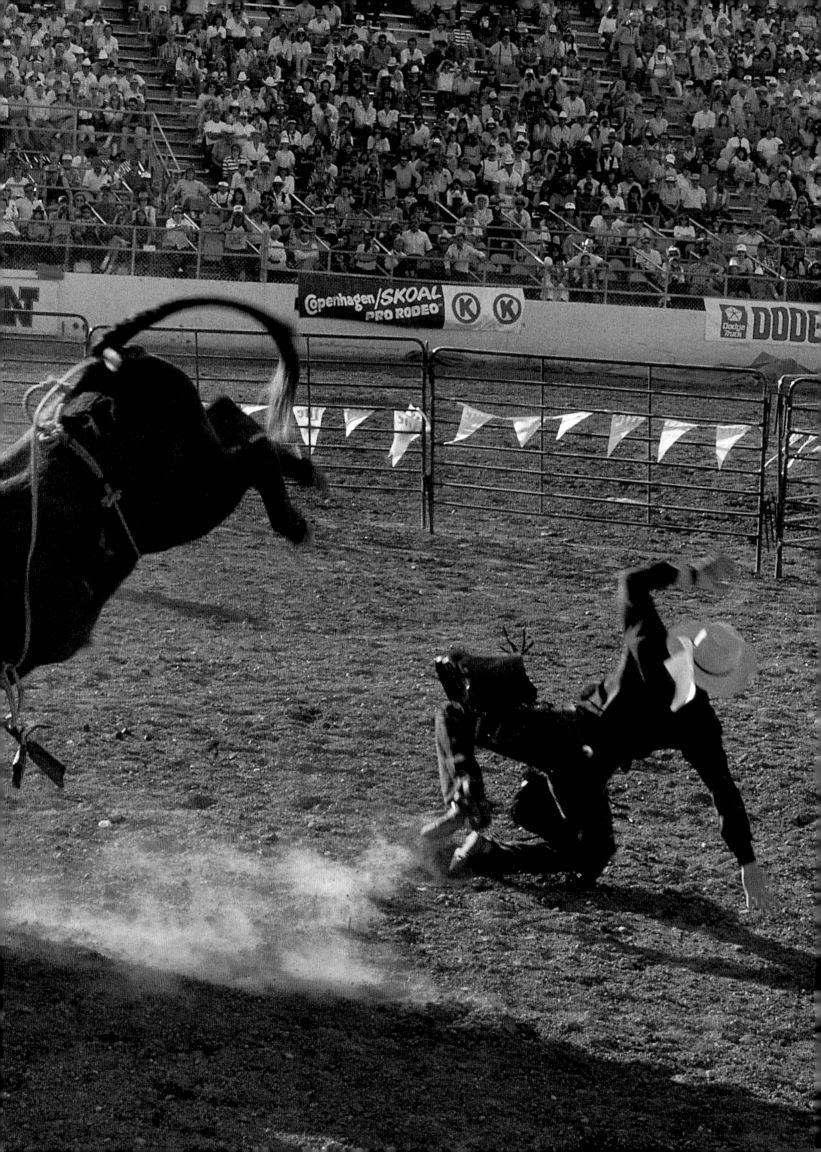

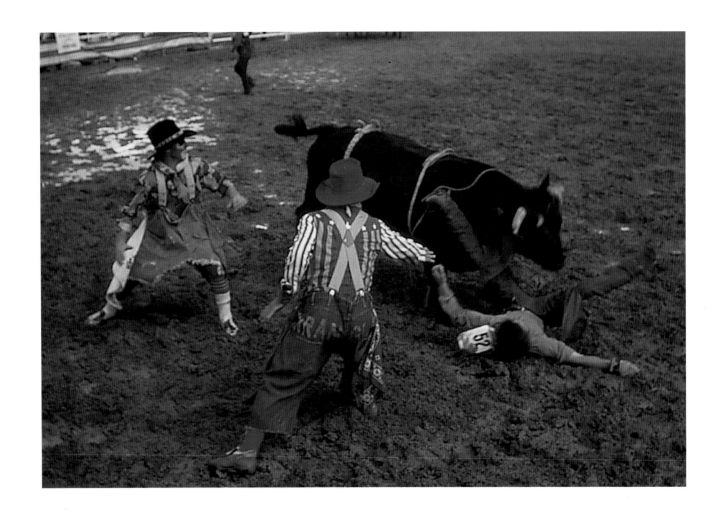

ABOVE: Bull-fighting clowns try to distract a mean black bull that shows no mercy to this fallen rider.

RIGHT: Dissatisfied with simply throwing and trampling this cowboy, a white faced bull tries to bite a piece out of him as well.

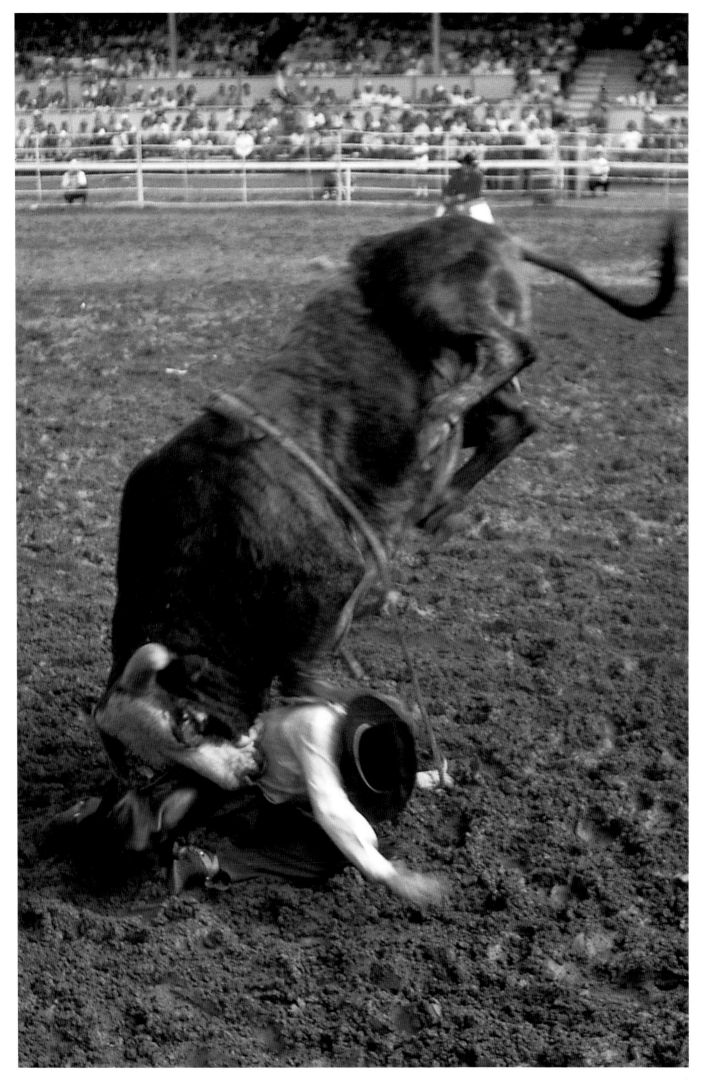

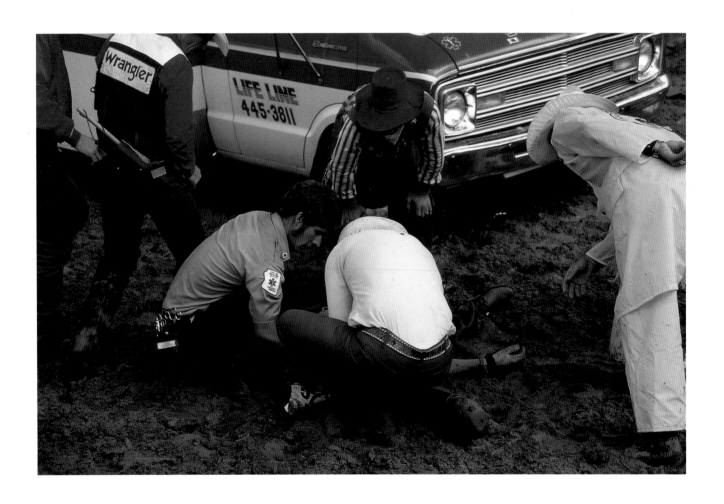

ABOVE: Paramedics try to revive an injured bull rider.

RIGHT: Professional bull riding champion Aaron Semas takes home the kind of payday that remains out of reach for most rodeo cowboys.

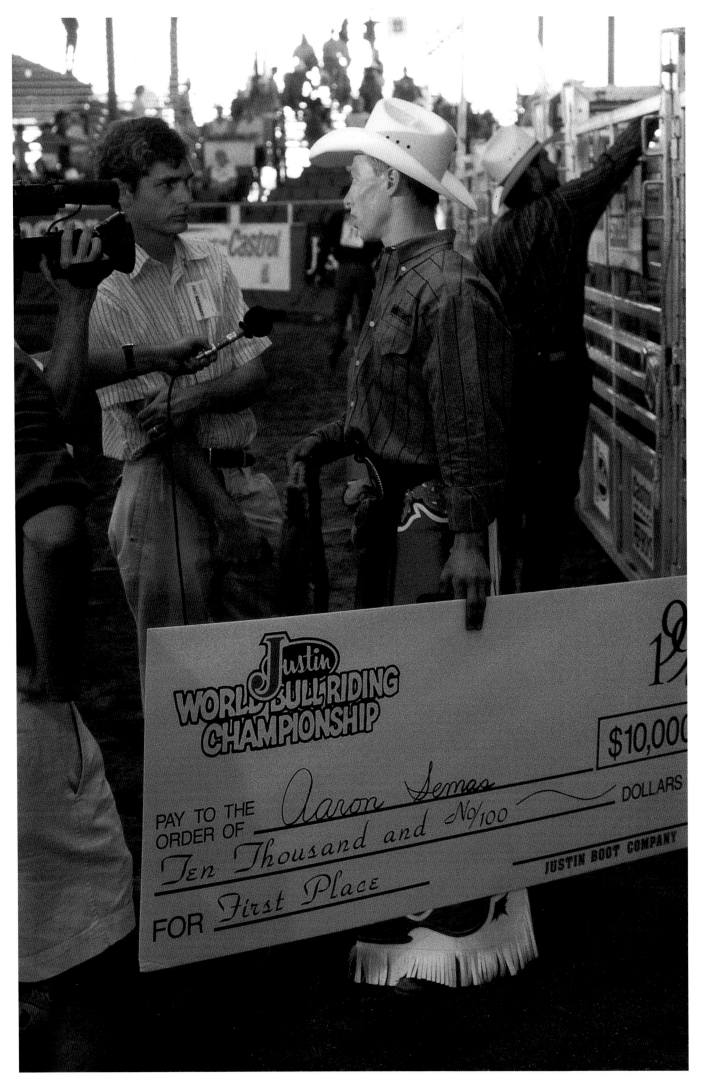

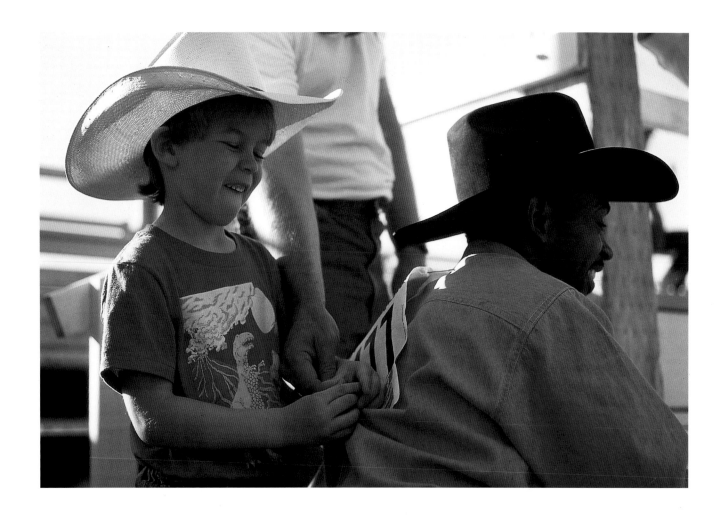

ABOVE AND RIGHT: Willie Nelson also crooned, "My heroes have always been cowboys, and they still are, it seems." Champions 'till the end, Charlie Sampson gives up his number to a young fan, while Dwayne Hargo hands out autographed pictures.

OVERLEAF, LEFT: "Bull Dancer" Bobby Romer says adios from the World's Oldest Rodeo in Prescott, Arizona.

OVERLEAF, RIGHT: Many cowboys, wrote one balladeer, "were born to follow rodeo."

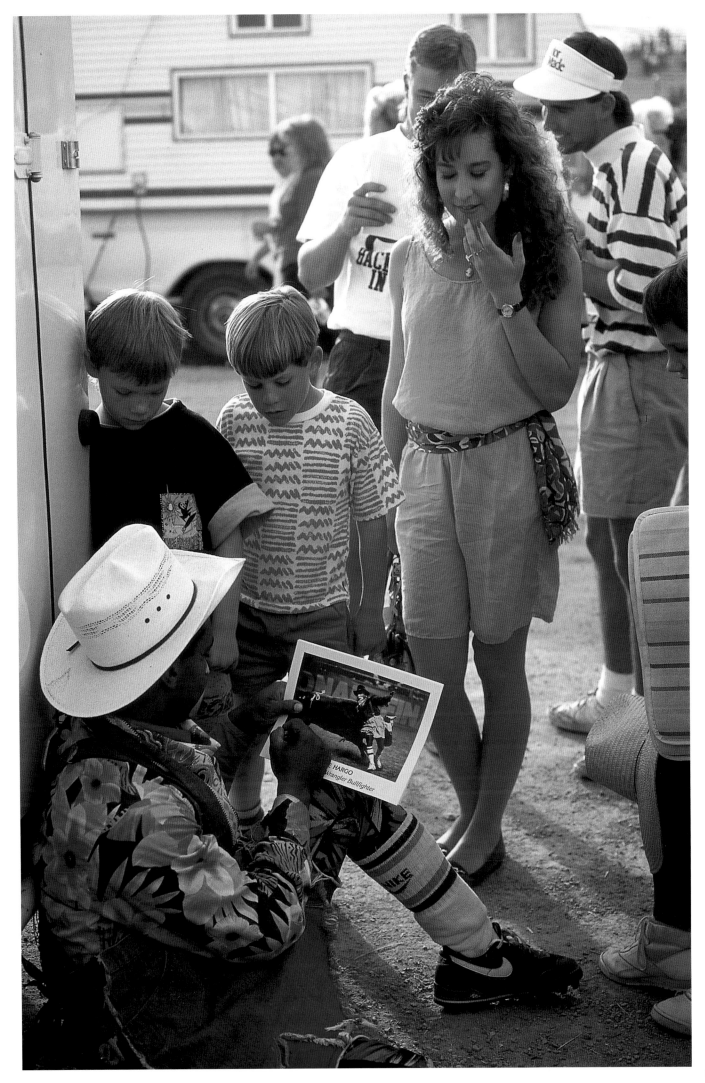

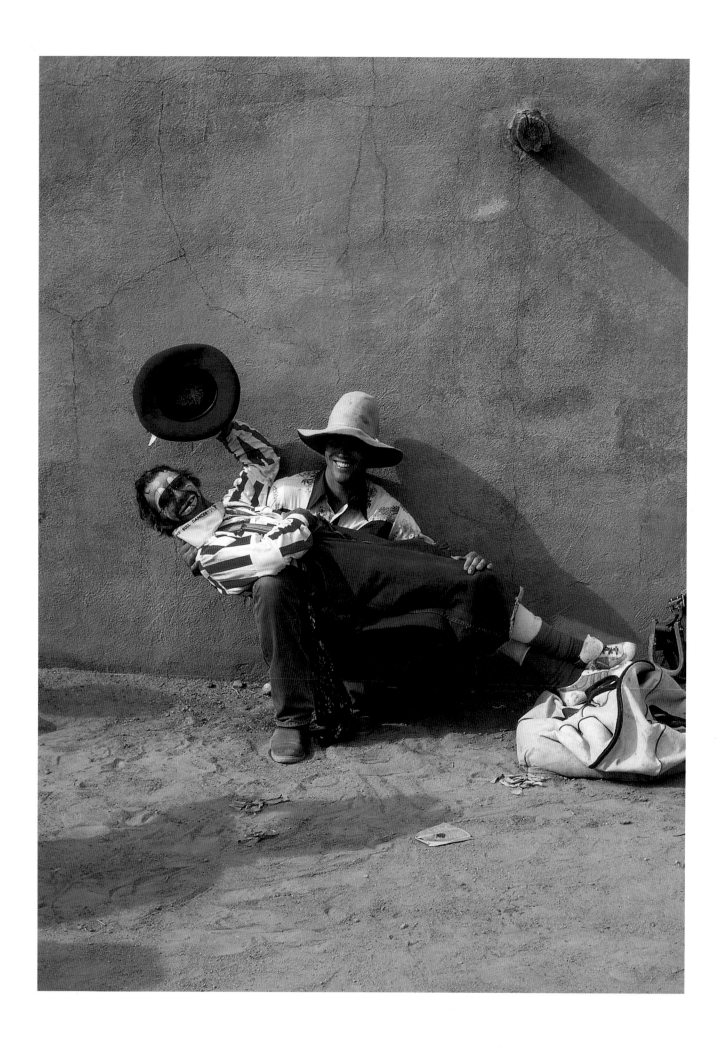

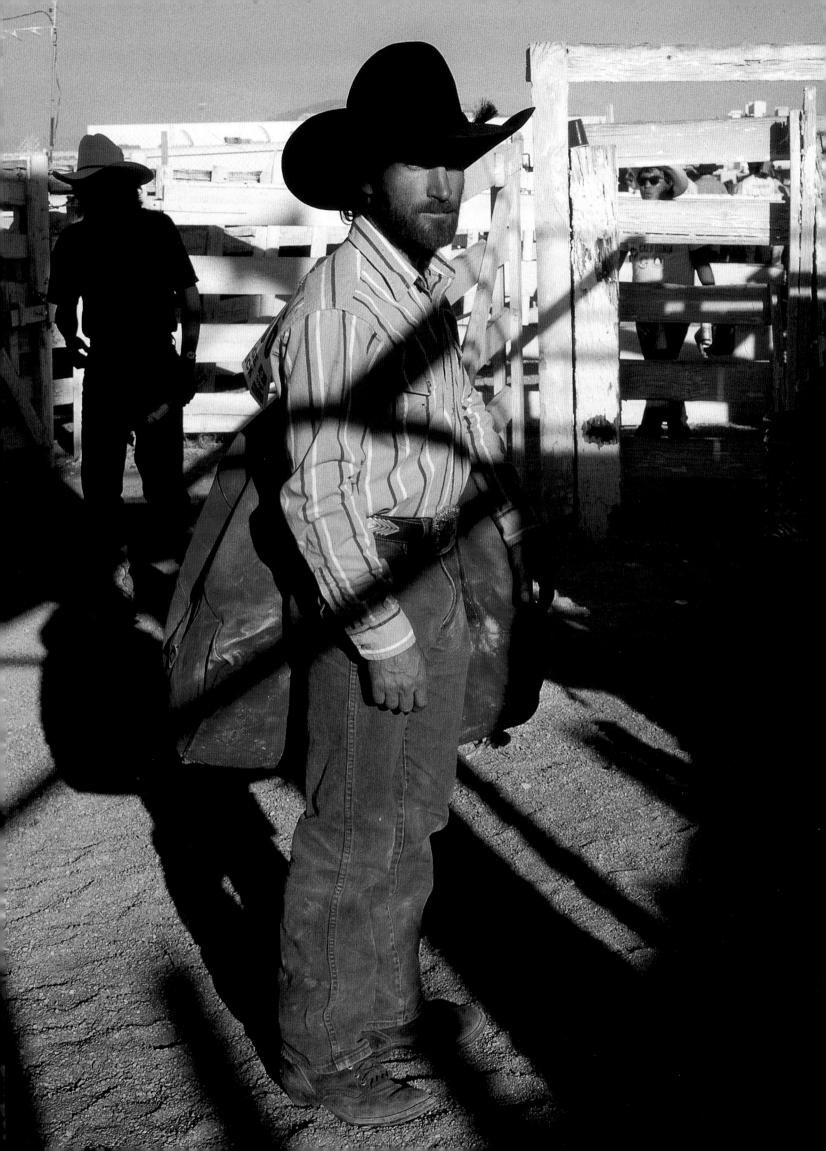

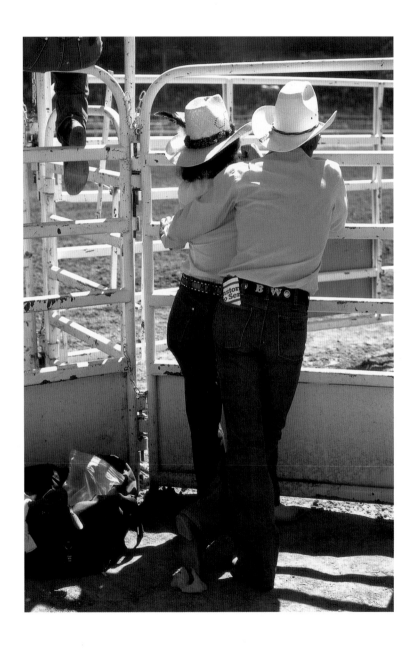

Bibliography

Abbott, E. C. "Teddy Blue," and Helena Huntington Smith. *We Pointed Them North: Recollections of a Cowpuncher*. New York: Farrar and Rinehart, 1939.

Annerino, John. "Behind the Chutes: An Inside Look at the Toughest Events in Rodeo," (photo essay by the author). *Northern Arizona Life*, vol. II, no. IV (June 1985): 25–29.

___."Roughstock," (photo essay by the author). *Phoenix*, vol. 27, no. 2 (February 1992): 82–89.

___."The Original Cowboys: Los Charros," (photo essay by the author). *Phoenix*, vol. 29, no. 5 (May 1994): 76–81.

___. "The Cowboy Way, Indian Style," (photographs by the author).*The Arizona Republic, Perspective* (October 16, 1994): E-1, E-2.

___. "Roughstock, A Photo Essay on Bareback, Saddle Bronc, and Bull Riding," (photographs by the author). *Valley Guide Quarterly*, vol. 5, no. 4 (Winter 1995): 84–91.

Baillargeon, Morgan, and Leslie Tepper. *Legends of Our Times: Native Cowboy Life*, (illustrated). Vancouver, British Columbia: UBC Press and Canadian Museum of Civilization, 1998.

Bancroft, Hubert Howe. *The Works of Hubert Howe Bancroft, Volume XVII. History of Arizona and New Mexico: 1530–1888*. San Francisco: The History Company, Publishers: 1889.

Bell, Major Horace, and Lanier Bartlett, ed. *On The Old West Coast: Being further Reminiscenses of a Ranger*. New York: William Morrow & Co.: 1930.

Bergner, Daniel. *God of the Rodeo: The Search for Hope, Faith, and a Six-second Ride in Louisiana's Angola Prison*. New York: Crown Publishers, 1998.

Borthwick, John David.*Three Years in California*, 1851–1854. Edinburgh, Scotland: Blackford & Sons, 1857.

Chávez, Octavio. *La Charrería: Tradición Mexicana*, (illustrated). Mexico: Instituto Mexiquense de Cultura, 1991.

Cisneros, José. *Riders of the Border: A Selection of Thirty Drawings*, (with text by the artist). Southwestern Studies, Monograph No. 30. El Paso: Texas Western Press, 1971.

Conrad, Barnaby. *The Death of Manolete*, (illustrated). Cambridge, Mass: The Riverside Press, 1958.

___. *Barnaby Conrad's Encyclopedia of Bullfighting*,(illustrated), Cambridge, Mass: The Riverside Press, 1961.

Conrad, Jack Randolph. *The Horn and the Sword: A History of the Bull as Symbol of Power and Fertility*. New York: E.P. Dutton, 1957.

Crawford, William.*The Bronc Rider*. New York: G.P. Putnam's Sons, 1965.

Daniels, George G., ed. *The Spanish West*, (illustrated). The Old West Series. Alexandria, Virginia: Time-Life Books, 1976.

Dempsey, Hugh A. *Tom Three Persons: Legend of An Indian Cowboy*. Saskatoon, Saskatchewan: Purich Publishing, 1997.

Dobie, J. Frank. *The Mustangs*. Boston: Little, Brown & Co., 1952.

Durham, Phillip, and Everett L. Jones.*The Negro Cowboys*. New York: Dodd, Mead & Co., 1965.

Forbes, William H. *The Cowboys*, (illustrated). The Old West Series. Alexandria, Virginia: Time-Life Books, 1973.

Haley, J. Evetts. *Charles Goodnight: Cowman and Plainsman*, (illustrations by Harold Bugbee). Norman: University of Oklahoma Press, 1949.

___. *Life on the Texas Range*, (photographs by

Erwin E. Smith). Austin: University of Texas Press, 1952.

Hall, Douglas Kent. *Let 'er Buck*, (photographs by the author). New York: Saturday Review Press, 1973.

___. *Rodeo*, (photographs by the author). New York: Ballantine, 1975.

Hanes, Colonel Bailey C. *Bill Pickett, Bulldogger: The Biography of A Black Cowboy*. Norman: University of Oklahoma Press, 1977.

Hartangle-Taylor, Jeanne Joy. *Greasepaint Matadors: The Unsung Heroes of Rodeo*, (illustrated). Loveland, Colorado: Alpine Publications, 1993.

Horgan. Paul. *Great River: The Rio Grande in North American History*. 2 vols. New York: Rinehart & Co., 1954.

Johnson, Dirk. *Biting the Dust: The Wild Ride and Dark Romance of the Rodeo Cowboy and the American West*. New York: Simon & Schuster, 1994.

Jordon, Bob. *Rodeo History and Legends*, (illustrated). Montrose, Colorado: Rodeo Stuff, 1993.

Lawrence, Elizabeth Atwood. *Rodeo: An Anthropologist Looks at the Wild and the Tame*. Chicago: University of Chicago Press, 1982.

LeCompte, Mary Lou. *Cowgirls of the Rodeo: Pioneer Professional Athletes*. Urbana: University of Illinois Press, 1993.

Manje, Juan Mateo. *Unknown Arizona and Sonora, 1693–1721, from the Francisco Fernández del Castillo Version of Luz de Tierra Incognita*. (Harry J. Karns et al, trans.) Tucson: Arizona Silhouette, 1954.

Martin, Russell. *Cowboy: The Enduring Myth of the Wild West*, (illustrated). New York: Stewart, Tabori & Chang, 1983.

McMurtry, Larry. *It's Always We Rambled: An Essay on Rodeo*. New York: Frank Hallman, 1974.

Ramírez, Nora E. "The Vaquero and Ranching in the Southwestern United States, 1600–1970." Ph.D. Dissertation, Indiana University, 1979.

Richardson, Rupert N., *The Comanche Barrier to South Plains Settlement*. Glendale, California: Arthur H. Clark Co., 1933.

Robertson, M.S. *Rodeo: Standard Guide to the Cowboy Sport*, (illustrated). Berkeley, California: Howell-North, 1961.

Robinson, Alfred, and Friar Geronimo Boscana. *Life in California: During a Residence of Several Years in That Territory*. New York: Wiley & Putnam, 1846.

St. John, Bob. *On Down the Road: The World of the Rodeo Cowboy*, (photographs by Lewis Portnoy). Englewood Cliffs, New Jersey: Prentice-Hall, 1977.

Savage, Candace. *Cowgirls*, (illustrated). Berkeley, California: Ten Speed Press, 1996.

Serpa, Louise L. *Rodeo: No Guts, No Glory*, (photographs by the author, notes by Larry McMurtry). New York: Aperture, 1994.

Steele, Fannie Sperry, as told to Helen Clark. "A Horse Beneath Me...Sometimes," (illustrated). *True West* vol. 23, no. 3, (January–February, 1976): 8–13, 36–37, 45–46.

Woerner, Gail Hughbanks. *Fearless Funnymen: The History of the Rodeo Clown*, (illustrated by Gail Gauddolfi). Austin, Texas: Eakin Press, 1993.